Saving the World and Healing the Soul

Saving the World and Healing the Soul

Heroism and Romance in Film

David Matzko McCarthy

and

Kurt E. Blaugher

 CASCADE *Books* · Eugene, Oregon

SAVING THE WORLD AND HEALING THE SOUL
Heroism and Romance in Film

Cascade Books
An Imprint of Wipf and Stock Publishers
199 W. 8th Ave., Suite 3
Eugene, OR 97401

www.wipfandstock.com

PAPERBACK ISBN: 978-1-4982-1950-1
HARDCOVER ISBN: 978-1-4982-1952-5
EBOOK ISBN: 978-1-4982-1951-8

Cataloguing-in-Publication data:

Names: McCarthy, David Matzko. | Blaugher, Kurt E.

Title: Saving the world and healing the soul : heroism and romance in film / David
Matzko McCarthy and Kurt E. Blaugher.

Description: Eugene, OR: Cascade Books, 2017 | Includes bibliographical refer-
ences and index.

Identifiers: ISBN 978-1-4982-1950-1 (paperback) | ISBN 978-1-4982-1952-5 (hard-
cover) | ISBN 978-1-4982-1951-8 (ebook)

Subjects: LCSH: 1. Film criticism. | 2. Motion pictures—reviews. | 3. Heroism. | 4.
Romance. I. Title.

Classification: PN 1995 S3126 2017 (print) | PN 1995 (ebook)

Manufactured in the U.S.A. 04/06/17

With gratitude:

To Peter Skutches, my undergraduate mentor, who taught me about "good stories well told," and Joseph Campbell, and heroes, and the quest;

To all of my graduate mentors, who taught me how to tell theatrical stories;

To Florence Shields, my "Auntie Mame" of an aunt, who always encouraged my dreams;

To my daughter, Amanda, to whom I have sung and told stories through her entire life;

And to Rita Blaugher, my mother—who clearly didn't read Frederic Wertham, and therefore let me read comic books when I was four; and who let me watch "Sunday Afternoon Movies" when I was eight; and who through all of that allowed me eventually to come to know just how truly valuable all of those comic books and movies and superheroes and stories really are.

—Kurt E. Blaugher

And with devotion:

To Stanley Hauerwas, my teacher, who loves telling, hearing, and telling about hearing good stories and taught me to look for God in every one of them;

To Bridget, please continue visualizing future chapters to our story;

To nearly a decade of students in Theology and Film, with great thanks for all the connections we have made and the insights we have shared.

—David Matzko McCarthy

Contents

1

The Hero, the World, the Soul

"I don't believe in either modernity or post-modernity. I find no persuasive evidence that either modern or post-modern humankind exists outside of faculty office buildings. Everyone tends to be pre-modern."[1] This claim is made by sociologist Andrew Greeley as he is introducing the idea that human beings have a need to be connected to a cosmic order and that we then find ways to make this connection through story, images, and ritual. In the context of Greeley's claim, "modern" and "postmodern" (as they are in "faculty office buildings") refer to philosophical theories about how we know what is real and true. A typically modern, philosophical approach reduces our connection to the world to scientific experimentation and logical inference, whereas the postmodern disparages the view that we can make any connection to an order of things at all. Think of the premodern in terms of medieval cathedrals that draw our attention upward and put us in a grand vertical space. In this regard, the modern, in the philosophical sense, flattens out how we are situated in the world; we live in a rectangular office building with a central hallway and uniform square rooms on each side. In response, postmodern theories ridicule this modern uniformity as yet another grand space—as grand schemes that attempt to connect us to a cosmic order, but in the process impose a homogeneity that constrains us. Postmodern philosophers want us to bask in the disconnected universe and be free. In contrast to these theories, Greeley proposes that stories, images, and rituals continue to connect people, together, to greater meaning and a sense of the order of things.

1. Greeley, *The Catholic Imagination*, 2.

1

Greeley is not the only writer to contemplate the power of story to connect audiences to a shared humanity and meaning. Consider the arguments of detective Thursday Next, the protagonist in Jasper Fforde's comic fantasy/alternate universe/science fiction novel, *Thursday Next: First Among Sequels*. She is making a case for literature, for writing better books, as opposed to developing plot lines through interactive polling data and demographic analysis.

> Humans like stories. Humans *need* stories. Stories are good. Stories *work*. Story clarifies and captures the essence of the human spirit. Story, in all its forms—of life, of love, of knowledge—has traced the upward surge of mankind. And story, mark my words, will be with the last human to draw breath.[2]

In Fforde's *Thursday Next* series, Thursday is the kind of hero that we will encounter in the films that we treat. Within a highly advanced world of cloning, various technological communications media, and "reality" TV, she defends the human, which means she champions story.

Peter Brook, renowned theater director, playwright, and filmmaker, speaks of story in terms of a silence, which gathers and articulates a profound sense of human connection. "Silence," in his account of storytelling in theatre, is contrasted with applause and cheering—with seeking merely to entertain. Silence refers to a depth of experience, experienced by both performers and audience. On one hand, Brook holds, there is a silence that separates—a dead silence. On the other hand, there is a silence that connects.

> There are two silences. Perhaps there are many, but there are two ends of the pole of silence. There is dead silence, the silence of the dead, which doesn't help any of us, and then there is the other silence, which is the supreme moment of communication—the moment when people normally divided from one another by every sort of natural human barrier suddenly find themselves truly together, and that supreme moment expresses itself in something which is undeniably shared, as one can feel at this very moment.[3]

From his account of this empathetic silence, Brook argues for the priority of storytelling in theater. "Here is a human being, other human beings watching. Now, can we tell the whole story we want to tell, and bring to life the theme we want to bring to life, doing no more than that?"[4]

2. Fforde, *Thursday Next*, 204.

3. Brook, *Between Two Silences*, 5.

4. Ibid.

It is obvious that stories are alive and well in our world in many ways, and one of the most recognizable ways that stories are told in contemporary popular culture is through the medium of film. Here, Brook's contrast between noise and silence is profoundly applicable. Amid the big bangs and special effects of the blockbuster, storytelling remains at the heart of good film.

From George Lucas and *Star Wars* forward, screenwriters, directors, and producers have followed the trail of Joseph Campbell and others who have catalogued the uses of human mythology in various storytelling forms.[5] Not only are these deeply human stories alive and well, but also they tend to reinforce ways of framing life as a whole. We are able to witness a set of characters and a course of events in relief—with a meaningful framework that has a beginning that we see through to the end. One of the most commonly used frameworks shows a "hero's journey" (to use the Joseph Campbell phrase), in which a hero battles against injustice and villainy. This path tends to follow the same course and get to the same conclusion: that no matter how bleak and hopeless things seem, the heroes will not allow the world to be destroyed, and in the process they will discover something noble about themselves, discover friends, and find love and/or gather new hope and direction in their lives. We know well the various genres and their characters and plot lines, and here, we find a ritual element to film: we head to the theatres and streaming devices to witness the same basic stories and images, again and again. A framing of the order of the world and a struggle to find meaning and a place in it are fundamental to a whole host of films.

Saving the World and Healing the Soul is about how four sets of films attempt to put order to the world, and how the heroes of these films (literally or figuratively) save their worlds from destruction, while at the same time achieving inner and personal restoration and renewal. To this degree, our inquiry is religious. *Religion*, as we are using the term here, has an unavoidably modern connotation. *Religio*, in the ancient world, was understood not so much as a grasping, but as a responding to an unavoidable and enduring order and divine presence in the world. For the ancients, a lack of religion was like going to dinner and failing to recognize and give due honor to the host. But if the real, modern world is flattened out and disenchanted (in theory at least), then religion becomes a way to imagine there is a dinner (a kingdom feast) and a divine host.[6] It is grasping for order and meaning, imagining and

5. Campbell, *The Hero with a Thousand Faces*; Campbell, *The Power of Myth*.
6. Charles Taylor notes these modern shifts in *A Secular Age*.

acting out how things are when they are as they should be. Insofar as characters in film act meaningfully, the film assumes and sometimes establishes a connection between the individual agents and the order of things.

In our treatment of film, we will not be concerned to identify specific elements of religion or religious themes. We will not focus on overtly religious films. We will hardly use the term *religion* after this first chapter. It is not difficult to see that Jason Bourne (in the *Bourne* trilogy) goes through the process of baptism (dying and rising to new life), or that the vampires of the *Twilight* saga are a species of demigods; immortal forces of evil and good existing in a human world. By the same token, Bruce Wayne/Batman realizes resources of strength and power through his trials of self-discovery, literally climbing out of the pit where he has been imprisoned, and Katniss Everdeen triumphs over forces of evil manipulation through three sets of Hunger Games, and finally realizes the power she has—a power and strength of authenticity and compassion. These are religious elements, but our concerns are more broadly religious.

Films are necessarily religious when they present a hero; they are religious in the sense of grasping an order and meaning of things because the hero will inhabit a world with good and bad, act amid that world, and find him- or herself in it—"find" in the sense of self-discovery. As protagonist (as central character), the hero and heroic action will be central to the meaning and course of life as it is framed in the narrative. The films that we consider tell the story of what the world is like, imagine an order of things, and connect particular lives to this order of things through struggle against inner and outer forces. In the *Republic*, Plato sees a parallel structure of soul, city, and cosmos. The same symmetry is characteristic of various genres of film; the hero is broken in some sense and seeks deliverance and wholeness. The hero's brokenness has a direct relationship to fragmentation in the world, and likewise, the hero's redemption through his or her acts of redemption in the world.

It is important to note that we do not expect films to be theological in the sense that religions, like Christianity, Judaism, and Islam, are theological. That is, theology is based on how God reveals God's very self to the world. In this sense, these faiths are religious in the ancient rather than modern sense. They respond to God who is revealed, to the God who is manifest and who speaks. Although some theologians (most notably Karl Barth) set religion and revelation in opposition, we do not make that

THE HERO, THE WORLD, THE SOUL

assumption.[7] We are assuming that in our modern religious grasping for connections to a larger order—and in imagining heroic action as central to that order—contemporary film draws on the natural desires of the human being for God, which can only be fulfilled by God. We don't see much benefit in criticizing film for not being theological. Rather, we make explicit the kind of grasping for order and for good and for a place in the order of things that is implicit, and sometimes explicit, in various films.

In this book, we treat the *Bourne* films, Christopher Nolan's *Batman* trilogy, the *Twilight* saga, and *The Hunger Games* series. Admittedly, other movies would have offered suitable and fruitful material for our angle on film, and there is an element of personal preference and affinity built into our treatment. We are a theologian and a theater artist, both professors at Mount St. Mary's University in Emmitsburg, Maryland. David has been teaching a course titled "Theology and Film" since 2008, and he and Kurt have been discussing film regularly and collaborating on the make-up of the course ever since. *The Bourne Identity* and *The Dark Knight* were on the course syllabus in 2008 (along with twenty-three other films), and the film list and course have developed organically (between David and Kurt) from there. We have chosen films that are quite different, yet when considered closely, have a similar thematic core. All are box-office success stories. The *Twilight* novels, for example, are written for a teen, female audience, but the films (against the odds it seems) have enjoyed much wider appeal (grossing about $1.5 billion in the U.S. and $3.3 billion worldwide).[8] We have two heroes and two heroines, and various genres and mixes of genre within a single film (thriller, action, romance, drama, etc.). In short, the films we treat are appealing and popular, they cover quite a few dramatic forms, and fit together in a whole argument as well—the heroic saving of the world from corruption while on a parallel path of healing the soul.

Consider these plot and character markers for the films discussed in this book: 1) a heroic battle against evil that is marked by questions of personal identity, 2) a homeless hero seeking a restoration or discovery of home, 3) a romantic stance of the authentic and loving individual against corrupt institutions, industrial-scientific technology, and the powers of the world, 4) a romantic hope to be known truthfully by another and to become a better person, and through this relationship, have hope for an alternative

7. See Barth, *Epistle to the Romans.* Also see chapter 1 of Lohfink, *Does God Need the Church?*

8. "Twilight," *Box Office Mojo.*

social space (alternative to social corruption), and 5) an interplay between love (which can inspire vengeance) and justice where personal identity and truth are at stake. The action film is romantic when the hero strives to find a human place, a connected, integral set of relations to the world—given that the world has been disenchanted by corruption (power and greed), cold rationality, and technological manipulation. The world is saved for personal relations (for a healing of the soul).

These themes are sometimes convoluted in a particular film. For example, Batman uses the symbol of a bat (rather than, say, iron—or a big red "S"), but is heir to one of Gotham's captains of industry, and needs the technology that that fortune can purchase to do his work. It is the villains who want to destroy the city; Talia al Ghul wants to do so with the inventions of Wayne Enterprises. The Joker can be seen as a sympathetic figure because he represents a romantic stance against "having a plan" and technological advancement (he loves simple dynamite). It seems, here, that Batman is on the wrong side of the romantic reaction against utilitarian advancement. However, in the end, Bruce must be stripped of everything and climb out of the pit with only his courage. And to find peace, he will have to leave the city and Batman behind. (As an aside, his relationship with Rachel Dawes, his childhood friend, will never work because she ties him to Wayne Manor, Wayne Enterprises, and the technological advancement of Gotham.) In regard to this kind of romanticism, *Twilight* presents an interesting case. Manipulation (planning) and corruption (a lust for power) are placed within a government of vampires, which takes control of various vampire powers (technologies?). The Cullens are vampires who represent a different relationship to the world, and Bella will offer an "organic/natural" future to the vampire world. If this romantic framework in *Twilight* is not entirely clear at this point, we will get there in chapter four.

At this juncture, we are providing short synopses of each set of films, along with *précises* of their critical and popular reception. In our writing, we assume the readers have seen each film. We do not want to bog you down in plot summary, but we know that you are likely to need reminders. We place the summaries here, all in one place, so that you can skip them now if you wish and turn back to them as needed. In addition, bibliographical information is provided for all the films at the end of the book. All quotations and dialogue from the films throughout the book refer to DVD versions of the films.

Bourne Series: Synopsis

The basic structure of the *Bourne* series of films is relatively simple. All of the films depict a conflict between a man and a corrupt bureaucracy. A man's life—his identity, personality, and dispositions—has been altered by a covert government program. This program, called Treadstone, has broken Jason Bourne down, conditioned him to obey and to kill, and enhanced his abilities through intensive training. He wants his life back; the directors of the program want to maintain control or, if they cannot, then to kill this rogue agent. The covert program has a wide ranging intelligence network, state-of-the-art technology, and other trained assassins at its disposal. Bourne has only his strength, wits, resourcefulness, and a sequence of women who love, support, and/or encourage him along the way. These women keep him connected to an alternative way of living, outside the institutional control that has shaped him as an assassin. If we were to remove the "black ops" from the movies, they look similar to classic stories about the struggles of the American middle class (in the line of *Death of a Salesman* or even *The Great Gatsby*). We seek success and the American dream, but what happens to us in the process? We become separated from who we are, our loved ones, and our homes. Can we fight our way back?

The series of *Bourne* films did not start as a continuous narrative. *The Bourne Identity* can stand alone. *Supremacy* and *Ultimatum* fit together as a whole; they acknowledge the plot points of *Identity*, but have to provide a new beginning, a restart after the conclusion of *Identity*. In short, *Identity* has a happy ending: Jason and his new found love, Marie, are no longer on the run. As they embrace on an exotic Greek island, the final scenes suggest that they will settle and make a home there. *Supremacy* starts by pulling Jason back into the chase. Without much of an explanation, Jason and Marie are together but in hiding, and as the action gets started, Marie is assassinated. Jason now has a reason to strike back. *The Bourne Legacy*, a fourth movie in the series, does not have Jason Bourne as the main character, so it develops continuity by extending the reach of the antagonist, the covert government bureaucracy, which now has so many offshoots that it can no longer keep track of its operations and divisions. The fifth installment of the series, *Jason Bourne*, appears to retrieve the character of Bourne by going back to the original formula: introducing the identity question (who am I and what have they made me?) with a potentially romantic connection in order to provide an alternative relational space (alternative to the bureaucratic relations that have oppressed him).

In the *Bourne* films, romance and relationships with women are not problematic; they tend to be a safe haven, if not outright solution to Jason's struggles. In *Identity*, *Supremacy*, and *Ultimatum*, women are lovers (Marie Kreutz, the drifter), vaguely referenced would-be lovers (Nicky Parsons, an operative/handler at Treadstone), and allies (Pamela Landy, a deputy director at the CIA). At the core, the *Bourne* films are about basic questions of identity. Who am I? What do others (the powers, authorities, society, the system) want me, or want to force me, to be? Who will I choose to become? And can I succeed? Above we likened these struggles of *Bourne* to tales of the lost or illusory American dream. Given our treatment of *Twilight* and *The Hunger Games* in following chapters, we should note that these questions are also developed in the teen coming-of-age film. These coming-of-age films build romantic rivals and indecision into larger questions of identity and purpose. The *Bourne* films, however, are not as complex. In a world of men at battle, women are friends, and this simplified structure keeps domestic life and romantic love on the horizon for Jason, as the place where we will rest, find himself, and flourish as a new man.

In the last paragraph, we focused on Jason rather than Aaron Cross, the protagonist in *The Bourne Legacy*. The key difference between Jason and Aaron is that Aaron wants to be what Operation Outcome has made him. He simply want to be free of its control. As the plot unfolds we find that the program is being shut down and its operatives assassinated. Aaron wants to maintain and make permanent the enhancements to him that were developed by Operation Outcome (a chemically enhanced human be-ing), but he wants to be able to outlive his creators and pursue his own path. For Jason, women offer an alternative to the bureaucracy that has created him. In contrast, Aaron's ally and love, Dr. Marta Shearing, offers a route to extend his Operation Outcome enhancements. She represents something more like a vacation getaway rather than home; a possibility rather than peace of mind and a settled place. While *Legacy* retains the intrigue and action of the other *Bourne* films, its hero is comparatively shallow. He does not seek a deeper self, a self that has been defeated and nearly destroyed, but fights to be resurrected and renewed. Through what *Legacy* lacks, we can see what is captivating about Jason Bourne.

Throughout the Jason Bourne trilogy, water—obviously an allusion to baptism—marks his various rebirths. We learn through flashbacks that a form of water torture is used by Dr. Hirsch and Treadstone to break David Webb down and to manipulate him, so the person who becomes Jason

Bourne could be shaped to their needs. Also through flashbacks, we discover that the amnesia and identity crisis for Jason Bourne begins when he is unable to murder Wombosi and his son. After he is shot by Wombosi, he floats in the ocean (apparently dead), and is pulled from the water by fishermen. At the end of *The Bourne Identity*, aerial shots over the Mediterranean Sea signal our approach to Jason's reunion with Marie, presumably to start a new life together. But at the beginning of *Supremacy*, he and Marie are thrown into the water again; Marie is dead, and Jason is compelled to take on the life of a spy and covert warrior again. Finally, after he faces up to his creation as Jason Bourne, he willingly jumps from a ten-story building (and in the process avoids killing a CIA assassin), in order to begin a new life again.

Rotten Tomatoes (www.rottentomatoes.com)—*Bourne* Films[9]

Film	"Tomatometer" (Tomatometer Critics)	Audience Score
Bourne Identity	83% Average Rating: 7/10 Reviews Counted: 185 Fresh: 154 Rotten: 31	93% liked it Average Rating: 3.9/5 User Ratings: 963,412
Bourne Supremacy	81% Average Rating: 7.2/10 Reviews Counted: 190 Fresh: 154 Rotten: 36	90% liked it Average Rating: 3.9/5 User Ratings: 707,154
Bourne Ultimatum	93% Average Rating: 8/10 Reviews Counted: 258 Fresh: 240 Rotten: 1	91% liked it Average Rating: 4.1/5 User Ratings: 1,920,861
Bourne Legacy	56% Average Rating: 5.9/10 Reviews Counted: 219 Fresh: 122 Rotten: 97	58% liked it Average Rating: 3.5/5 User Ratings: 281,258

9. *The Bourne Identity, The Bourne Supremacy, The Bourne Ultimatum*, and *The Bourne Legacy, Rottentomatoes.com*.

The widely favorable reception of the *Bourne* trilogy—*Identity, Supremacy*, and *Utlimatum*—can be framed by the lukewarm response to *The Bourne Legacy* (2012). *Legacy* tries to ride on the coattails of the Jason Bourne films to form a bridge between Jason (who is not in the film other than as a reference) to the plight and struggles of its new hero, Aaron Cross. Once the bridge is formed and crossed, *Legacy* moves off in its own direction. Roger Ebert puts the plot arc of *Legacy* succinctly; it "is the story of a man who needs some medication and spends the whole movie trying to get it."[10] Compare a similarly short description of the trilogy: "Jason Bourne . . . after losing his memory and all sense of self, has come to realize that he has also lost part of his soul."[11] In other words, *Legacy* is about performance-enhancing drugs; the trilogy is about the near total destruction of a person and whether or not he can find new life. To find restoration and redemption, Jason has to do battle with corruption—in the government and in himself. The action lies in the fight against a secret intelligence program, but the captivating part of the film is the struggle that lies within.

In his review of *The Bourne Identity*, Ebert is unenthusiastic. His moderate appreciation of the film is due to the fact that he sets it entirely and only within the action film genre.

> "The Bourne Identity" is a skillful action movie about a plot that exists only to support a skillful action movie. The entire story is a set-up for the martial arts and chases. Because they are done well, because the movie is well-crafted and acted, we give it a pass. Too bad it's not about something.[12]

Ebert's reviews of *Supremacy* and *Ultimatum* are consistent. About *Ultimatum*, he explains, "Jason Bourne's search for the secret of his identity doesn't involve me in pulsating empathy for his dilemma, but as a MacGuffin [a plot trigger], it's a doozy."[13] Other reviewers agree that the trilogy of Jason Bourne films is about nothing insofar as it is a political action thriller.

> There are some espionage writers who use the form as a way of probing troubling geopolitical realities and vexing ethical dilemmas [T]he utter and systematic irrelevance of "The Bourne

10. "The Bourne Legacy," *RogerEbert.com.*

11. Dargis, "Under New Management, Movie Review: 'The Bourne Legacy.'"

12. Ebert, "The Bourne Identity."

13. Ebert, "The Bourne Ultimatum."

Identity" to anything currently or formerly happening in the world comes as something of a relief. Comic relief, even.[14]

In other words, Bourne does not go in the direction of films like *The Sum of All Fears* (dir. Phil Alden Robinson, 2002) that offer scenarios about real, or at least plausible, wars, catastrophes, and terrorist acts. The films are about Bourne.

In effect, one's attraction to *The Bourne Identity*, *Supremacy*, and *Ultimatum*—one's view of them as good or great—will hinge not on the action sequences or intricate plot, but on how much one is engaged by Jason's questions about who he was, is, and will be—how he examines his life and faces hard moral questions. The Bourne trilogy, finally, is not about assassins and secret government programs, but "about consequences, about chickens coming home to roost." He can no longer live with who he has become.

> Stripped of his identity, his country and love, Bourne is now very much a man alone, existentially and otherwise The light seems to have gone out in his eyes, and the skin stretches so tightly across his cantilevered cheekbones that you can see the outline of his skull, its macabre silhouette. He looks like death in more ways than one.[15]

For example, it could be argued that the real climax of *The Bourne Supremacy* is when Jason confesses to the daughter of two of his victims (the victims from his first mission). She had been led to believe that her mother had murdered her father and then killed herself. Jason wants her to know the truth: "It changes things, that knowledge . . . when what you love gets taken from you." Amid action scenes, he is calm, confident, and deliberate. Here, he falters when he talks. He sweats and trembles. On his way out, as he says, "I'm sorry," he has trouble walking across the room (to be fair, he has just been through a major car chase, which has left him bruised and battered). Clearly, speaking the truth about himself is far more antagonizing and unnerving for him than facing bullets and bombs.

The *Bourne* trilogy is obviously a better set of movies than *The Bourne Legacy*. We propose that a key reason why is that the plot line from *Identity* to *Ultimatum* includes Jason's facing up to personal darkness and a hope that, by passing through the darkness, he will have a chance for a new life.

14. Scott, "'The Bourne Identity': He Knows a Lot, Just Not His Name."

15. Dargis, "'The Bourne Ultimatum': Still Searching, but With Darker Eyes."

Legacy offers us no such introspection or prospect for a renewal of the soul. Aaron Cross simply wants it all: he wants to be free from the confines of Operation Outcome, but he also wants to maintain the technological and chemical enhancements that the program put in process. He wants to be what the leviathan has made him; he just doesn't want the heads of the covert operation, his creators, to tell him what to do.

Christopher Nolan's *Batman* Trilogy: Synopsis

Bruce Wayne's story begins with scenes of childhood trauma, which reveal both the care and the loss of his loving parents, in particular his father. His story concludes, at the end of *The Dark Knight Rises*, with the apparent and symbolic death of Batman, so that Bruce, with Selina Kyle, will be free to begin to establish his own loving family and home. For Bruce, home and family are tied to the health and development of Gotham, where his father—as town planner and patron, physician, philanthropist, and the chair of Wayne Enterprises—was a preeminent citizen. A recurring motif through *Batman Begins*, *The Dark Knight*, and *The Dark Knight Rises* is exile from Wayne Manor and Gotham, whether a self-imposed flight, the destruction of Wayne Manor, voluntary ostracization and villanization (at the end of *The Dark Knight*), grief-induced seclusion, and expulsion and imprisonment by vicious vigilantes who take over the city. Each devastation or departure brings a return and rebuilding project in order to save and restore Gotham *and* to build a life for Bruce. The final sacrificial "death" of Batman is also liberation and the hope for a new life for Bruce. Each stage of the journey—return, sojourn in the city, and sending out—takes the form of a quest, where Bruce's hope for a restoration of home comes into conflict with Batman's quest to restore Gotham.

By the end of *Batman Begins*, Bruce's soul-searching appears to be done, and a plan for restoration of Gotham seems to be in place. The knight has nearly completed his duty. *Batman Begins* gives us the origin of his quest. The childhood trauma of falling into a well (and encountering bats) is connected to, at least in his mind, the subsequent murder of his parents by a thug and thief, Joe Chill. Years later, Chill's release from prison provides Bruce an opportunity to face his fears and to exact revenge. But as it turns out, he is only belittled by mob boss Carmine Falcone, who has Chill killed, and lectured by his childhood friend and now assistant district

attorney, Rachel Dawes. Bruce has failed both Gotham and Rachel, the representative of his father's legacy in Gotham.

From this failure, he sets out on a quest through the underworld to learn how to face and grapple with injustice. Imprisoned in the Himalayas, he is enlisted and comes under the tutelage of Henri Ducard, as he is initiated into Ra's al Ghul's vigilante army, the League of Shadows. He turns against the league when he discovers that Ra's al Ghul intends to destroy Gotham. Bruce returns to Gotham, develops the image of Batman, delivers evidence against Falcone to Rachel, and thwarts Ducard's and the league's attempt to destroy Gotham. At the end of the film, Rachel pledges her love to Bruce but puts off a relationship until Batman's work is done. Batman initiates a working relationship with trustworthy police sergeant James Gordon, now promoted to lieutenant. And Bruce and Alfred set out to rebuild Wayne Manor, now Bruce's home, to be better than it was.

From the rebuilding at the close of *Batman Begins*, *The Dark Knight* heads toward the disintegration of Bruce's plans for home and Batman's flight from Gotham—as the dark knight, while defending the reputation of his chosen "white knight." The film begins with Batman and Lieutenant Gordon planning to replace Batman with District Attorney Harvey Dent as the "white knight" of Gotham. Once Batman's work as the defender of the city is passed on to Dent, Bruce believes that he can start a courtship with Rachel. As his childhood friend and guardian of Thomas Wayne's legacy of service to Gotham, Rachel seems to be "meant" for Bruce. Unknown to him, she will eventually pledge her love to Harvey (who is a white knight for her as well). At this point, however, Bruce thinks that he can secure Gotham (through Dent) and have Rachel too.

The Joker is Bruce's undoing, but through Batman's noble sacrifice, Gotham does not fall into moral ruin. The Joker's rise as a master criminal parallels the success of the collaboration between Batman, Gordon, and Dent, who has found a patron in Bruce Wayne. Their success against organized crime in Gotham corresponds to successes by the Joker, through his disorganized crime. The Joker's madness and penchant for chaos are belied by his elaborate and deceptive schemes—by which he is able to kill or capture leaders of organized crime as well as the heads of Gotham's three branches of government. In the end, thanks to the Joker, Rachel is murdered, and Dent is half-burnt. In grief and despair, Dent takes on Joker's madness and embraces chaos. As Two-Face, he goes on a killing spree that

ends in his own death. And in order to protect Dent's image as the white knight of Gotham, Batman takes on his guilt and flees Gotham as its villain.

In *The Dark Knight Rises*, Batman's duty to Gotham and his hope for a home come to a resolution. Bruce has sacrificed Batman's image for the sake of Gotham; Rachel has been killed by the Joker. The hero's humiliation is clear. Bruce is despondent and languishes in Wayne Manor, which is effectively shut down as if the owner had moved out. Along with his spirit, his body is broken by his life of crime-fighting as Batman. He learns that Rachel, before her death, had chosen Dent over him. Because of his risky return to his work as Batman, he is abandoned by Alfred Pennyworth, his butler, guardian, and surrogate father. Alfred expresses to him his long-held dream that Bruce would have a new life with a wife and children, with a normal life far away from Gotham. This dream is farfetched. Early in the film, Bruce loses his family's fortune to the treachery of a revived League of Shadows. Later, the apparent commander of the league, Bane, will break Batman's back and throw him into the pit—a South Asian prison.

However, amid the despair, we see possibilities. Before his imprisonment, Bruce has been enlivened by his sparring with Selina Kyle/Catwoman, and Miranda Tate enters his life as the one who will sustain Wayne Enterprises and protect the legacy of his father's house. Miranda will turn out to be Talia, the daughter of Ra's al Ghul who is directing, through Bane, the operations of the League of Shadows. Tate, Bane, and the League have Gotham collapsing into mob rule and class warfare, but all the while they intend to destroy the city. Wayne Enterprises had achieved the technological marvel of developing clean energy through a fusion reactor. Through Bane, Tate has it turned into a bomb. Down to the clothes on his (broken) back and imprisoned in the pit, Bruce marshals his courage and resolve. He returns to Gotham, enlists Selina/Catwoman, and reunites with Alfred, Lucius Fox, and Commissioner Gordon. Together they defeat the league (killing Bane) and seize the nuclear weapon from Tate's control. But time has run out; the bomb cannot be disarmed. Batman must sacrifice his life by jetting over the Gotham Bay and exploding with the bomb—it seems. Then we are given indications that Batman had a plan of escape, and we see Alfred's dream fulfilled as he watches Bruce and Selina enjoy a quiet moment at a Florence café. Batman has saved Gotham; Bruce has started a home.

Rotten Tomatoes—Nolan's *Batman* Trilogy[16]

Film	"Tomatometer" (Tomatometer Critics)	Audience Score
Batman Begins	84% Average Rating: 7.7/10 Reviews Counted: 268 Fresh: 226 Rotten: 42	94% liked it Average Rating: 3.9/5 User Ratings: 1,109, 981
The Dark Knight	94% Average Rating: 8.6/10 Reviews Counted: 317 Fresh: 298 Rotten: 19	94% liked it Average Rating: 4.4/5 User Ratings: 1,822,797
The Dark Knight Rises	87% Average Rating: 8/10 Reviews Counted: 333 Fresh: 289 Rotten: 44	90% liked it Average Rating: 4.3/5 User Ratings: 1,206,456

Of the four movie series that we are discussing, the *Batman* saga pretty clearly received the most positive reviews, both from the journalistic community and from the "fanboy" community. Using the "Rotten Tomatoes" website (rottentomatoes.com) as one measure, the movies averaged an 88.33 percent positive ranking from journalists, and a 92.67 percent positive ranking from the fans. Reviews from *The New York Times* as well as from the Roger Ebert movie review website (rogerebert.com) show the same kind of positive response displayed on Rotten Tomatoes. In her *New York Times* review of *Batman Begins*, Manohla Dargis points to the differences between this movie and Batman's previous cinematic appearances, noting that in *Batman Begins*, director Christopher Nolan achieves what previous directors have not—a balance between the characters of Batman and Bruce Wayne. Specifically, she notes:

16. *Batman Begins, The Dark Knight, The Dark Knight Rises, Rottentomatoes.com.*

> [W]ithout Bruce Wayne, Batman is just a rich wacko with illusions of grandeur and a terrific pair of support hose. Without his suave alter ego, this weird bat man is a superhero without humanity, an avenger without a conscious, an id without a superego.[17]

And later in the same review:

> Mr. Nolan's (Batman) is tormented by demons both physical and psychological. In an uncertain world, one the director models with an eye to our own, this is a hero caught between justice and vengeance, a desire for peace and the will to power.[18]

As we have noted as well, the two parts of the character are necessary to display both his broken soul as well as his vengeful desire to protect and save Gotham.

Dargis's review of *The Dark Knight* is even more complimentary (as were most film critics). Much of her (and other's) positive response to the movie can clearly be laid at the feet of Heath Ledger, whose performance as the Joker was so well regarded as to win the only posthumous Oscar for Best Supporting Actor (one of only two posthumous Oscars in the award's history). She describes the character as "a demonic creation and three ring circus . . . a self-described agent of chaos." The Joker's desire for chaos is obviously at odds with Batman's desire for balance, and Dargis notes that by the end of this second film of the trilogy, despite Batman's best efforts, chaos, if not winning, certainly reigns supreme.

> That change in emphasis leaches the melodrama from Mr. Nolan's original conception, but it gives the story tension and interest beyond one man's personal struggle. This is a darker Batman, less obviously human, more strangely other. When he perches over Gotham on the edge of a skyscraper roof, he looks more like a gargoyle than a savior. There's a touch of demon in his stealthy menace. During a crucial scene, one of the film's saner characters asserts that this isn't a time for heroes, the implication being that the moment belongs to villains and madmen.[19]

Batman's decision to make Harvey Dent the hero and for him to take on the role of the hunted turns the plot toward his self-inflicted punishment. With the second movie ending with his decision to turn away from heroism, we

17. Dargis, "Dark Was the Young Knight Battling His Inner Demons."
18. Ibid.
19. Dargis, "Showdown in Gotham."

believe, in contrast to Dargis, that the conflict within the character of Batman has reached its peak, and that the third movie of the trilogy shows us the character restoring his fractured self at the same time he reintegrates himself into Gotham and into his own humanity.

It's not surprising that *The Dark Knight Rises* received the (comparatively) lowest percentage of positive reviews of the trilogy. It is a complicated movie, with a number of seemingly disparate plot threads that need to be tied together. Nolan and his brother, who together wrote the screenplay, have acknowledged their debt to Charles Dickens's *A Tale of Two Cities*— not necessarily source material for a superhero movie. It also introduces a villain (Bane) who, despite the menace of his plan to destroy Gotham under the guise of "purifying" it through economic and cultural revolution, doesn't match up to Heath Ledger's Joker, and who, thanks to his breathing apparatus, at times is just difficult to understand. Roger Ebert's review on rogerebert.com notes that:

> "The Dark Knight Rises" leaves the fanciful early days of the superhero genre far behind, and moves into a doom-shrouded, apocalyptic future that seems uncomfortably close to today's headlines. As urban terrorism and class warfare envelop Gotham and its infrastructure is ripped apart, Bruce Wayne (Christian Bale) emerges reluctantly from years of seclusion in Wayne Manor and faces a soulless villain as powerful as he is. The film begins slowly with a murky plot and too many new characters, but builds to a sensational climax.
>
> The result, in Christopher Nolan's conclusion to his Batman trilogy, is an ambitious superhero movie with two surprises: It isn't very much fun, and it doesn't have very much Batman.[20]

The real center of the movie is not Batman, but Bruce Wayne. As Bruce Wayne notes at the beginning of the trilogy, Batman is the tool that he develops to try to save Gotham. As such, it's not at all surprising that, at the end of the trilogy, the movie uses Batman as the tool to bring Bruce Wayne out of the pit, out of his clinical depression, and into a healthy relationship and into a life apart from Batman.

Manohla Dargis's review of *The Dark Knight Rises* continues the focus that she has had on the previous two movies, pointing out the broader

20. Ebert, "The Dark Knight Rises."

messages regarding terrorism, good and evil, and the uses of power that she believes Nolan has been dealing with throughout the trilogy. As she says:

> Mr. Nolan has also taken the duality that made the first film into an existential drama and expanded that concept to encompass questions about power, the state and whether change is best effected from inside the system or outside it.[21]

However, she does acknowledge in the concluding paragraph of her review that one of our major points about the trilogy is in play—that Batman's salvation can be seen not only in his own actions, but also in the actions of the community of Gotham, as they stand up against Bane's evil.

> But it also serves Mr. Nolan's larger meaning in "The Dark Knight Rises" and becomes his final say on superheroes and their uses because, as Gotham rages and all seems lost, the action shifts from a lone figure to a group, and hope springs not from one but many.[22]

To note that "hope" grows out of the actions of Batman, as well as the citizens of Gotham, is to point directly to one of the last things Batman says in the movie: "A hero can be anyone. Even a man doing something as simple and reassuring as putting a coat around a young boy's shoulders to let him know the world hadn't ended."

Spoken to Commissioner Gordon about the darkest night in young Bruce Wayne's life, this line of dialogue succinctly speaks to one of the underlying threads that we have been dealing with in all of these movies— the concept of the hero, and how contemporary heroes, whether they are superheroes or newborn vampires or trained CIA assassins, can be found anywhere, like in a police station or even in a poor coal mining village. How these potential "heroes" embrace their potential for action and how they live their lives as heroes is at the heart of our examination, and even in the case of the most obvious hero, Batman, how their actions change them through their quest are measures of how much of their world they save, and how much of their soul they heal.

21. Dargis, "A Rejected Superhero Ends Up at Ground Zero, Review: 'The Dark Knight Rises,' With Christian Bale."

22. Ibid.

The *Twilight* Saga: Synopsis

"I'd never given much thought to how I would die. But dying in the place of someone I love seems like a good way to go." This declaration is the audience's introduction to the *Twilight* Saga, in the form of a voice-over, as Bella Swan leaves her home and the sunny heat of Phoenix in order to settle with her father amid the clouds and dense forest of Forks, Washington. At this point, we see that she is making a sacrifice of her home, for the sake of her mother who wants to travel with her new, minor league baseball player of a husband. Bella gives us an indication, however, that the sacrifice is considerable but not great; she is not yet sacrificing her life. As she suffers through the friendliness and hospitality on her first day of school, we understand that she doesn't really feel comfortable anywhere. As the films progress (see the conclusion of *Eclipse*), we begin to realize that she does not feel at home as a person and that she fits in no relationships with ease—until she is able to be close to Edward, her vampire boyfriend. At the conclusion of the saga (*Breaking Dawn, Part 2*), Bella has it all: immortality, a loving and devoted husband and a marriage that will last forever, a loving family (also immortal), a beautiful and gifted child who is close to immortal, and a son-in-law who she adores. In the end, life is perfect.

So what do we make of her initial declaration of sacrifice? Her climactic sacrifice, at the end of *Breaking Dawn, Part 1*, is her willingness to die so that the child in her womb can have life. Indeed, the fetus grows so quickly and drains so much life out of Bella that the life of one seems to negate the life of the other. Edward calls his/this unborn offspring a "monster." The scenes the audience sees just prior to delivery, the birth, and afterward are presented as a way to death, a stage of lifelessness, and a resurrection into new, supernatural (vampire) existence. Becoming a vampire turns out to be the best thing that can happen to a girl. This summary of the films, however, has moved far too quickly. In the first stages of the saga, Bella's desire to be near her vampire boyfriend is presented as a death wish, which will result in the destruction of her soul. Edward certainly believes so. Once he and Bella make a plan for her death into vampire life, the initial fears turn out to be correct. Bella seems destined to die (and not into vampire-hood) first by the burdens of her pregnancy and then because of the threat the child poses to the vampire world.

The first two films, *Twilight* and *New Moon*, set up a web of life-and-death conflicts. The overarching opposition is between human life and

vampire existence. This fundamental conflict forms the basic stuff of ro-mance, like Romeo's Montagues against Juliet's Capulets. At first, however, we simply find awkward teenage desire and frustrating attempts to get to know the other. Through this process, Bella figures out that Edward is a vampire. She is not repulsed (on the contrary), but the threats to her life from the vampire world appear during their first official date. Marauding vampires come on to the scene and are enticed by Bella's human scent. In the final scenes of *Twilight*, Edward's family battles against one of these marauding vampires, James, who hunts down Bella. She is bitten by James in the process. James is destroyed by the Cullens, and Edward—battling powerful vampire instincts—has to suck James's venom from her wound so that she can remain a human being.

In *New Moon*, Bella is both adopted by her Capulets, who are at war with Edward's Montagues, and given a pledge by the Cullens that she will be made into a vampire—adopted into their coven. At first, fearing the threat that they pose to her life, Edward and the Cullens leave Forks, ap-parently for good. After a seemingly interminable period of staring blankly in her room, Bella turns to a family friend, Jacob, in order to find a way out of her deep depression. Jacob turns out to be a member of a pack of werewolves, whose very *raison d'etre* is to battle the vampires. At this point, a third group comes into the picture—the Volturi, a vampire coven of self-appointed overlords. Thinking that Bella has committed suicide, Edward attempts suicide by Volturi—breaking the vampire code that vampires ought not to reveal themselves to humans. With the help of Edward's "sis-ter" Alice, Bella attempts to stop him. They are seized by the Volturi, and Bella's life is spared only because Alice reveals, through her gift of seeing the future, that Bella will be transformed into a vampire (which the Cullens later, by a family vote, agree to do).

Eclipse and *Breaking Dawn, Part 1* and *2* put Bella at the center—as the unity and purpose—of the perfect world that is represented at the end of the saga. *Eclipse* introduces a new threat from the vampire world, which requires Jacob and Edward to make peace and join forces in order to pro-tect Bella. She is under attack by an army of fledgling vampires, created by Victoria, James's mate, to take revenge upon the Cullens and Bella. In effect, Bella is the cause for the Cullens to be embattled in the vampire world. She is also the cause for Jacob and his closest friends to be divided, at first, from the core of the wolf pack, which maintains its hostility toward all vam-pires. Jacob's werewolves and the Cullens eventually fight together against

the army of vampire newborns. Amid the battle, Bella pledges her love to both Jacob and Edward, with Edward receiving the greater and decisive measure. From this juncture, *Breaking Dawn, Part 1* tells the story of Bella and Edward's wedding, the conception of the child, Bella's sacrifice so that the child might live, and her resurrection into vampire life.

Breaking Dawn, Part 2 concludes with Bella's perfect world of marriage, motherhood, family, and their eternal home. Before we arrive at this good end, however, we witness an extended battle where many die—the noble and the vicious—including Carlisle, the patriarch of the Cullens, and Aro, the lord of the Volturi. Amid the battle, a fissure is opened in the earth, which starts to consume the combatants both good and bad. The source of this catastrophic conflict is the very existence of Renesmee, the human-vampire child of Edward and Bella. As it turns out, however, the battle is not real, but only Alice's vivid foresight—shared with Aro—about the outcome if a battle were to ensue. The real outcome of the would-be battle is peace. The defense of Renesmee is the reason for the gathering and unity of the werewolves, the Cullens, and a coalition of vampires from across the world. As Renesmee waits (to flee) on the back of Jacob (in wolf form), the Volturi depart without fighting. From here, we witness a sharing of good will among vampire friends departing for their distant homes. We witness love among the Cullens, Jacob and Edward, Jacob and Renesmee, and so on, concluding in a beautiful meadow, where Bella, now able to master her protective shield, uses it to project the entirety of Edward's and her romance into his mind.

Rotten Tomatoes—The *Twilight* Saga[23]

Film	"Tomatometer" (Tomatometer Critics)	Audience Score
Twilight	48% Average Rating: 5.4/10 Reviews Counted: 206 Fresh: 99 Rotten: 107	72% liked it Average Rating: 3.9/5 User Ratings: 576,981
New Moon	28% Average Rating: 4.7/10 Reviews Counted: 220 Fresh: 61 Rotten: 159	61% liked it Average Rating: 3.6/5 User Ratings: 625,568
Eclipse	49% Average Rating: 5.5/10 Reviews Counted: 234 Fresh: 114 Rotten: 120	60% liked it Average Rating: 3.6/5 User Ratings: 333,312
Breaking Dawn, Part 1	24% Average Rating: 4.3/10 Reviews Counted: 195 Fresh: 47 Rotten: 148	60% liked it Average Rating: 3.5/5 User Ratings: 186,007
Breaking Dawn, Part 2	49% Average Rating: 5.2/10 Reviews Counted: 181 Fresh: 88 Rotten: 93	70% liked it Average Rating: 3.8/5 User Ratings: 292,172

23. *Twilight, The Twilight Saga: New Moon, The Twilight Saga: Eclipse, The Twilight Saga: Breaking Dawn, Part 1, The Twilight Saga: Breaking Dawn, Part 2, Rottentomatoes. com.*

In our own discussions of the *Twilight* films, we somewhat facetiously asked ourselves, "What can you say about an eighteen-year-old girl who really, really, really wants to be a vampire?" According to rottentomatoes.com and the critics they use to create their percentages, not a lot of terribly positive things. The positive ratings across the five movies average 39.6 percent, the lowest of our four sets of movies. The positive reviews are also wide ranging, from a low of 24 percent for *Breaking Dawn, Part 1* to a high of only 49 percent for both *Eclipse* and *Breaking Dawn, Part 2*. The fan responses, on the other hand, were significantly higher, with an average positive response of 64.6 percent, and percentages ranging from a high of 72 percent for *Twilight* to a low of 60 percent for both *Eclipse* and *Breaking Dawn, Part 1*. The critical response to the saga from *The New York Times* is telling. The introduction to Manohla Dargis's review of *Twilight* tells us pretty much all we need to know about how this writer feels about this movie:

> It's love at first look instead of first bite in "Twilight," a deeply sincere, outright goofy vampire romance for the hot-not-to-trot abstinence set. . . . [T]his carefully faithful adaptation traces the sighs and whispers, the shy glances and furious glares of two unlikely teenage lovers who fall into each other's pale, pale arms amid swirling hormones, raging instincts, high school dramas and oh-so-confusing feelings, like, OMG he's SO HOT!! Does he like ME?? Will he KILL me??? I don't CARE!!! :)[24]

Probably not many movies can be rated both as "deeply sincere" and as "outright goofy." The review points out that classic "teen movie" tropes are made benign by the Cullen's decision not to hunt humans and the chaste nature of Edward and Bella's courtship. Dargis notes that the movie subverts the traditional "vampirism equals sexuality" of most like-minded stories, but also suggests that the absence of sexuality makes the film too naïve for its own good.

New Moon is probably the least interesting of the five movies, if only because of the consistent "teenage wasteland" of depression that Bella falls into. Dargis takes note not only of her depression, but also of the growing relationship between Bella and Jacob.

> Alas, Bella, whose palpable hunger for Edward gave the first movie much of its energy and interest, has been tamped down for "New Moon." . . . So, while Jacob's body grows harder and harder before

24. Dargis, "'Twilight': The Love That Dare Not Bare Its Fangs."

Bella's widening eyes, she looks—mirroring the audience's appreciative gaze—but doesn't at first touch.[25]

It would seem that Dargis would like her vampire movies straight up, without Stephenie Meyer's fairy tale world intruding on all the desire.

The *New York Times* review of the third movie in the series, *Eclipse*, was written by the other Times movie reviewer, A. O. Scott. Published in June 2010, Scott's review is just as tongue-in-cheek as were Dargis's, although Scott seems less insistent on vampires behaving like traditional vampires. Scott does acknowledge the "critic proof" nature of these films from this point forward, commenting upon audience reaction to various scenes:

> Her predicament is both the stuff of high, swooning melodrama—the preferred "Twilight" mode—and traditional romantic comedy [B]ut the producers of the "Twilight" movies may face a bit of a dilemma in the next two chapters if audience sentiment turns against the eternal love of Edward and Bella in favor of the slightly more conventional mammalian match between Bella and Jacob.[26]

By this point in the saga, the audience clearly understands that Bella will remain chaste, despite Jacob's protestations of love and Edward's Victorian moral code. More importantly, the audience knows (with the helpful confirmation of the scene between the three of them the night before the final battle) that Bella and Edward are absolutely and incontrovertibly in love. No amount of hoping from "Team Jacob" will change that.

Breaking Dawn, Part 1 (and its companion piece *Breaking Dawn, Part 2*) does move the plot outside of teenage desires, and adds a wedding, a honeymoon, and a long-anticipated consummation. Edward and Bella might be able to find the happiness that has eluded them for the three previous movies. Unfortunately, in this particular fairy tale, their consummation leads directly to Bella's pregnancy, and fear of the unknown nature of the baby rips them from their South American paradise.

Manohla Dargis returns to review *Part 1* in *The New York Times,* and at this point she, like us, has "surrendered" to the story. She gives much of the credit for her change of heart in the way the movie places Bella clearly in the center of the plot, and how Kristen Stewart finally rises to the occasion as performer:

25. Dargis, "'Twilight Saga: New Moon': Abstinence Makes the Heart Grow . . . Oh, You Know."

26. Scott, "'The Twilight Saga: Eclipse': Global Warming Among the Undead, Kristen Stewart and Robert Pattinson, Smoldering."

And, after all, so much does happen in this movie, which takes the arc of human experience—birth and death and everything in between—and works it up into a rich, sudsy lather. . . . Here, though, she [Bella] returns as the emotional and psychological cornerstone in a series in which the center of gravity has shifted from frenzied action and reaction to love.[27]

Later in the review, she notes how old fashioned the movie is, suggesting that it could be a swashbuckling feature from the 1940s.

One of the complex pleasures of the "Twilight" movies is the absolute sincerity with which they've revived the unironic romantic male lead, an ideal that works (when the movies do, anyway) because it's Bella who actively, even desperately, desires Edward. He's her choice, not that of her parents or anyone else.[28]

Her conclusion to the review returns to the satisfaction that she feels from seeing Bella as the center of this movie:

[Bill Condon, the director] resurrects the awkward teenage yearning that enlivened the first "Twilight" movie, but also transforms that initial, crude hunger into something deeper. Mostly, he brings Bella toward her happily-ever-after by giving this movie over to her, her dreams and her desires. . . . Edward may finally change Bella, but it's Mr. Condon who resurrects her.[29]

In our discussion of the movies as we prepared to write, we noted our belief that Edward and Bella achieve much more of a mutual and balanced understanding of their place in each other's lives than Dargis believes they do in this review. Nevertheless, it's good to read a critical response to the movies that takes them even somewhat seriously.

Is *Breaking Dawn, Part 2* a serious movie? With its display of various vampiric powers, the unexplained power of Renesmee (including her power to "imprint" with Jacob), and the climactic battle scene between the Volturi and the Cullens and their allies, the movie deals with few topics or themes that we could label as traditionally "serious." Some degree of snarkiness does creep into Manohla Dargis's *New York Times* review. At this point, however, Dargis recognizes that the point of this movie is not to continue to

27. Dargis, "'Twilight Saga: Breaking Dawn, Part 1': Edward, You May Now Bite the Bride."

28. Ibid.

29. Ibid.

develop the plot or the characters, but to give the audience the conclusion to the saga that they have been waiting for years:

> The director Bill Condon . . . who brought wit, beauty and actual filmmaking to Part 1, along with those enormous receipts, has nicely cultivated the art of the stall for Part 2. Working from a screenplay by Melissa Rosenberg, who adapted all the "Twilight" books, he doesn't have a lot to play with here, but he makes do and sometimes better than that, largely by turning his cameras into surrogates for the franchise's adoring fans.[30]

Dargis's concluding paragraph is a begrudging, if still slightly condescending, nod to the success of the saga.

> Despite the slow start Mr. Condon closes the series in fine, smooth style. He gives fans all the lovely flowers, conditioned hair and lightly erotic, dreamy kisses they deserve. Just as smartly he also shakes the series up with an unexpectedly fierce, entertaining battle that finds the Cullens, flanked by their wolf friends and various vampire allies, facing down the Volturi. . . . It also injects the movie with an invigorating energy that the movies have rarely sustained since the first *Twilight*.[31]

It might be wish fulfillment to hope that Dargis would have paid more attention to Bella's actions through the course of all five films. Perhaps if she'd have spent more time dissecting the fairy tale/fantasy that runs through all five films, she would have seen how Bella ultimately gains everything that she wanted, and how the course of this particular love story, although never running as smoothly as it could have, did indeed fulfill Bella's wishes, and the audience's as well.

The Hunger Games: Synopsis

The Hunger Games series spans four films, which correspond to three novels by Suzanne Collins.[32] The films are faithful to the novels for the most part. Because the books are written from the first person point of view, they include—indeed they emphasize—the inner life and inner dialogue of the,

30. Dargis, "Infusing the Bloodline With a Problem Child, 'The Twilight Saga: Breaking Dawn—Part 2' Ends the Series."

31. Ibid.

32. *The Hunger Games* (2012); *The Hunger Games: Catching Fire* (2013); *The Hunger Games: Mockingjay, Part 1* (2014); *The Hunger Games: Mockingjay, Part 2* (2015).

protagonist, Katniss Everdeen. This inner life cannot be presented nearly as well on film, if only because words on the page create mental images for the reader (which are personal for each reader), and filmed images, if only because of their relative objectivity, cannot show us as directly what is going on in Katniss's head. The films, as is necessary to the medium, set the focal points of the narrative on external events and other visual ways of conveying meaning. Apart from this basic difference, the films are also more romantic and less "realistic" than the novels. That is, the films as a whole head toward a conclusion that represents unambiguous healing and wholeness.

To frame the film series, consider these points of comparison. *The Hunger Games*, the first novel, begins with Katniss's thoughts—her description of her depressing prospects—waking up without her younger sister Primrose beside her, discovering that Prim (probably having had a nightmare) had crawled into bed with their mother. Katniss ponders the scene as she watches mother and sister sleeping together on the other side of the room. *Mockingjay*, the last novel, ends with restrained hope. After the terror of the Hunger Games, the oppression of the people by the Capitol, and rebellion, Katniss is psychologically, physically, and in both instances unmistakably, scarred. In contrast, the first film, *The Hunger Games*, begins with an embrace, as Katniss comforts Prim after her nightmare. In the final scene of the series (*Mockingjay Part 2*), Katniss cuddles her own baby in a bright and verdant meadow as she talks comfortingly to the child about terrible times from the past. The film series takes us from the dim and destitute scenes of the Everdeen home to a scene of peace and bounty; Katniss in the shade of a tree, with baby, watching her husband talk with their older child amid sun-drenched tall grasses waving in the breeze.

The tranquility and promise of this final scene is almost entirely absent in the four films, but images of family and home animate the whole. For the Capitol, the games are both terror and entertainment, instituted subsequent to a rebellion as a form of social control. The games are a gladiatorial fight to the death, and the warriors or "tributes" are a teenage girl and boy from each of the twelve districts of the nation, Panem. In *The Hunger Games*, we are introduced to Katniss on the "reaping" day, when the tributes will be chosen by lottery from her home, District 12. Katniss's younger sister is selected, and in order to protect her, Katniss volunteers as tribute to take her place. Peeta Mellark is also selected, and along with Effie Trinket as their escort and Haymitch Abernathy as their mentor, Peeta and Katniss head to the Capitol to prepare for the games. Over time, the four

develop a bond—a kind of family, whose members survive with Katniss all the way to the end.[33] Romantic tensions and possibilities become useful for Peeta and Katniss during the game—but, for Katniss, troublesome as well. Their very public "romance" is made more complex for Katniss by her ambiguous relationship with Gale Hawthorne, her District 12 beau want-to-be. Katniss and Peeta survive together, and in the process, the Capitol and President Snow are forced to break the rule of naming a single surviving victor. Katniss appears to be the real hero, but she has made an enemy in President Snow.

Everything is personal for Katniss. She protects the people she loves and those who she sees suffering. She is moved by personal face-to-face encounters. Conversely, she has no commitment to political ideals, to justice as a procedural or systemic matter, or to schemes of rebellion against President Snow and the Captiol. Further, her own use of her public romance with Peeta becomes a greater burden as she must now suppress her attraction to Gale (who at this point appears more noble and potentially more suited to her than Peeta). Throughout *Catching Fire* and *Mockingjay Part 1* and *Part 2*, Katniss is pulled—and torn—by the power, authenticity, and courageousness of her love. In *Catching Fire*, she has to leave her family, Gale, and District 12 in order to go through the districts on a so-called victory tour, which turns out to be a seething-under-the-surface rebellion tour. The Mockingjay image (taken from the pin she wore in the first Games) becomes the primary symbol of defiance for the rebellion (thus, the titles of the final two films). Both President Snow and the rebellion try to manipulate the image and to use Katniss's loves against her—especially her love for Peeta and Prim. We know her future with Gale is unlikely when he becomes increasingly politically and militarily focused as the rebellion moves forward. Katniss resists Gale's political and utilitarian calculations, and the final straw is the possibility that a trap that he designed—the "parachute bombs" that killed the Capitol children—also killed Prim. In the end, Katniss has something that none can control—her powerful, authentic, and courageous love. This passion, along with her skill with a bow, allows her to rise above the propagandistic manipulation of images for political purposes, and to find her way back home.

33. This is a significant difference between the books and the movies. The character of Effie Trinket is barely in the book version of *Mockingjay*. Thus, the "family" created in the movies is absent from the books. In the books, Katniss's retrieval of any semblance of "family" waits until nearly the end of *Mockingjay*, and is represented by a photo/scrapbook that she and Peeta create.

Rotten Tomatoes—*The Hunger Games*[34]

Film	"Tomatometer" (Tomatometer Critics)	Audience Score
Hunger Games	84% Average Rating: 7.2/10 Reviews Counted: 281 Fresh: 237 Rotten: 44	81% liked it Average Rating: 4.1/5 User Ratings: 900,247
Catching Fire	89% Average Rating: 7.5/10 Reviews Counted: 258 Fresh: 230 Rotten: 28	89% liked it Average Rating: 4.3/5 User Ratings: 422,507
Mockingjay, Part 1	65% Average Rating: 6.3/10 Reviews Counted: 251 Fresh: 164 Rotten: 87	72% liked it Average Rating: 3.8/5 User Ratings: 245,907
Mockingjay, Part 2	70% Average Rating: 6.5/10 Reviews Counted: 243 Fresh: 171 Rotten: 72	66% liked it Average Rating: 3.6/5 User Ratings: 200,215

Why do the ratings of *Hunger Games* films peak with *Catching Fire* and go down in the last two movies? We would like to consider this question with the help of *New York Times* film critic Manohla Dargis. The question will help us identify aspects of the films that connect to audiences. What about the films resonates with us? In her review of *Mockingjay Part 1*, Dargis notes a shift in tone from *Catching Fire*.

34. *The Hunger Games, Catching Fire, Mockingjay, Part 1*, and *Mockingjay, Part 2*, Rottentomatoes.com.

"Mockingjay Part 1" doesn't silence Katniss, but in some respects, it sidelines her. She still has plenty to say and do, though not enough, partly because, in chopping the last book into two movies ("Part 2" lands next year) and by embracing the blockbuster imperative— big bangs and action—the filmmakers lose sight of her.[35]

Mockingjay is about war—with strategies, armies, authority, and grand political purposes taking the spotlight. Katniss, from the beginning (from her first entrance into the Hunger Games), has resisted all of these impersonal and utilitarian things, so that she is sidelined not only by the "big bangs and action" of the blockbuster formula, but also within the narrative itself—in the shift from the arena of hunger games to the districts. Perhaps the reception of *Hunger Games* films peaks with *Catching Fire* because, at the end of the film, she is plucked/rescued at the moment that she is going to burn down the arena of the Hunger Games and is inserted into the plans, authority, armies, and grand political purposes of the revolution.

The series of films peaks as Katniss runs through the forest, facing dangers on all sides, depending only on her courage, wits, and skill with the bow. In her reviews of *The Hunger Games* and *Catching Fire*, Dargis focuses on the relationship between Katniss and heroes of classical myths. At one point, she states, "'The Hunger Games' works because it hits that sweet spot where classical myth meets contemporary anxiety to become a pop mind-blower."[36] What myths? Dargis calls *The Hunger Games* a "post-apocalyptic take" of the myth of "the American frontiersman . . . as if she were Natty Bumppo reborn and resexed."[37] Dargis's "Natty Bumppo" reference might not resonate with readers as much as "Hawkeye" or "Leatherstockings," more commonly known names given to him in James Fenimore Cooper's novels (e.g., *Last of the Mohicans*). She also adds the Greek myth of Theseus who enters the labyrinth (from which no one had ever returned) to slay the Minotaur. Theseus or Natty Bumppo, the Katniss we love is a hero of the untamed frontier—beyond the borders of civilization.

In terms of our consideration of film, the connection is simple. The films of *The Hunger Games* series that most resonate with audiences and critics have romantic themes at the forefront. The films are at their best

35. Dargis, "Up From Rubble to Lead a Revolution: 'The Hunger Games: Mockingjay Part 1' Opens."

36. Dargis, "Striking Where Myth Meets Moment: 'The Hunger Games: Catching Fire,' With Jennifer Lawrence."

37. Dargis, "Tested by a Picturesque Dystopia: 'The Hunger Games,' Based on the Suzanne Collins Novel."

when Katniss stands, as heroine with her bow, against the corporate, tech-
nological, industrial machine.

2

Bourne's Identity

As we write, a fifth *Bourne* film, titled *Jason Bourne*, has just opened. Matt Damon has returned as Jason Bourne. He is joined in the film by Julia Stiles, who has the part of Nicky in first three *Bourne* films, the last of which, *Ultimatum*, intimated that there had been some sort of romantic involvement between the two, when both were working for the covert intelligence program Treadstone. Nicky returns to rekindle Jason's battle with corruption; women provide moral grounding throughout the films. In *Jason Bourne*, we learn that Bourne volunteered for Treadstone because of the assassination of his father and that his father (like him) was tied up in Treadstone from the beginning. The question of identity becomes explicitly moral; did David Webb and his father establish the origin of corruption? In *Ultimatum*, we witness a flashback to a critical moment in the creation of the assassin Jason Bourne. David Webb (Bourne to-be) has been broken down physically and psychologically by Dr. Albert Hirsch. In the flashback Hirsch is completing his reprogramming of Webb by pressuring him to kill a man who slumps in a chair, helpless, hooded, and bound in a corner of the room. David's disorientation is evident; Hirsch is clearly manipulating him all the while emphasizing that David has already made the choice and, at this point, he—David—has to finish what he, David, has started. In short, the flashback presents to the audience an event in the creation of Jason Bourne, but the truth of the situation, its proper frame of reference, reasons and motives (political and personal), and who to blame remain obscure.

At the time of *The Bourne Ultimatum*'s release (summer 2007), Damon gave his reasons for not wanting to make another *Bourne* film in the immediate future (perhaps another "ten years" after *Ultimatum*):

> [T]he story of this guy's search for his identity is over, because he's got all the answers, so there's no way we can trot out the same character, and so much of what makes him interesting is that internal struggle that was happening for him, am I a good guy, am I a bad guy, what is the secret behind my identity, what am I blocking out, why am I remembering these disturbing images?[1]

Damon continues by noting that another installment in the *Bourne* series is not possible—at least not in the foreseeable future—because, with answers about his identity revealed, an "internal propulsive mechanism that drives the character is not there." In Damon's view, for *Bourne* films to work, Jason's identity has to be contested and pretty continually questioned.

For the character of Jason Bourne, this "internal propulsive mechanism" is a set of internal struggles that is not simply externalized through the action genre. For example, in some films an internal drive for revenge is simply externalized in violence. In the *Bourne* films, there is something deeper. The internal struggle is marked by a search for identity and for peace of mind and heart, for freedom from bureaucratic manipulation and control, for stable, loving, and domestic relationships, and these struggles are social struggles. In other words, the quest for identity is not simply a motivation for Jason Bourne; he is actually fighting with the leviathan for and about who he is and who he will be. This social struggle for personal identity—the opposition between the world and the soul, between the individual and social control—is at the heart of what we are calling "romantic." The romantic in this larger sense is also imaged in romantic love, as Jason's contested identity will have to be represented by competing sets of relationships: on one hand, the assassin Bourne is sustained within a heartless, utilitarian intelligence, and on the other hand, the promise of a new Bourne (a Bourne free of his cold, bureaucratic creation and manipulation) is fostered within a personal, loving relationship.

This opposition between pure person and world of contrivance is built into the character of the hero. Paul Greengrass, director of *Supremacy*, *Ultimatum*, and the recently released *Jason Bourne*, says of the character of Jason Bourne, "I'm always a very, very strong proponent myself of Bourne standing clear and unbroken at the end. . . . He's us against them

1. Weintraub, "Matt Damon Interview—*The Bourne Ultimatum*."

and they're never going to catch him, so I never want Bourne to be caught. That's something I always want to believe—that he's out there."[2] The "they" and "them" of Greengrass's statement are necessarily amorphous. Jason is an individual, broken by the intelligence machine and still in many ways within it. The quest for healing is a fight against "them," the powers of the world. Restoration for Jason is inextricable from exposing and defeating institutional, systemic corruption. Although we have cited Damon and Greengrass, our display of this layering of action and romantic plots is, in no sense, an appeal to authorial intention. On the contrary, the *Bourne* trilogy is tapping (intentionally or not) into a deeper reservoir of stories and desires about persons and relationships, connections and disconnections amid the world in our times.

Pilgrim's Progress

At the beginning of *The Bourne Identity,* the audience sees a crew of anonymous fishermen drag a body out of the Mediterranean Sea. We have no way of knowing who is floating in the water; in fact, the crew initially believes that the man is dead. When the body moves, the crew moves him inside the ship, and the onboard "doctor" (it's hard to believe that this particular man doesn't have extra duties on board the boat) proceeds to operate on the person we will come to know as Jason Bourne. After removing a couple of bullets, the doctor also removes a small metallic capsule implanted under the body's skin, discovering that it projects the number of a Swiss bank account.[3] At this point in the film, however, we have no way of identifying this person. He is anonymous, and we quickly learn that he's also an amnesiac; no self-identity, no identity for the audience. He and we don't know, at this point, that he is about to undertake an epic battle, not only to discover who he is, but also to overcome the powers of the world that have corrupted him and to be free for a new life.

From the amnesiac on the boat, the movie shifts to the almost traditional aerial shot of CIA headquarters, followed quickly by an interior scene of computers and operatives hard at work. One of the operatives enters the office of the principal antagonist (supervisor Alexander Conklin), to report a confirmation that a mission has failed. The corruption of the professional

2. Ibid.

3. In what can only be a bit of humorous homage, the first numbers in the bank account are "000–7."

espionage world is at the heart of the machine that has transformed Jason Bourne from a dutiful soldier into an amnesiac; a deprogrammed and reprogrammed monster—an instrument of death. As he moves forward in his attempt to recover the person within, "David Webb," he eventually discovers that he must do this by uncovering and exposing the institutional perversions that have shaped his life. The audience also follows him on this journey; as Bourne discovers more and more about who he is and the training he's received, he is more and more confused. He learns that heads of a number of secret government programs have exploited him; they have made him into a heartless assassin, and in the process, those leaders have succumbed to temptations of power and money. Just as an initial example, a meeting of "senior staff" of what we have to presume is the CIA centers on the failed Wombosi assassination attempt, and the person in charge of the meeting angrily presumes that no one in the room could have been reckless enough to sanction that mission. The institutions have become beastly and have made Jason into a beast as well.

As the CIA operations are cause for outrage, Jason reacts with dismay and worry about himself. The next step of self-discovery occurs at the Gemeinschaft Bank ("Community Bank"), where, with the unlocking of a safe deposit box, Bourne not only discovers a passport and what appears to be a Parisian address, but also, underneath a false bottom, thousands of dollars in various currencies, a number of passports that give him a series of "secret identities," and a handgun.[4] The background score nicely shifts to a pulsating horror film beat, which then slides into action-thriller music. Bourne is anxious; he looks around to see if anyone is watching him in his private room. Then he stuffs everything—identities, passport, cash—into a red bank bag. Escaping from police, Bourne makes his way to the American embassy. Here, the audience also first sees Marie Kreutz, trying without success to obtain an American visa. When Bourne is stopped by embassy officials, he miraculously fights, wiggles, and mountaineers his way out of the embassy, only fortuitously to meet Marie in the alley where she had parked her car. He offers her money for a ride to Paris—she accepts—and the two of them continue on Bourne's quest for his true identity. At a highway rest stop on the way to Paris, Jason comes clean with Marie.

4. Interestingly, he takes the documents and money, but leaves the handgun. Perhaps at least one audience member thought that leaving the gun might have been a bad decision.

Bourne: I'm not making this up. These are real. (He hands Marie the false passports.)

Marie: Okay.

Bourne: Who has a safety deposit box full of money and six passports and a gun?

Marie: (attempts to answer)

Bourne: Who has a bank account number in their hip? I come in here . . . and the first thing I'm doing is I'm catching the sight lines and looking for an exit.

Marie: I see the exit sign too. I'm not worried. I mean you were shot. People do all kinds of weird and amazing stuff when they're scared.

Bourne: I can tell you the license plate numbers of all six cars outside. I can tell you that our waitress is left-handed and the guy sitting up at the counter weighs 215 pounds and knows how to handle himself. I know the best place to look for a gun is the cab of the gray truck outside. And at this altitude, I can run flat-out for a half-mile before my hands start shaking. Now why would I know that? How can I know that and not know who I am?[5]

Here, the film establishes a framework of self-reflection and the hero's reaction of consternation and panic to what he sees. At the same time, however, what he sees in himself is awesome and praiseworthy on the field of battle.

From this point in the film, the corruption of world is against Jason and Marie, and not "the world" in the abstract; we see that the CIA/Treadstone in America is activating assassins throughout Europe who will be hunting them down. This conflict has a "romantic" theme, in the sense that the real, inner man, awakened by feminine support and love, must find himself amid the mechanism of social contrivance and an industrial, technological order. In the *Bourne* films (as well as the other films we cover in this book), this romanticism of organic feeling and the natural self (against utilitarian thinking and social control) is located in romantic love, in the hope that the love of two can establish a relational haven apart from the world. So, in order to be himself, we learn that Jason must free himself from a life that has been engineered and managed by powerful men (again,

5. Dialogue and quotations in this chapter are gleaned from the DVD versions of the films.

not women) and the world of covert espionage and assassination that those men have created.

Within this framework, the Marie of the film cannot be, as she is in Robert Ludlum's original novel, a successful Canadian government official (and here "Canadian" signals that she is not a threat as far as international politics—greed or belligerence—are concerned). In the film, Marie is homeless and directionless. The world which has taken the soul out of Jason is empty for her as well. She has, in a sense, been defeated; she cannot find a way to make it in the world. Together, they begin a quest, which they do not even know at this point will lead them to a home in a world apart from the leviathan—not only their love for each other, but also an exotic Greek island in the final scene.

In other words, it is the conception of a dominating, soulless world of governmental control in the film that transforms the amnesic spy's search for knowledge about who he is, what he is about, and whose side he is on into a quest for new life. The amnesiac's search to remember becomes a quest to become a person different from and released from what the forces of the world have made of him. This inner quest does not, in the least, detract from *The Bourne Identity* as an action film. As in a quest, the action takes on figurative (metaphorical and possibly allegorical) depth. Jason takes individual action against the seemingly inescapable powers that determine who we are in the world, and through his talents and native intelligence, succeeds in revealing their corruption at the same time that he purifies himself.

In fact, the action genre adds the intensity of "real world" firearms and chases to the inner, romantic subplot. The naturally exciting elements of the spy thriller also are used in *The Bourne Identity* to frame romantic desire as a real search for self. For example, when they first meet, after Jason escapes from the embassy, he finds Marie and suggests that they help each other out—money in exchange for a ride to Paris. On the drive, she talks; he listens. She worries that she is talking too much. He tells her that her talking makes him feel better, more relaxed. Soon, he is able to sleep; she seems to have a medicinal effect on him. He tells her that he is lost: "I don't know who I am. I don't know where I am going." As they arrive at his Paris apartment, it seems that they will part ways. But Jason suggests that Marie wait while he investigates "his" apartment. After faltering, she responds, "You would probably just forget about me if I stayed here." Jason reacts with a bit of surprise, "How could I forget about you? You're the only person

that I know." Because it is placed within the middle of what will become an action scene, we might miss it: Jason's reaction can stand up with the great romantic lines in film. At the heart of romance is to know and be known with a depth no others share. We cannot dwell on the moment, however, because their lives are in the balance.

After they battle with an assassin, Marie discovers that she is pursued as well, when she finds that the assassin has her photograph. Rather than looking to get out, however, she joins forces with Jason. Or, more accurately, a police pursuit forces a quick, impulsive decision. As police run toward their parked car, Jason says, "Last chance," and Marie buckles her seat belt. On the run together, Jason dyes and cuts her hair. They have sex and become partners in trying to track down the truth about Jason. If it were not for a pre-existing romantic trope in film and culture, this plot transition would be wildly implausible. Marie has been guarded and wary up to this point. But at the moment when she should flee from Jason, she stays, shares his vulnerability, and has sex with Jason in a grimy, depressing hotel room. Like Romeo and Juliet, Jason and Marie are together against the world. In the process, the lovers will save the world from a deeply entrenched site of corruption.

Unfortunately, the corrupt leviathan that is Treadstone continues its pursuit of the lovers, assassinating Wombosi, and expecting that that action will bring Bourne home. However, at this point, his amnesia continues to drive him down all the false pathways that his "pre-amnesia spy persona" set up to cover his tracks. Is he Jason Bourne or the man of the alternative passports, John Michael Kane? Every step he takes in his quest leads him only partially toward the truth. For example, when he discovers that Wombosi had visited the morgue, he attempts to confront him, only to discover the fact of Wombosi's assassination. Also, by reading the newspaper story about Wombosi's death, Bourne discovers his part in the failed original assassination attempt—that a man with two gunshot wounds was "chased off the boat."

Here, the question of identity becomes morally problematic. Once Bourne and Marie discover that the Parisian police have found their hotel, they go on the run again, finding their way to her half-brother's house in the south of France. There, they discover that the house they expected to be empty is decorated for the Christmas holiday. They are aided by the brother's hospitality, and even though he wanted to run, Bourne is persuaded to stay the night. Unfortunately, that gives yet another Treadstone assassin,

the Professor, a chance to catch up to them. In the calm before that storm, Bourne and Marie have another exchange about his identity:

Bourne: I don't wanna know who I am anymore.

Marie: Shhh . . .

Bourne: I don't care. I don't want to know.

Marie: Come on, we'll . . .

Bourne: Everything I found out, I wanna forget.

Marie: It's okay.

Bourne: I don't care who I am or what I did.

Marie: It's okay.

Bourne: We have this money. We could hide. Could we do that? Is there any chance you can do that?

Marie: (after a pause) I don't know.

Confronted with the reality that he has been trained as an assassin, it seems clear that Bourne equates his actions not with those of a government agent, but with those of a simple murderer. An innate morality seems to be driving him; the morality that we know will drive Jason Bourne through the course of the rest of the films.[6]

Despite the fact that he might feel like a murderer, Bourne spends most of the rest of the movie behaving like a trained spy.[7] Whether he is reflexively falling back on his Treadstone training or (what we will learn to have been) his military training or simple instinct, he is now one step ahead of the forces that are coming to kill him. Confronting first Conklin and then CIA section chief Ward Abbott, though, we see that he is still unsure of the central point of his larger quest—his identity.

Bourne: Who am I?

Conklin: You're US government property. You're a malfunctioning thirty million dollar weapon! You're a total goddam

6. The gunfight that ensues between "The Professor" and Bourne also shows us the first time that "hero Bourne" actually kills someone. Again, another case in which we allow the hero to kill enemies that are worse than him.

7. He also begins to use what we would label as "spy equipment": homing beacons, telescopes, and so on.

catastrophe and, by God, if it kills me, you're gonna tell me how this happened! . . . I sent you because you don't exist!

And a little later, after he does remember that he couldn't kill Wombosi because his children were in the room with him:

Abbott: No, you do remember. Don't you?

Bourne: I don't wanna do this anymore.

Abbott: I don't think that's a decision you can make.

Obviously, Bourne's innate morality is so at odds with the assassin that Treadstone has created (a man who murders a child) that the conflict created the initial amnesia. And, as he escapes, we discover that the final Treadstone assassin has been given a new target—Conklin, Bourne's over-seer. Clearly, the rot within Treadstone goes much deeper than we thought.[8] We also see Jason Bourne's life take on its new purpose, as he pledges to Conklin:

Bourne: Jason Bourne is dead. You hear me? He drowned two weeks ago. You're gonna go tell them that Jason Bourne is dead. You understand?

Conklin: Where are you gonna go?

Bourne: I swear to God, if I even feel somebody behind me, there is no measure to how fast and how hard I will bring this fight to your doorstep. I'm on my own side now.

This combination of Bourne's innate morality (no killing of innocents, and so on) and his vow to defend himself against the espionage leviathan drives our hero through the conclusion of this movie, and continues to drive the character through the sequels. His fractured psyche will continue to heal, and for a time, he will find rest (on the Greek island) with his love. But this particular knight will continue to find himself fighting more and more dangerous enemies—literally both foreign and domestic. His claim, "I'm on my own side now," has a romantic tone—as the individual finds the purity of his own place apart from the machinations and contrivances of the world.

8. In the penultimate scene of the movie, we see that Abbott is testifying to Congress about the failure of Treadstone. He brings up a name that we will need for later—"Blackbriar."

Exile from Eden

In the second film in the series, *The Bourne Supremacy*, we find not so much an amnesiac, but a tortured soul. Recovering his memory and his identity is still Jason's goal, but the journey brings painful realities to mind. *Supremacy* begins with Bourne continuing to fight to uncover as much truth about his identity as he can, because he is troubled by nightmares surrounding his missions and the people who he killed. *The Bourne Identity* ends with Marie and Jason holding each other gently and lovingly in a new place—Marie's place—far away from Jason's fight with Treadstone. It is an incomplete resolution; Jason does not yet know who he was before Treadstone, but he is free. The conclusion of *Supremacy* inverts the (still incomplete) ending; Jason discovers who he was before Treadstone, but he is still on the run with no place to rest.

In the first scenes of *Supremacy*, we find that Jason and Marie are in hiding, having somehow been exiled from their Edenic existence in the Mediterranean and living in tropical India. Two years have passed, and Marie is still operating as Bourne's lifeline, questioning whether his nightmares are simply that, rather than recovered memories of his life as an assassin. Calming him down, she returns to what has clearly been a "project"; writing down the memories, no matter how horrifying. She reminds Jason, "But that's why we write it down. Because sooner or later you remember something good." He responds, "I do remember something good," gazing at her. "All the time." Over the course of their time together, Bourne and Marie have obviously deepened their relationship. She is more than concerned when she reviews the notebook, its disorganization clearly meant to signify the still fractured nature of Bourne's memories.

At the same time, the audience also confronts larger and larger parts of the intelligence community, discovering the corrupt and compartmentalized nature of espionage in this world. Assassins, like Kirill, work for the highest bidder. They are amoral, with Kirill stealing and then framing Bourne for stealing the documents that the CIA needs to uncover the mole in their Russian operations. Once Jason sees that Kirill has discovered their hiding place, he collects Marie, and they go on the run again. Jason is driving their jeep, but he tells her to switch seats and drive, so that he can find and load his gun.

Marie: What if it's not who you think it is?

Bourne: It's them. It's Treadstone. [He might be wrong—this guy could have been trained by Treadstone, but he was sent by the Russians]

Marie: Jason—don't do it!

Bourne: Marie, I warned you. I told you what would happen if they didn't leave us alone.

Marie: It's never gonna be over like this. I don't want . . .

Bourne: We don't have a choice.

Marie: Yes, *you* do. [We italicize "you" because in the scene the stress is clearly made here.]

A second after these words, Marie is shot and the car plunges off the side of a bridge and into the water. After Jason fails to revive her—giving mouth-to-mouth resuscitation under water—we see him floating, suspended under water in a cruciform position. The pose is similar to the opening of *The Bourne Identity*, where we see the silhouette of a man floating in the sea. In effect, Bourne is back to the beginning; he must battle with the power, resources, and corruption of the CIA again.

From this point forward, Bourne is driven as much by vengeance as he is by his desire to uncover his past. Vengeance, however, might also be mixed with guilt; until moments before Marie is shot, Jason had been driving. It's hard to know if the assassin knows that the switch has occurred; we see him shoot, but it's unclear if he actually sees who is driving. In any case, it seems that she is killed in his place. This guilt for putting Marie in the sights of an assassin, as well as his desire for vengeance become inextricably linked to the illumination of his past—a past that gives the wheels of the espionage machine cause to grind Bourne beneath them. Again Bourne continues to surprise the audience with his reflective tactical and covert capabilities. He becomes more and more adept at manipulating technology—cell phones, earpieces, listening devices. How does he know these things? They are clearly a part of his training, and clearly available to him even through his amnesia.

The new character in the second movie is CIA Deputy Director Pamela Landy. She is not a member of the good old boy network. She is the only woman with an administrative position in an office full of men, and as such, she represents a break with the agencies' insularity. She is the new

agent; one who has not been bloodied in the field. She asks questions. She stays skeptical through the entire movie. She, in a sense, takes our (the audience's) point of view. But we know more than her. She does not accept the first answer she gets; she keeps probing, but she still puts the pieces of the Bourne puzzle together wrong, assuming that the evidence planted by Kirill implicates Bourne in the murder of her Berlin agents. Given all of this, it is not surprising that, by the end of this movie, this character is the first character within the machine that Jason Bourne trusts.

At this point, however, Landy takes the lead on the pursuit of Bourne, but her pursuit is not a cover-up. It is truthful and in the end beneficial to him. (He is not as alone as he and we think.) It's not quite a "cat-and-mouse game," but Bourne and Landy are pretty obviously contending with each other through the next beats of the film.

Landy: (having seen a surveillance video of Bourne in Naples): What is he doing?

Cronin: (Landy's assistant): He's making his first mistake.

Nicky: It's not a mistake. They don't make mistakes. They don't do random. There's always an objective. Always a target.

Landy: The objectives and targets always came from us. Who's giving them to him now?

Nicky: Scary version? He is.

It's not immediately apparent what propels Jason toward his next target, another Treadstone agent stationed in Munich. We do, however, get a number of important details. While he is on the highway, the lights at night seem to trigger a flashback to his first mission in Russia—the assassination of the Neskis. He seems to conflate this mission with the information he hears from Landy—the assassination of the two operatives by Kirill. The fog that is Bourne's memory is still confusing him, and finding the Treadstone agent in Munich might be a way for him to achieve a bit more clarity.

After killing the agent, Bourne looks in the mirror. He is in a public washroom to clean his hands; Lady Macbeth-like, he seems unable to fully wash away the blood. There are any number of times in these movies when we see Jason Bourne contemplating his reflection in a mirror. Does he recognize that image? Can he live with himself? Is his fractured memory in conflict with that reflection? Is the hero that Jason Bourne is growing to be (that we want him to be) held back by the guilt that he carries about his

past? With the full force of the espionage leviathan against him, can this hero fight back, or will he be crushed? When Bourne and Landy finally connect, we see just how much doubt his fractured memory can create. Landy tells him the truth about Treadstone being closed down, and says that she is trying to capture him because of the recent assassinations in Berlin. Bourne connects those assassinations to his first Treadstone mission—the assassination of the Neskis.

He volunteers to "come in from the cold" and offers up Nicky as someone he seems to trust. In this short "connection" scene, the audience sees a continuing *Bourne* trope—the almost miraculous way that he can find ways to observe his pursuers. He outmaneuvers the machine. We catch a narrative thread that ties the movies together—the clear connection between Bourne and women who give him stability, not only Landy, but here Nicky Parsons. In *The Bourne Identity*, the audience learns that both Nicky and Jason were part of the Treadstone program, and we see in the climax of *Identity* that he doesn't kill her when he has the chance. In *Ultimatum*, we learn that she coordinated the actions of the Treadstone agents in Europe, as well as observing them for signs of the physical and emotional problems that their training created. At this point in *Supremacy*, even if there were no past connection between the two characters, it seems that Nicky has more than a little understanding of what Jason Bourne can do, and perhaps an understanding of who he really is.

Like Landy, Nicky will play an important role in how Jason starts to fill in the gaps of his memory. In the next scene, the relationship between Bourne and Nicky is renewed and tested when the agency sends her to Alexanderstraße to bring him in. Once he sees that she is not alone (in fact, it seems like the full force of the CIA has descended upon Berlin), he takes her from the tram and begins to question her. She is terrified, "Please don't hurt me." He feels betrayed, "What were my words? What did I say? I said leave me alone, leave me out of it." She tries to reassure him, but he threatens to kill her. By the end of the interrogation, he will put a gun to her head. He wants to know about Pamela Landy and if she is running Treadstone. Finally, he asks, "Why is she trying to kill me?" We see, at this point, that the agents are also listening to this conversation. Landy is at the center. She is obviously learning things she did not know. Abbott lurks in the background, worried about what Landy will hear.

Nicky:	Last week an agency field officer tried to make a buy off of one of her ops. He was trying to sell out a mole or something. [Bourne interjects, "And?"] And you got to him before we did.
Bourne:	I killed him?
Nicky:	You left a print. And they were partial prints that trace back to Treadstone. They know it was you.
Bourne:	That's insane.
Nicky:	Why are you doing this? Why come back now? Landy will find . . .
Bourne:	Stop! Stop. Last week I was 4,000 miles away in India, watching Marie die. They came for me, and they killed her instead. This ends now.

From here, Bourne pushes Nicky into a room where her microphone will not transmit. Landy commands her operatives to find her.

For purposes of the plot, we receive information that Landy will not hear. Bourne grows more and more agitated. "Why are you trying to frame me?" Nicky pleads and distances herself from the operation: "I'm only here because of Paris. Abbott dragged us" Bourne does not know who Abbott is. He is starting to become unhinged, "Who's Abbott?" Before his probing causes Nicky to break down completely, he asks, "What was Landy buying? What kind of files?" Nicky is barely able to answer, "Conklin. Stuff on Conklin. It was something to do with a Russian politician." With that, the coin drops, and Bourne flashes back to the killing of the Neskis. He learns from Nicky that this mission was "off the books," as Nicky knows nothing about it and knows that the mission was not in his file. As sure as he is about his first assassination operation in Berlin, he still needs to fit the final pieces into this particular puzzle. As he discovers that Neski was involved in international energy concerns, both Bourne and the audience begin to see how deep the corruption goes (including Abbott murdering the former Treadstone agent who figured out that someone was setting up both Bourne and Conklin), and that he was an unwitting and unwilling pawn in Conklin and Abbott's plot to control global oil prices.

Abbott's greed and cunning, along with his manipulation of Bourne, gives us a perspective on Jason's make-up as a trusting, ingenuous assassin. But with his attempt to free himself from the covert operations of the CIA

and from Abbott, he is gaining insight and understanding. Nicky's information and his flash of memory about Berlin give a route to fitting the puzzle pieces together. He goes to the Hotel Brecker, where he killed the Neskis. Although at this point in the movie the audience sees this event from Bourne's fractured perspective, it seems clear that the original plan was to kill Neski, and that killing his wife was an unfortunate necessity. We also see that Bourne discovers a photograph of the Neski family: father, mother, and daughter. At this point in the narrative, the photograph becomes a talisman of Bourne's guilt, and gives the audience another glimpse of Bourne's innate morality. It helps Bourne's case for our mercy that he has been a pawn in some larger scheme and that he is not quite free of Abbott's brutal reach.

Eventually, we see that Abbott and Gretkov (the Russian we saw at the beginning of the movie) had conspired to purchase oil leases with "$20 million in stolen CIA seed money," and that Abbott's plan was to pin all of this on Bourne. He wants Bourne shot on sight; Landy resists. Danny Zorn, one of Abbott's assistants, figures out that Bourne was framed for killing the Russians. Abbott then seizes Zorn when his back is turned and murders him with what appears to be a pocket-sized knife. Shortly after, Bourne appears from behind Abbott in Abbott's hotel room. Bourne gets straight to what he wants to know. "You killed her."

> Abbott: It was a mistake. It was supposed to be you. There were files linking me to the Nesky murder. The files disappeared; they suspected you. They've been chasing a ghost for ten years.
>
> Bourne: So we got in the way Is that why Neski died? Is that why you killed Marie?
>
> Abbott: You killed Marie. The minute you climbed into her car. The minute you entered her life—she was dead.

In response, Bourne rushes toward Abbott, grabs him from behind, and puts a gun to the back of his head. "I told you people to leave us alone. I fell off the grid; I was halfway around the world." His confrontation from behind offers us a comparison to Abbott's killing of Danny Zorn.

> Abbott: There's no place it won't catch up to you. It's how every story ends. It's what you are, Jason . . . a killer. You always will be.

> (Bourne hesitates, just barely shakes his head, and breathes heavily. As if to prove himself right—that Jason is a killer—Abbott commands him to shoot.)

Abbott: Go ahead. Go on, go on. Do it. Do it.

Bourne: (still breathing heavily) She wouldn't want me to. That's the only reason you're alive.

Then he shows Abbott the tape recorder that was recording the confrontation. He clicks the recorder off in Abbott's ear and then slams a pistol down on the desk. The pistol is used by Abbott to commit suicide; apparently, this is the purpose for which Bourne intended it to be used. But before he shoots himself in the head, Abbott is defiant and unrepentant. He tells Landy, "I am a patriot . . . I am not sorry."

Is Bourne, at his core, the killer that Abbott claims that he is? Although that question can't be answered with a categorical "no" (if only because of the trail of bodies of other agents in Bourne's wake), his actions are obviously connected to his feelings of guilt for Marie's death, as well as the guilt that he feels for his actions in the past. As he moves forward from this point (in this case, going to Moscow to confess to the Neskis' daughter), it seems as though he has a clearer sense of purpose. Is he moving toward absolution? At this point, we don't know. Unfortunately, going to Moscow also brings the Russian agent Kirill back into play, and Bourne's absolution will have to wait. Our knight must continue to do battle before he can confess. Fighting against the forces of the Russian police, the Moscow traffic, and a maniac Kirill, Bourne continues to do what Bourne does—fight until the bitter end.

If vengeance pushes Bourne to fight at the beginning of the film, here he is driven by a desire to right the wrong that he has done. As much as a chase scene above ground and through tunnels seems to be overkill, Bourne somehow survives, and makes his way to Irena Neski's apartment. He will not be deterred from telling her the truth. Their conversation is disjointed. Amid his own anxiety, he seems to try his best to be personable (although he cannot pull it off). She sees an intruder with a gun.

Jason: You're older . . . older than I thought you'd be. That picture? (The camera cuts to the picture of the Neskis that Bourne has remembered) Does that mean a lot to you?

Irena: It's nothing. It's just a picture.

Jason: No. It's because you don't know how they died.

Irena: I do.

Jason: No, you don't. (pause) I would want to know. I would want to know that . . . that my mother didn't kill my father, that she didn't kill herself.

Irena: What?

Jason: It's not what happened to your parents. (pause) I killed them. (pause) I killed them. It was my job. It was my first time. Your father was supposed to be alone. But then your mother . . . came out of nowhere . . . and I had to change my plan. It changes things, that knowledge. Doesn't it? (pause) When what you love gets taken from you, you wanna know the truth. (Pause; Irena weeps; Bourne stands to leave) I'm sorry.

And Bourne walks away into the Moscow winter. Bourne makes his way back to the point of his fall, his first "kill," which is also occasion for killing the innocent, leaving a child as an orphan, and unknowingly playing a role in Abbott's corrupt plans. But he makes his confession, and stumbles out into the cold.

New Life

Bourne's confession was where the second movie was supposed to end, but as a note on IMDb.com (Internet Movie Database) suggests, the epilogue between Bourne and Landy was added following poor responses from test audiences.[9] In this epilogue, Landy thanks Bourne for giving her the recording of Abbott's confession, and she apologizes (off the record). In good faith, she tells him his real name—David Webb. She wants him to come in and talk, but Jason (or is he now David?) walks away down a New York sidewalk and disappears. *The Bourne Identity* comes to a conclusion with Jason and Marie in a peaceful place, and the beginning of *Supremacy* shifts their home to one of hiding; they go underground. Here, at the conclusion of *Supremacy*, Jason disappears, alone, with newfound knowledge of his identity. The revelation that he is David Webb introduces as many questions as it does answers; the unfinished quest leads into *The Bourne Ultimatum*.

9. "The Bourne Supremacy: Trivia." This claim is repeated on several fan sites, but we could not find an original source.

The Bourne Ultimatum begins by returning to the site of Jason's confession to Irena Neski. He is in Moscow on the run from the police. He's wounded (thanks to Kirill), and searching for any means of escape he can find. While tending to his wounds, he has another flashback—this time to what we will learn is the torture that was the Treadstone brainwashing. We also see that these memories of his final test include him being hooded, an absolutely necessary detail to remember for the climactic scenes of the movie. At this point, however, we hear him being asked if he will "commit to the program." His reply, "I can't." In the next scene, labeled "six weeks later," Abbott's taped confession is being heard at CIA headquarters. It would seem that Pamela Landy is standing by her word to Bourne—that she will continue to try to clear his name. Unfortunately, we see the first evidence (in this movie, at any rate) that the espionage leviathan will continue its pursuit of Bourne, as the CIA Director Ezra Kramer deems that Bourne is still a threat to the agency. Landy, on the other hand, suggests that Bourne may be operating with a different agenda—that he might be "searching for something in his past." We've seen the torture that he underwent to join Treadstone; at this point we have to ask, is this part of the past that he is searching for?

From the start, we witness a tangled web of truth, misunderstanding, and fabrication. Jason will have to fight his way through. When a journalist on the trail of Blackbriar and Treadstone connects with Bourne, the CIA again begins to tighten its net around him, and yet another upper-level CIA supervisor, Noah Vosen, leads the charge. The nets that begin to tighten around Bourne are more than just those of the CIA. In fact, Bourne is more motivated at this point by the journalist's efforts than by those of the CIA, and once he discovers that the news media is on his trail, he moves to intercept the writer. It's interesting to note that, as Bourne reads the newspaper account of his life, his memories connect his life with Marie to his initiation into Treadstone: His "waterboarding" at Treadstone reminds him of the plunge of the car off the bridge in India. The reporter has gotten very close to the truth, and Bourne has to find him, if only to see exactly how much he knows. It's also interesting, if a little bit frightening, that the covert surveillance in this movie has evolved to the point where Vosen and his group can listen, not only into phone conversations, but also to conversations in offices, in train stations, and seemingly wherever they wish. The leviathan that Bourne is challenging has grown much larger. But will its surveillance get to the truth?

Bourne's savvy and abilities have kept pace with the government's covert operations. There is a kind of arms race in getting at the truth. Indeed, he seemed "superheroic" at the end of *Supremacy,* seemingly invulnerable to every collision in the Moscow streets and tunnels. In this movie, his "powers" appeared to include the ability to mask his cell phone conversations from Vosen, as well as to evade surveillance cameras in public places. He leads Ross (the journalist) through Waterloo Station, and almost saves him. Ross's actions, however, as well as the size of the forces against them, eventually lead to Ross's death. A key avenue of self-knowledge for Jason is cut off. At this point, the weight of the leviathan is definitely pressing on Jason Bourne. We see Landy and Vosen attempting to pull pieces of evidence from every possible electronic nook and cranny to try to discover what Ross had found. Meanwhile, Bourne is doing what he normally does, and has followed Ross's trail to the office of Neal Daniels, the CIA station chief in Madrid. Daniels, formerly a Treadstone recruiter, had given Ross the story about Treadstone and Blackbriar.

It's at Daniels's office that we see more evidence of the connection between Bourne and Nicky, when he finds her entering that very same place. With a gun aimed at her, Bourne threatens her, but Nicky lies to Vosen, telling him that all is well in Madrid. By the end of this scene, Nicky is assisting Bourne in his quest. What does this mean? It's hard to say at this point, but there are suggestions that some kind of past relationship between Nicky and Bourne is driving her actions. Women function in all the films to connect him to who he really is. Nicky, in *Ultimatum*, gives us and Bourne a grounding that goes back before his relationship with Marie. At one point, Jason confesses to Nicky.

> I can see their faces. Everyone I ever killed. I just don't know their
> names. . . . Marie used to try to help me remember their names.
> I've tried to apologize for . . . for what I've done. For what I am.
> None of it makes it any better.

This confession to Nicky keeps Bourne's guilt at the forefront of his memories. Through all of this, Landy (Jason's other confidant) is getting closer to the truth about Blackbriar. She confronts Vosen, who tells her that Blackbriar is the "omnibus section" that covers all "black operations" within the American intelligence community. On the hunt for Daniels, Vosen knows that if they find him, they will find Jason Bourne. At the same time, Bourne is with Nicky, on the road to find Daniels.

At a highway rest stop reminiscent of a conversation with Marie in *Identity*, Bourne reveals to Nicky what he knows. First, she wants to know why he is looking for Daniels. He shows her a photograph of Daniels and someone else (who we will learn is Dr. Albert Hirsch). She identifies Daniels, but does not know the other man, and she ask Bourne who he is.

Bourne: He was there at the beginning. I remember meeting him. The first day. Daniels brought me to him. That's where it all started for me. Something happened to me, and I need to know what it was . . . or I'll never be free of this.

Nicky: Daniels said the training was experimental. Behavior modification. They had to break down the agents before they became operational. He said you were the first one.

Bourne shifts the conversation, asking if she is helping him. Nicky's response is spaced out with long pauses and intense gazes from her to him and back again. (As the camera angles shift, each is in fact gazing at us.) "It was difficult for me . . . with you You really don't remember anything?" He does not. The looks between Nicky and Bourne clearly point to some sort of previous relationship, however, at this point in the story, we can't clarify that relationship in any specific way.

Like Marie, Jason unwittingly puts Nicky in the crossfire of his battle with the CIA. Vosen is still following a path that he hopes will lead to the assassination of Bourne. Meanwhile Jason begins to follow the assassin sent to kill Daniels. We hear Landy, as a voice of reason and constraint, trying to hold back Vosen, who is now going after Nicky too.

Landy: What basis are you continuing this operation on?

Vosen: On the basis that Nicky Parsons has compromised a covert operation. She is up to her neck in this.

Landy: This is about Daniels, not Nicky.

Vosen: She has betrayed us.

Landy: You don't know the circumstances, Noah.

Vosen: She's in league with Jason Bourne, for Christ's sake.

Landy: You do not have the authority to kill her.

Vosen: Oh, yes, I do. And you had better get on board.

Landy: Noah, she's one of us. You start down this path, where does it end?

Vosen: It ends when we've won.

But what can winning possibly mean at this point? For Vosen, winning means erasing Treadstone, Blackbriar, and any trace of Jason Bourne. For Landy, "winning" is a much more nuanced situation. While Vosen follows his singular path toward Bourne, Landy seems to be attempting to find another way. Unfortunately, Vosen has friends in higher places, and we discover that CIA Director Kramer is calling the shots behind the scenes, and that not only Bourne and Nicky, but also Landy could be easily sacrificed to their larger purposes.

Landy and Bourne have common purposes, and in the end, they give each other vital assistance. With only approximately thirty minutes left in this movie, we see one more time the scene that ended the previous movie—the telephone conversation between Bourne and Landy. This time, however, we see it in "real time," with Vosen and his agents bugging the call. We also see Bourne's "superpowers" another time (outwitting the intelligence machine), as he phones Vosen from Vosen's own office, having broken into his safe and taking the Blackbriar files. After yet another chase and the defeat of another assassin, Bourne and Landy meet outside the Treadstone training building. He asks her why she has helped him. She claims that what Vosen is about and what Abbott has done do not represent her or the CIA ("This isn't us"). Landy has consistently proven herself, both as an ally of Bourne and as an agent who is willing to maintain a positive moral code. He hands her the files that he has stolen from Vosen's office. She will make the file public before Vosen can stop her. Blackbriar, Treadstone, and their creators will face the judgment they deserve. Bourne enters the training facility—where it all began for him.

He has to confront Dr. Hirsch and the last of his memories of the Treadstone training—the moments where he makes the transition from Webb to Bourne.

Bourne: You said I'd be saving American lives.

Hirsch: You were.

Bourne: I was killing for you. (Here he puts a gun to Hirsch's head.) For them.

Hirsch: You knew exactly what it meant for you if you chose to
 stay.

At this point, we enter a flashback. We share Bourne's memory of the deci-
sive moment, when David Webb is lost (but not dead), when he murders a
helpless and hooded person for no apparent purpose except that he needs
to overcome his resistance to killing on command. We see in David Webb
(and now Jason Bourne) a good man who is confused and torn. We see
Hirsch using David's goodness against him—using his willingness to sacri-
fice for the good of others in order to turn him into a monster.

Hirsch: When we are finished with you, you will no longer be
 David Webb.

Bourne: I'll be whoever you need me to be, sir.

Hirsch: You haven't slept for a long time. Have you made a deci-
 sion? This can't go on. You have to decide.

Bourne: Who is he?

Hirsch: We've been through that.

Bourne: What did he do?

Hirsch: It doesn't matter.

Hirsch: You came to us. You volunteered. You said you'd do any-
 thing it takes to save American lives. You're not a liar, are
 you? Or too weak to see this through?

Hirsch: This is it. Let go of David Webb. Really give yourself to
 this program.

Finally, David shoots the man with repeated shots. Hirsch congratulates
him, "You're no longer David Webb. From now on, you'll be known as Ja-
son Bourne. Welcome to the program." (The hood is taken off the dead
man, and we see no enemy, but what appears to be another American.) In
the present, Hirsch makes the meaning of the event clear. "You can't out-
run what you did, Jason. You made yourself into who you are. Eventually
you're going to have to face the fact that you chose right here to become
Jason Bourne." Seeing Bourne accomplish what his training led him to, we
are forced to see this scene from his past as his lowest point, as his "being
thrown into the pit." In the rest of the movie, we see Bourne in the present

escape from the pit and, at least in the eyes of the world, carry out the death of Jason Bourne and the institutions that created him.

In the final scenes, we observe two sets of public declarations, and one private moment, all of which speak the truth. First, Landy testifies before a Senate hearing with proof against CIA corruption in hand. Second, the television news reports on the results of Bourne's victory against Blackbriar and Treadstone: "CIA Director Ezra Kramer is under criminal investigation Two agency officials have already been arrested—Dr. Albert Hirsch, the alleged mastermind of the Blackbriar program, and CIA Deputy Director Noah Vosen, the program's operational chief." The report is interposed with image of Bourne floating under the water. The images replicate the first scene of *The Bourne Identity*, when the amnesiac floats in the sea. Third, amid reports and images of Jason, we see Nicky at a restaurant watching the news as the report continues:

> Meanwhile, mystery surrounds the fate of David Webb, also known as Jason Bourne, the source behind the exposure of the Blackbriar program. It's been reported that Webb was shot and fell from a Manhattan rooftop into the East River ten stories below. However, after a three-day search, Webb's body has yet to be found.

Nicky gives us a knowing grin. Someone knows the real man, and that he is still alive.

With that, the third movie of the *Bourne* saga comes to a close; the three movies tied together by two scenes of baptism. At the beginning of *Identity*, we witness the beginning of the end of Jason Bourne the assassin, and at the end of *Ultimatum*, we are given a perspective, shared with Nicky, of Jason reviving in the water and swimming away. But still there is an unfinished story, and no doubt, Nicky will be part of it. We have no indication at the end of this movie that Bourne/Webb will find his way to some sort of reintegration, into some sort of common life. Clearly, Jason's final plunge into the water represents personal freedom and the hope, if not the reality, of healing for his soul. We certainly cannot separate his prospects

of healing from his victory over the corruption of the world that fractured him and elided who he is in the first place.

Romance and Action

The *Bourne* films (starting in 2002) are unlike the spy thrillers of the 1980s that inspired them.[10] The thriller is transformed into a contemporary quest for self-knowledge, and because it is much more of a classical quest narrative, Jason's journey to discover his identity is not just a simple remembrance. The quest requires struggles with demons, both outside (in countryside and cities) and within himself. Jason's search is not a return home, although, in *Identity*, returning to what he initially believes are his origins is the ostensible purpose of his trek to Zürich and to Paris. Indeed, the further he travels physically on this first leg of his journey, the more complicated the quest becomes, as the physical travel becomes entangled with his growing confusion about who he was and who he is now.

As he continues uncovering layers of his past and the truth of his identity, the more his quest becomes transformative. Jason is searching for who he was, but he is struggling for a new identity as much as for the old. The heroes of "traditional" spy films and thrillers—like James Bond, Ethan Hunt, or the young Jack Ryan—are fighting to stay alive, as they root out crime and corruption. Through a series of battles with corrupt institutions and persons, the hero saves the world from both villains and maladies. As the hero of a quest, Jason Bourne give us something more. He is battling dangers and challenges on his way to finding his way home. He has become less than human (a mechanical killer), and he desires healing—actually more than healing—a recovery of his soul. Bourne's quest through the three movies puts the thesis of our book in focus. Thematically, we are framing key themes as romantic. These themes complement the elements of the spy and action thriller, as the violence, surveillance, and military

10. The "Bourne saga" films are not like the novels that inspired them. The novels by Robert Ludlum are not a struggle for liberation and change; they are a discovery, a remembrance, that Bourne and his covert program were good all along. All of the corruption, personal and institutional, was a ruse. The continuity of old and new, David Webb to Jason Bourne back to David Webb, is not achieved as much as it is recollected. Jason recalls that he can trust his superiors and the CIA. David returns to himself. Given this trajectory of the novel, it is hard not to appeal to the year of publication of *The Bourne Identity* (1980) as the beginning of the Reagan era. In the novel, the covert government agency is—for most of the book—the problem. In the end, our confidence is restored.

tactics correspond to both an inner struggle and the battle to preserve loving relationships.

By "romance," we are referring to the affirmation of the individual against powerful institutions and government, to the power of love and personal bonds over and against rationalized and intrusive bureaucracy, and to the organic and pastoral (or earthly non-western city) against technology and machines. In the *Bourne* trilogy, both internal and external conflicts are romantic; the battle for the self is enlivened by the possibility of love while the loving pair must stand against a managerial, utilitarian, governmental leviathan. Put another way, a humanization of the governmental machine cannot be had without the humanization of the soul, and vice versa. This connection between soul and the social body goes at least as far back as Plato's *Republic*. The interlocking pattern of soul and world continues to be interesting in our time, even when soul and self are considered entirely private domains and the cosmos (as conceived in a scientific age) is indifferent to a moral order. If affective religion and a disinterested universe are set apart in our—advanced, western—society, then the medium of film, specifically those films that interweave action and romance, can be a key medium for thinking of our place within a larger metaphysical order.

To underline this point by way of contrast (to the heroic and romantic connections to a grand order of things), we only need to discuss how *The Bourne Legacy* (2012) deviates from the prior three *Bourne* films. First, the question of identity for Jason Bourne is replaced by a search for freedom for Aaron Cross and, second, the larger romantic structure of the *Bourne* trilogy is narrowed in *Legacy* to the relationship between Aaron and his companion, Dr. Marta Shearing. The romantic structure of Jason Bourne's quest is deeper: it is about the recovery of human sensitivity, the organic and the bodily as they fight against an impersonal, utilitarian management of life by the state and by corrupt institutions. Jason Bourne fights against a scientific and clinical control of life. Jason has been programmed; he is a machine, although he yearns to be free of those mechanical bonds.[11]

Aaron Cross, on the other hand, does not necessarily want to return to a life of organic development; rather, once he discovers the truth about the drug regimen he has been placed into, he seeks freedom from that clinical control, only so that the technological changes can be made permanent.

11. Jason's romantic relationship with Marie is imbued with the deeper romantic, indeed almost nature-centered framework that we see as positive and nurturing in the *Twilight* films.

Recognizing the addictive quality of the drugs, he wants freedom, even if it means that he might revert to who he was before his scientific and medical modification began. His relationship with Marta begins with the fact that he knows she is a scientist who has the ability to enhance him, and he goes to her initially so that he can maintain his enhancement, rather than revert to his previous, unenhanced identity. Aaron's liberation is more utilitarian than romantic, and his relationship with Marta is finally conveyed more as a "getaway" (a vacation getaway) rather than a deeper connection of souls (between Jason and Marie). Rather than a connection with others in the world or the completion of a search for self, *Legacy* works toward detachment from the world. In short, *Legacy* inverts the romanticism of *The Bourne Identity*. While *The Bourne Identity* ends with idyllic imagery of home, *The Bourne Legacy* ends with images of an escape from home. On a boat, with Pacific islands in the background, at a table, as they are cooled by the sea breeze, Aaron rolls out a map. But Marta says she wants to be lost.

The *Bourne* trilogy is about finding a place in the world. Jason is an action hero; he stands as an individual against evil in the world, and he wins. But he also stands as an individual in need of love and community. He needs healing, and the healing comes through love, vulnerability, and trust. Jason's vulnerability—the frequency of his confusion, anxiety, self-doubt, and self-loathing—draws us in. He needs people. Marie becomes the catalyst for Jason's eventual transformation; Nicky his confidant, and Pamela Landy his guide. They ground him; they don't want him to be alone. In the end, Jason Bourne is set apart from Aaron Cross or James Bond or Jack Reacher because he is the action hero fighting so that he does not have to be one. What he shares with the women in his life is that he and they want him to be a better person—to throw off mechanisms and machinations and to return to living. We—the audience—want to see the best of him too.

Appendices

Bourne 4: *Jason Bourne*

The fourth movie in the Bourne franchise, not terribly imaginatively titled *Jason Bourne*, opened July 29, 2016. According to the website comingsoon. net, the film was estimated to have a worldwide opening weekend box office of just over $110 million, with a $60 million domestic box office. That

figure made *Jason Bourne* the number one movie in the world for the weekend of July 29–31 2016. That figure also makes the movie second only to *The Bourne Ultimatum* for an opening weekend in the Bourne franchise.[12]

Just because it makes a lot of money, however, doesn't mean that a movie is universally loved. According to Rotten Tomatoes (www.rottentomatoes.com), *Jason Bourne* was tepidly received. Its 56 percent critics rating was the same as Jeremy Renner's *Bourne Legacy*. Its audience positive ranking of 68 percent is nearly 30 points below the rankings of any of the previous three "Damon Bournes." A quick look at a few reviews shows the wide-ranging response that the movie is receiving.

In his review in *The New York Times*, A. O. Scott teeters between positive and negative, saying at one point that Greengrass and Damon making another Bourne movie is "both welcome and weary."[13] He adds that the updated subplot of the new generation, social media savvy CIA and its new form of illegal espionage does make the film current, but doesn't necessarily add anything to Bourne's character. In his *Rolling Stone* review, Peter Travers concludes:

> Through it all, Damon keeps us glued to the war going on inside Bourne's head. It's a brilliantly implosive performance; he owns the role and the movie. It's a tense, twisty mindbender anchored by something no computer can generate: soul.[14]

We can safely say that Travers liked the movie. On the other hand, Chris Klimek, in his review on NPR.com, roundly pans the film. Consider his concluding statement.

> This new wrinkle (the plot point surrounding Bourne's father and his hand in Treadstone) is a desperate bid to give Bourne an emotional stake in his campaign of throat-punching, except the filmmakers did that already, when they killed off his girlfriend 12 years ago.[15]

A quick synopsis of this movie can display some of the mixed messages that it sends. As the movie begins, Bourne is living off the grid and seems to be functioning (or dysfunctioning) as a bare-knuckle fighter somewhere in Europe. At the same time, Nicky Parsons is working with some sort of

12. "Jason Bourne Hits $110 Million Globally, Bad Moms Opens Strong."
13. Scott, "In 'Jason Bourne', a Midlife Crisis for a Harried Former Assassin."
14. Travers "'Jason Bourne' Review: Matt Damon Is Back and Badass."
15. Klimek, "This Time Out, Matt Damon's Not Feeling The 'Bourne.'"

WikiLeaks-like organization, and has hacked into secure files at the CIA. That hack comes to the attention of CIA Director Dewey (Tommy Lee Jones) and Heather Lee (Alicia Vikander), a high-ranking CIA analyst with a great deal of internet expertise. What Nicky has discovered is information regarding Treadstone, and the fact that Bourne's father was one of the agents responsible for Treadstone at its very beginning.

Nicky and Bourne connect, and attempt to escape CIA surveillance in Athens. As they go on the run, they are attacked by a CIA/Treadstone trained operative known only as "The Asset" (Vincent Cassel). Upon first viewing, it's unclear what happens during that attack. Does The Asset shoot Nicky as they try to escape? Or does Nicky fall off the motorcycle during the escape? Whatever occurs initially, The Asset does eventually kill Nicky. Thus, Bourne is again faced with the kind of double task that has been part of the plots of the three previous movies. He is attempting to seek vengeance for Nicky, but at the same time he must uncover the truth about his father's death and his eventual recruitment (and/or manipulation) by Treadstone.

Eventually, Bourne accomplishes his goals. He goes after Director Dewey and Heather Lee, but Dewey is killed by Lee in his hotel suite. His fractured memory heals enough for him to remember that The Asset was responsible for his father's death. He kills The Asset after a climactic chase through the streets of Las Vegas. Eventually, Lee makes contact with Bourne, and offers him a chance to "come in from the cold." Bourne, however, has recorded Lee's conversation with Intelligence Director Russell, where she reveals what she would be willing to do to amass power for herself. So, Bourne walks away across the Washington, DC Mall, as alone as he has been at the end of every movie except *The Bourne Identity*.

What has changed in 2016? The world of espionage, for one thing. In this movie, the threat of social networks and personal computers being used for surveillance underpins the operations of the CIA. This is the world that Nicky Parsons is fighting against. This is the world that Bourne, as a bare-knuckle fighter in the mountains of Europe, has rejected. At the same time, this is the world that Bourne is drawn back to as he attempts to uncover the truth about his father. As he uncovers that truth, does he find any more healing? As he fights against the new leviathan of internet surveillance, does he come close to saving another part of his world?

It's probably fair to say (thanks to what appears to be a move on the part of producers and movie studios to highlight the brand and maximize profit) that *Jason Bourne* can be seen as another story in the continuing

saga of a spy reluctant to be drawn into the world of espionage. On the other hand, it is also fair to say that Jason Bourne the character is still broken, and, despite all of his actions, that he will have to continue to fight if he wants to keep healing. This quest for healing will continue, as it is inseparable from the Bourne brand. But he may become, for his audience, just one of those friends that repeats the same life crisis over and over again. Sooner or later, we might just tell poor Jason to get over it and move on.

The Sympathetic Serial Killer

Jason Bourne is a trained, effective, and when necessary, merciless killer. But we are on his side. As we—audiences in general—enjoy film, we often cheer on the protagonist as he or she maims, murders, and destroys whole towns and landscapes. Often we become a bit frustrated when the hero shows restraint in exacting revenge and attaining satisfaction against an adversary. We just don't tolerate the killing; we look forward to it. The development of such heroic killers and our sympathy for them follows some basic narrative strategies. These narrative cues shape likeable assassins and executioners. To provide a comparison to Jason Bourne, consider the main character of the Showtime series *Dexter*, which ran for eight seasons (2006–2013). The Showtime website provides this description of Dexter:

> He's smart, he's good looking, and he's got a great sense of humor. . . . As a Miami forensics expert, he spends his days solving crimes, and nights committing them. But Dexter lives by a strict code of honor that is both his saving grace and lifelong burden. Torn between his deadly compulsion and his desire for true happiness, Dexter is a man in profound conflict with the world and himself.[16]

The short outline of the character provides the basics: Dexter is attractive, honorable, and self-critical, always trying to be and to live better, always looking within himself to be honest about who he really is. We can readily say the same about Jason Bourne.

To identify the basics of such a character, one need only watch the first episode of the first season of *Dexter*.[17] Imagine the writers getting together and setting out the project: "OK, we have fifty minutes to get people to like a

16. "About the Series."

17. "Dexter," directed by Michael Cuesta, written by James Manos Jr.

serial killer . . . and to get them wanting more." From the very start, we have Dexter's first-person point of view, his introspection and self-examination in a voice-over. We watch him, and we hear him thinking. From the very the start, we are situated to understand him. Within the first five minutes, he captures a killer (and molester) of boys. In a secluded building, Dexter has laid out three victims (which he had to unearth) so that the killer could face his moral reckoning. The killer is weak and cowardly as he faces Dexter. He pleads, "I couldn't help myself . . . please you have to understand." Dexter responds, ironically, "Trust me, I definitely understand." But he also puts himself above his fellow serial killer, "I could never do kids . . . I have standards." In the first five minutes, we are positioned to understand Dexter and to affirm his moral superiority.

Moral superiority is always understood by a means of comparison. Dexter is superior in at least three ways: he is better than he could have been, he is better than other killers, and he is better to good, regular people than almost everyone else in the episode. In terms of what he could have been, we learn that Dexter grew up in a foster home, and before being placed with his foster parents, he had been damaged somehow. His kind and caring foster father, Harry, recognizes Dexter's sociopathic make-up and helps Dexter to turn it to good. Throughout the first episode, we learn about the "code of Harry:"

> Harry: Son, there are people out there who do really bad things, terrible people, and the police can't catch them all, do you understand what I am saying.
>
> The young Dexter: You are saying they deserve it.
>
> Harry: You have to learn how to spot them, and cover your tracks. But I can teach you It's OK, Dex. You can't help what happened to you, but you can make the best of it.

Harry is a detective with the Miami police, so that he is able to train Dexter; to shape his indelible, irresistible urges to kill so that he can become a secret, but noble vigilante. Dexter becomes far better than he would have been if his nature had taken its natural course. In this way, he becomes a serial killer of serial killers. He is morally superior to them.

It would not be enough for Dexter to be simply a serial killer with higher moral standards. Apart from the murders or at least setting them aside for a moment, we can see that he is comparatively better than many "normal" people. In attempting to direct this murderous instinct, Dexter

has learned to be introspective and self-critical—to name his immoral tendencies and needs and to check them as well as he is able. Further, he does his best to direct his instinctual self to a positive good (i.e., killing killers who the police can't catch). Though the first person, voice-over narration, we are able to hear his thoughts—his self-knowledge and his struggles. In his self-evaluation and efforts to be good, we see a man who is exemplary. We see no such struggles in anyone else. In the first episode, we witness his foster sister's ambition, the hostility of Detective Doakes, the political posturing of Lieutenant LaGuerta, and so on. In contrast, Dexter is charming and sensitive.

Dexter's sensitivity to others is convoluted by his voice-over narrative, but if we were only to witness his actions, his kindness and warmth would be unambiguous. There is a disconnection between what he says about himself (to us in his thoughts) and how we see him act. He says that human interaction is unnatural to him and feels odd, yet his interaction with others is almost seamless. He displays moral qualities that we hardly observe in any other character: he listens carefully to what others say; he is sensitive to what they need. He remembers what makes them happy; he tries his best not to give or take offense. Even his own discomfort with physical intimacy becomes an asset in being sensitive to his girlfriend (who is recovering from an abusive relationship) and to resisting the awkward sexual overtures of his boss, Lieutenant LaGuerta. He seems to have a gift in relating to children. In effect, Dexter's actions come off less dysfunctional than most of the characters. And our knowledge of what he is thinking (his worries and self-evaluation), only make his actions more exemplary.

How is a sympathetic serial killer created? Make him a deep, reflective thinker, who is at odds with the world around him. But have him exhibit noble aspirations and fight the battle between good and evil. Make him unsatisfied with who he is and have him do his best to convert his moral failures to a social and moral good. He will fail, of course. But along the way, have him kill people with whom we have no sympathy and who are unambiguously evil. Insert Jason Bourne into the narrative. He was created by Treadstone to be an impassive killing machine. But he finds himself wanting to be different; he has a good heart. He is sensitive and wants to do the right thing. Around him for a short time, Marie falls in love. In the process of trying to discover who he is and to be free of Treadstone, he fights against the people who made him, against their cold political calculations, and their corrupt use of power. He says he is sorry to the daughter of

a couple that he assassinated long ago and gives a full accounting to her of the truth. In the end, we almost forget that he is a skilled assassin as he is, like Dexter, "smart . . . good looking, and . . . lives by a strict code of honor that is both his saving grace and lifelong burden."

The Moral and Religious World of Jason Bourne

The strategies employed to fashion an assassin as a hero shape a moral and religious world. In highlighting elements of *Bourne*'s moral world, our point is not to critique but to illuminate a structure. For example, identifiably good and bad characters—heroes and villains—are a time-honored framework for storytelling and for narrating the contours of a moral universe. But in real life, such clear and identifiable characters are seldom (if ever) seen and known. In fact, our tendency to tell the story of disagreements and rivalries in such oppositional terms as good guys and bad guys is a moral problem. Consider the whole point of the parable of the Good Samaritan (Luke 10:25–37). One clear theme of the parable is that the would-be bad guy, the Samaritan, is in fact our neighbor and an exemplar of how we should live. Yet, in the telling of the Gospels, such groups as the Pharisees and Scribes (and, in the Gospel of John, "the Jews") are cast as bad guys. In short, when considering Bourne's world, we will look behind the caricatures of goodies and baddies and look for a deeper structure of his moral universe.

The first questions to consider are who Jason kills and why.[18] It is hard to say exactly how many are killed given the frequent car and motorcycle crashes. But it is safe to say that all those who die at Bourne's hand (rather than by automobile) are attacking and apparently out to kill him. He fights in self-defense, and self-defense is, arguably, a justifiable reason to kill. The film (any film) carefully frames violent encounters so that even when Bourne initiates the conflict, he actually kills after being attacked. We mention this point because if a person (in real life) wants to avoid killing another, the best course of action is to avoid conditions where lethal violence would be required. As an action hero, of course, the opposite occurs in the life of Jason Bourne. He lives in a moral world where killing is unavoidable. With self-defense as the "why" of Bourne's killing, the "how" follows; the Jason Bourne that we know—the Jason who is trying to fight his way out

18. We are gleaning this information from each of the film's pages on www.moviebodycounts.com and "On Screen Kills By Jason Bourne," at http://bourne.wikia.com.

of Treadstone and the assassin's life—kills only other assassins (such as the Professor, Kirill, and Jarda) and CIA operatives. He kills the bad guys.

The films, however, allow us to witness an exception to the rule of the hero's self-defense. He has a flashback in *The Bourne Ultimatum* where he shoots a bound and hooded man—not knowing who he is or what he has done. The scene develops an aura of ambiguity concerning Bourne's "choice" to kill the man, and by extension, his choice to become Jason Bourne. He is sleep deprived, and obviously he has been manipulated psychologically and tortured physically by Dr. Albert Hirsch. The flashback offers an answer about how Jason Bourne, the assassin, came to be, but it does not answer the question of responsibility. David Webb (Bourne-to-be) hesitates and resists. Dr. Hirsch looms over him giving him the hard sell ("Are you too weak to see this through?"), convincing him that he has already chosen this path willingly and is failing by not honoring his commitment. How did David Webb experience the murder when it happened? He appears disoriented. Was it a willful act? We do not know. But we do know that the murder is in the past, and that Jason does not want to be what that murder has made of him. He is repentant. In the end, because the killing is ambiguous and he is full of remorse and regret, the flashback serves to make the need for Bourne's violence against Treadstone and its operatives all the more clear. He needs to kill them in order to die to himself.

Jason is two people at once; the cold, efficient assassin and the man who loves and protects. This double identity has obvious advantages for a hero (like Superman and Clark Kent). Bourne can be effectively invulnerable as he, alone, takes on an entire government organization and its nearly unlimited technological resources and arsenal. Yet, he is also sensitive and caring; he is repulsed by the life he has lived as Bourne. Yet, he kills, when necessary, without pause; that is, his fighting is mechanically seamless, and no conscience, regret, or feeling gets in the way. When the killer is not needed, he relates to people in a non-problematic way. His training (brainwashing) as an assassin does not show itself in social or interpersonal dysfunction. He experiences no hitches in shifting from action hero to romantic hero. In *The Bourne Identity*, for example, the stress of fighting Treadstone and dealing with amnesia does not create a single harsh or unfeeling word toward Marie. He is a superhero in the arena of boyfriend.

Bourne's double identity has interesting implications for how we think about his and the audience's moral landscape. The amnesiac assassin becomes morally sensitive and capable simply by forgetting who he is (and

yet not forgetting his intelligence and fighting skills). For this moral self to emerge immediately and seamlessly, it must be the case that a person's virtues and moral vision are natural and require virtually no training—a belief in the purity of the natural savage (à la Jean-Jacques Rousseau). We could imagine, for example, at the beginning of *The Bourne Supremacy* that Jason's continuing psychological trauma would manifest itself in his relationship with Marie. But together, they are perfect; only his memories and the threat of the CIA's intrusion into their lives are the problems. This framework nicely sets up the destruction that the agency will execute upon Bourne's new life when Marie is killed. Bourne's double existence is possible as a framework because we (the audience) accept, without question, the disjunction between his personal trauma and his effortless relationship to Marie. In film in general, heroes often have to learn to fight, but seldom do they have to learn virtues necessary to love well. Love just is, and all we need to do is find it.

If our analysis is correct, Bourne's universe is well ordered—ordered to what is good and loving—yet also empty of life to be shared. Behind the institutional corruption, the abuse of power and people, the lies and killing, there is something—deep down—that we can trust. This conception of life is embodied (or presented sacramentally) in Jason's struggles to be free and in Marie's (as well as Nicky's and Pamela's) instinctive trust in him. In this sense, the trilogy of Jason Bourne films is comforting; there are cosmic implications to his struggles with corruption, his eventual victory, and his chance for new life in the end. Ironically, however, his new life at the end of *Ultimatum* has no content, no people to swim to, nothing to live for. He swims away as a lone individual, presumably to be whatever he chooses to be. This irony illuminates much about modern individualism; it is common for people to turn to love and freedom as answers, but we have difficulty articulating how to measure them (and their reality) or what they are for.

3

Batman's Quest

Jason Bourne does not want to be a superhero. He wants to fight his way back to being a person, even though he has no idea who or what he will be. He needs to get away from what the intelligence machine has made him. In the previous chapter, we noted that *The Bourne Identity* by itself establishes a complete narrative—a fight against the leviathan and freedom for a new beginning in an idyllic and a romantic embrace. *The Bourne Supremacy* begins with an exile from this Eden—an exile that extends through to the end of *The Bourne Ultimatum*. Exile is necessary to re-establish the struggle to be free; for the striving to begin again to find a home. As Bourne swims to the surface at the conclusion of *Ultimatum*, we ought to assume that he can now be anything he wants to be—fulfilling the quest of the modern individual.

In this regard, Jason Bourne and Christopher Nolan's Batman are very much alike in their quest for romantic domesticity—for the simplicity of a table at a Florence café, "with a wife and maybe a couple of kids."[1] Bruce Wayne's life of searching begins with the loss of his parents. In *Batman Begins* he leaves home, in a first attempt to learn how to "fix" the corruption that he sees in Gotham (in a sense looking to heal his soul by learning to save the world). He returns home, and he creates the powerful image of the Batman, from which he eventually discovers he must free himself. He embraces his father's work in Gotham, but takes on the role of villain at the conclusion of *The Dark Knight*. In *The Dark Knight Rises*, he loses every-

1. This is Alfred's dream for Bruce, which he communicates to him in *The Dark Knight Rises*. Quotations and dialogue from the *Batman* films are from the DVD versions.

thing as Batman, and he must climb out of the pit of hell as Bruce Wayne. Finally, he will emerge from it all when he can finally free himself from the duties of Batman, in order to live his own life as Bruce.

In his trilogy, Nolan describes the formation and unraveling of the hero: from frightened boy, to the hero set apart, to a man hoping to be like everybody else. This trajectory weaves together themes that are developed through the *Bourne* series: (i) a heroic quest marked by questions of personal identity, (ii) the homeless hero, (iii) a romantic stance of the individual against powers of the world, (iv) a romantic hope to be known truthfully by another, and (v) an interplay between love and vengeance where personal identity and truth are at stake. Nolan's Batman, like Bourne, is a hero forged through suffering the loss of love and home, and as an eventual consequence, the loss of identity and direction. In the case of Batman, the hero's quest is to rediscover direction (or find a new direction—the problem of *Batman Begins*), to form an identity—to have purpose, to love, and to be known truthfully by another (the struggle of *The Dark Knight*), and to be at peace and find a home (Alfred's hope in *The Dark Knight Rises*). The hero is made by a profound unsettling, which drives him toward an elusive peace of mind and heart—the drive to un-hero himself.

The beginning, middle, and end of this hero's tale is, in short, to be set apart as a hero, to be set on the outside as a stranger, to seek to have a place (with Rachel and Gotham) and finally to quest for a peaceful and loving home. Batman saves the world (i.e., Gotham and its soul), and in the process, he is healed (enough) to become fully part of the world—to become anonymous and unheroic in it—hardly noticed at a Florence café. (It is worth wondering if Nolan put the café in Florence because it was a center of the Renaissance and now Bruce's rebirth.) As Batman explains in his final dialogue with Gordon, when he reveals himself as Bruce Wayne: "A hero can be anyone. Even a man doing something as simple and reassuring as putting a coat around a young boy's shoulders to let him know that the world hadn't ended." For decades, readers and audiences have wanted to be like Batman, and we find, in the way that Nolan tells his story, that Batman just wants to be like us.

Batman as Icon

Given that Batman is the most "human" of superheroes (since he has no super powers), it makes sense that he is widely embraced in popular culture.

His character has proven to be arguably more popular than his more powerful superhero colleagues. Audiences are enamored of Batman movies, and criticisms of *Batman V Superman: Dawn of Justice* (directed by Zack Snyder, 2016) reveal some of that love. Snyder's film has been criticized for its lack of a coherent narrative, and narrative is fundamental to identity and character. A fundamental problem in *Batman V Superman* is that we do not share much with this Batman. He is not someone we want to come to know; we are at times frightened of him. Robbie Collin, of London's *Daily Telegraph*, finds that Zack Snyder, the director of *Batman V Superman*, shapes Batman to be mythic rather than human:

> Snyder wants to show us gods and monsters, battling against a backdrop of lightning and smoke. Every other scene is a murky allusion to classical mythology or baroque religious art. But that's categorically all they are: the film regularly defies common sense and logic in order to cue up the next cod-transfiguration or Pietà Giving Affleck's Batman the physique of a concrete pillar makes aesthetic sense, but did he need the personality of one too?[2]

Matt Zoller Seitz (rogerebert.com) puts it this way: "the Caped Crusader [is] practically a lycanthropic rodent-beast who emerges at night, summoned by his own monogrammed spotlight-moon."[3] This widely felt annoyance with *Batman V Superman* reveals what much of the audience wants from Batman as a superhero, that is, don't be "super" or above us, but be a hero like we like to think we can be.

It is temptingly easy to suggest, as does Christopher Nolan's *The Dark Knight*, that almost anyone can wear the superhero mask, albeit without verve and skill. Batman's appeal can be traced to his inherent "humanness"; that is, for all intents and purposes, he is the same as all of us. Consider all the wannabe batmen who show up early in *The Dark Knight*, with their hockey pads, and who the real Batman must fight through to apprehend the Scarecrow. As he fights through the soft and out-of-shape batmen, it is clear that what separates him from them is not only talent, but commitment and equipment. Batman is a human being, not Kryptonian, Martian, or Amazonian. Batman solves crimes and catches criminals because he is the "World's Greatest Detective"—a job we might all be able to take on if we had Bruce Wayne's unlimited resources. More precisely, we could take the

2. Collin, "Batman V Superman: Dawn of Justice is the most incoherent blockbuster in years."

3. Seitz, "Batman V Superman: Dawn of Justice."

job if we also had "his superb acrobatic skill, his scientific keenness, [and] his mastery of disguise" to go along with his detective skill.[4]

In his more than seventy-five years of existence, Batman has consistently remained one of the most popular comic book, television, and film characters. When first introduced to the comic book readers of 1939 (in the May issue of *Detective Comics*[5]), Batman had many of the same characteristics we associate with him today. Readers eventually discovered that he was in reality Bruce Wayne, a brooding millionaire who as a child had witnessed his parent's deaths in a robbery gone badly, and who was searching for a way to fight the crime and violence he saw in the world. He trained his body and mind to the peak of strength and intelligence, waiting for the moment when he could stand up to the criminal underworld of Gotham, his home. When a bat flew into his study through an open window, his path was clear—he would strike fear into the "cowardly lot" of criminals by becoming the "Bat-Man" (which, of course, was quickly shortened to simply "Batman").[6]

Through the first twenty or so years of the character's existence, Batman gained a partner (Robin, the "Boy Wonder") and classic enemies (like the Joker and the Riddler), increased his fighting skills and investigative prowess, and generally took on the darker side of the criminal universe that his closest friend and colleague, Superman, did not fight against. In the 1960s, however, due as much to the waning interest in comics in general as to Frederic Wertham's condemnation of comic book violence, Batman and all superheroes declined in popularity. Wertham was a psychiatrist who analyzed the character traits, personas, and graphic images of crime, detective, and horror comic books. His book, *Seduction of the Innocent*, published in 1954, was the primary catalyst for the formation of the Comics Code Authority and the subsequent establishment of self-censorship by the comics industry.[7]

In the 1960s, Batman (as well as most other comic book characters) was made lighter, less violent, and more "family friendly." That friendliness was best exemplified by the late 1960s television show, in which Batman/Bruce Wayne, Robin/Dick Grayson, loyal butler and confidant Alfred Pennyworth, and Bruce's Aunt Harriet lived in "stately Wayne Manor" in the

4. Fleisher, *The Encyclopedia of Comic Book Heroes Volume 1 Batman*, 31.

5. *Batman: A Celebration of 75 Years*, 8–14.

6. Ibid., 6.

7. Wertham, *Seduction of the Innocent*.

lap of luxury, fighting crime and criminals two times a week with gadgets, humor, and even two-dimensional graphic "BAMS!" and "POWS!" superimposed on the television screen. Consider the opening acknowledgement (or disclaimer) from the 1966 film, *Batman: The Movie.*

> We wish to express our gratitude to the enemies of crime and crusaders against crime throughout the world for their inspirational example. To them, and to lovers of adventure, lovers of pure escapism, lovers of unadulterated entertainment, lovers of the ridiculous and the bizarre—To funlovers everywhere—This picture is respectfully dedicated. If we have overlooked any sizable groups of lovers, we apologize.—The Producers[8]

The film follows the tone and style of the 1960s television series. It could even be seen as a parody of both the Cold War era and the dark crime fighter/film noir projects of the 1940s and 1950s. "He isn't driven by darkness at all. More than anything else, *Adam West's Batman is just a big kid.*"[9]

Although various artists and writers attempted to pull Batman back from the brink of sixties silliness, it wasn't until the publication of Frank Miller's *The Dark Knight Returns* in 1986 and Tim Burton's 1989 *Batman* film that the character was fully freed from triviality.[10] Despite the differences in the two characterizations, both Miller and Burton give their audiences a troubled and brooding Bruce Wayne who takes on the Batman persona not only to fight crime, but also to deal with his own tortured psyche and as a kind of penance for his parents' deaths. Particularly in Miller's version, Batman also provides a defense against all forms of cultural corruption, from his perpetual archenemy the Joker to the police in Gotham to the highest levels of government (the President—a caricatured Ronald Reagan—has hired Superman as a government-guided weapon of mass destruction). Despite his advancing age and the ravages crime fighting have taken on his body, Batman stands up to and defeats all of these enemies, even cheating death in the final panels of the last book of the series.

From Miller's graphic novel forward to the present, and most prominently in the published comics, Batman has come to stand for an unflinching and rigid focus on healing the evil world in which he lives. He defends his vision of the correct path against everyone from common criminals to his superhero colleagues. In Christopher Nolan's Batman trilogy, we see

8. *Batman: The Movie*, Dir. Leslie H. Martison, Opening Credits.

9. Sims, "Comics Alliance Reviews 'Batman' (1966), Part 1."

10. Miller, *The Dark Knight Returns*; *Batman*, dir. Tim Burton, Warner Brothers.

the addition of an introspective aspect of the character—the toll that being Batman has taken on Bruce Wayne. From the first beats of *Batman Begins*, when the audience sees both the familiar (the shooting deaths of Thomas and Martha Wayne) and the new (his journey to the "ninja monastery," where he learns the ways of the League of Shadows), we see how vengeance and personal mania fuels Bruce Wayne's transformation into this particular Batman. We hear in various scenes how Batman is the "symbol" that Bruce Wayne must use to seek his vengeance, even if it means that he loses Bruce as he becomes the Bat.

Another way to think about this is that Nolan's trilogy of Batman films plays on the character of Batman as cultural icon rather than comic book superhero. In *Batman Begins*, when Bruce is on his way back to Gotham (after his training by and liberation from the League of Shadows), he tells Alfred that he needs to "show the people of Gotham that the city does not belong to the criminals and the corrupt." But he cannot shake the citizens out of their complacency as a man. "As a symbol, I can be incorruptible. I can be everlasting . . . [through a symbol] something elemental, something terrifying." By making the iconic character of Batman explicit, Nolan is able to set up a tension between the needs of Bruce Wayne as a person and the responsibilities of the social-moral symbol of the Batman. Part of the tension is that Bruce needs Batman to save him too. Bruce needs to be Batman, but over time, Batman will have to step aside for the sake of Bruce Wayne.

The Quest

Nolan's Batman trilogy forms a quest of self-discovery. Bruce must come to terms with his past. He has to face challenges, and the manner in which he meets these trials and his fears will define who and what he is able to become. What drives him and what he wants will change throughout the quest. He will be burdened with guilt (a child's guilt) over the murder of his parents. Guilt will turn to anger and a desire for revenge. He will seek justice—disinterested justice behind the mask of Batman. But finally, he will desire freedom from the mask and the burdens of Batman. The quest will require both a literal transformation (from Bruce Wayne to Batman) and symbolic transformations (more than once, dying and being made new). As a child, falling into the underground well establishes the origin of Batman—first the origin of Bruce's fear and then a quest to conquer

fear.[11] When he returns to Gotham in *Batman Begins*, he finds that Richard Earle—in charge of Wayne Enterprises in Bruce's absence—has had him pronounced dead. And in a sense, it is true. The wandering, aimless Bruce is gone; the new Bruce returns with a purpose. In *The Dark Knight Rises*, Bruce will have to be fearless as he climbs out of the well-shaped prison—the "pit" or "hell on earth"—in order to return to Gotham and save it from annihilation. In a sense, both Gotham and Bruce repeatedly come back from the dead—in order to be renewed.

The Batman trilogy is a quest for identity, and Bruce's identity is tied up in his father's love and work, his father's house, and Gotham. To this degree, Rachel Dawes represents Bruce's proper future—presumably joining him when he takes on his father's role in his father's house and his father's Gotham. When his father's house is destroyed, Bruce will tell Rachel that he will rebuild it, "just the way it was, brick for brick." For her part, Rachel puts Bruce to the measure of his father. As a young man, he hopes (but misses the opportunity) to assassinate Joe Chill, the killer of his parents. In response, Rachel—now as assistant district attorney—treats him like she is the parent and he a teenager. She lectures him on crime, justice, and the criminal justice system. Nolan sets the lecture in Rachel's car; she is driving, and he is in the passenger seat, cowering under her words. When he reveals his lost hope of murdering Chill, she slaps him and tells him that his father would be ashamed of him. Subsequent to this scene, Bruce is intimidated and belittled by Falcone, the drug lord and mob boss of Gotham. After being treated as a child by both Rachel and Falcone, he leaves Gotham and seeks to face his fears and find himself on his worldwide trek through the underworld.

When Bruce meets Rachel for the first time upon his return, as Bruce (not as Batman), he is playing the part of a rich, spoiled playboy. In putting on the playboy persona, he is taking Alfred's advice: a false public image for Bruce Wayne is needed to divert suspicion away from Bruce as Batman—as the vigilante who turns criminals over to the police. He meets Rachel on his way out of a hotel restaurant, after he and his two beautiful companions have taken a "swim" in a decorative pool.

Rachel: I'd heard you were back. What are you doing?

Wayne: Ahh . . . just swimming here. Wow, it's good to see you.

11. This fear is the catalyst (he thinks) for his parent's death. Frightened at the opera (presumably *Mefistofele*) by performers in bat costumes, he asks his parents to leave early, and upon leaving, they are robbed and shot.

Rachel: You were gone a long time.

Wayne: I know. How are things?

Rachel: The same. Job's getting worse.

Wayne: Can't change the world on your own.

Rachel: What choice do I have . . . when you're too busy swimming?

Wayne: Rachel . . . all . . . all of this . . . it's . . . it's not me. It's . . . Inside . . . I am . . . I am more. [In the background, Bruce's companions are calling, "Come on, Bruce, come on. We have some more hotels for you to buy."]

Rachel: Bruce . . . deep down you may still be that same great kid you used to be. But it's not who you are underneath . . . it's what you do that defines you.

The scene is worth watching. Nolan models the beginning of the scene as the pleasant and awkward surprise of meeting an old flame. There is an uncomfortable searching for words—a hint that these two were once more than friends. Their smiles are both genuine and overdone. But the mood changes quickly when Bruce tells Rachel that she can't change the world on her own. She becomes parental and tells him that he might be the same "great kid" that he used to be.

The dialogue sets up a shift where the real Bruce turns out to be found in the identity of the mask and costume rather than the person inside. What is the significance of the line, "it's not who you are underneath"? Is it an anti-romantic statement, against the notion that an essential self is hidden beneath social roles and constraints? Is it a statement that Bruce is empty inside? Is it simply a way to identify Bruce with the work and identity of Batman? It is not clear at this point. But by *The Dark Knight Rises*, it will be obvious, at least, that Bruce must journey through and beyond Batman; being Batman will become a trial within a larger quest. However, at the point where he is talking with Rachel outside the hotel, he is concerned only to dissociate himself from his feigned playboy persona. He tells her that he is different on the inside. She counters that we are what we do. Later in the movie, when—as Batman—Bruce saves her from the knife of a vicious criminal, he identifies himself to her by using her own words. "It's not who I am underneath . . . but what I do that defines me."

This question of identity comes at the end of *Batman Begins*, in what seems to be closure, but turns out to be an indictment of Bruce's fractured self. Bruce is boarding up a well amid the smoldering remains of Wayne Manor. Nolan's symbolism is well done; Bruce appears to be putting the last nail in the coffin of his childhood fears. At that moment, Rachel arrives, to foreshadow (or even to announce) that bringing an end to the corruption of Gotham, completing his father's legacy, and building a life with Rachel will not be that easy.

Wayne: I'm sorry I didn't tell you, Rachel [that I was Batman].

Rachel: No. No, Bruce . . . I'm sorry. The day that Chill died, I . . . I said terrible things.

Wayne: But true things. I was a coward with a gun . . . and justice is about more than revenge. So thank you.

Rachel: I never stopped thinking about you. About us. And when I heard you were back, I . . . I started to hope. [And here she offers some false hope with a lingering kiss. After the kiss, she gives the "but" that brings Bruce down.] But then I found out about your mask.

Wayne: Batman's just a symbol, Rachel.

Rachel: No. This . . . [touching his face] is your mask. Your real face is the one that criminals now fear. The man I loved . . . the man who vanished . . . he never came back at all. [At this point Bruce is starting to look grim, as Rachel plows ahead.] But maybe he's still out there somewhere. Maybe someday, when Gotham no longer needs Batman . . . I'll see him again. [Bruce gives a very slight, but determined nod . . . and the scene shifts to Alfred standing among the ruins.]

Rachel longs for the Bruce that is "still out there somewhere," and at face value, her longing doesn't make sense. Bruce's grim affirmation doesn't make any sense either. In the typical romantic scene—if it is at the end of a film—the encounter would end with the kiss as a clear sign of a shared future (as *The Bourne Identity* ends as Jason and Marie embrace). If the scene were earlier in the development of the characters—and we can grant this frame for the scene as part one of a trilogy—Bruce would protest as soon as Rachel followed her "I started to hope" with a "but." The lover is supposed

to overcome the "but;" to fight it from beginning to end and prove his love. Bruce is supposed to say, "Rachel, you are not making any sense."

Rachel's reservations about the missing Bruce ("still out there some-where") and Bruce's solemn nod of agreement make sense if she is really talking about their relationship to Gotham and all about Bruce that he has not yet achieved. What is missing is the uncorrupted Gotham and Bruce's father's place in it. What is missing is Dr. Wayne's role as preeminent citizen, which is supposed to fall to Bruce. Rachel is tying Bruce's return to her to Gotham's rescue and redemption by Batman. Rachel refused to see Bruce and Batman as a united self. Apart from the long kiss, their interchange is subtly anti-romantic (at least as romance usually works in film). It is as though Rachel says something like, "Our relationship is not just about you and me riding off into the sunset . . . or embracing at twilight on an exotic Greek island. We'll get things going after you establish yourself as the patron of Gotham, like your father. And to do that you are going to have to clean up Gotham first. You're a sensitive guy; Batman is a tough crime fighter; but Dr. Wayne's son is still out there somewhere and he is both."

Although we have called this interchange anti-romantic (in the context of *Batman Begins*), it actually makes the romantic tension work within the Batman trilogy as a whole. If romantic love proves itself by overcoming obstacles (of wealth and class, for example, or family feuds), the obstacles set up by *Batman Begins*—and carried over to the second and third parts of the trilogy—are crime and corruption. Bruce, as Batman, will set out to romance Rachel by saving Gotham. Here, romance and quest coalesce. As Bruce or Batman, he is a fractured self. Saving Gotham, as Batman, is the pathway of Bruce's quest to discover, not only who he is, but first of all, who he is called to be.

The Man, the Mask, and the Machine

Will the quest destroy him? It is our thesis on romance that it fits within a larger romantic theme of the hero's stance against an impersonal, bureaucratic, and industrial world. With nineteenth-century industrialization, a romantic affirmation of the individual and natural life emerges against cold relations in the city and its technological control. Like Jason Bourne, the hero will find out who he is through personal bonds that contrast with dominating institutions. In these terms, finding love and his own place in the world will not be easy for Bruce. It will tear him apart; Bruce's parents,

particularly his father, are so closely identified with the engineering and machinery of Gotham that, at first glance, the Batman trilogy might seem inconsistent with a romantic challenge to modern industry and the machine. Dr. Thomas Wayne's legacy is technological order and industrial development. Bruce admires the legacy; Batman depends upon it.

However, there is another side to Dr. Wayne and to Bruce. As a physician and in the few scenes we see of Thomas Wayne as a father, he is primarily concerned with care and healing. He is the complete man, both sensitive and technically savvy. These are the two sides that we see in Bruce. But his life is fragmented. On one hand, Bruce is entirely detached from wealth and power. He naturally has what might be called spiritual freedom. He leaves everything, in *Batman Begins*, in his journey through the underworld and he discovers his inner power outside the city. (In effect, he leaves the city, finds a desert ascetic, and is integrated into a monastic community.) In *The Dark Knight*, the same spiritual freedom is evident. He has to pretend to be a profligate socialite; it does not come naturally to him. As Bruce, he seems uncomfortable among the urbanites. On the other hand, he wants to protect his father's legacy of industrial and technological development. Batman is the best and most needy consumer of Wayne Enterprises research and development. He is a man attached to a machine. In *The Dark Knight Rises*, when he loses Wayne Enterprises to Roland Daggett (Bane's puppet), his only worry is the safety of the city. Wayne Enterprises, with the goal of creating clean energy for Gotham, has also created a weapon of its mass destruction.

In effect, Christopher Nolan uses the identities of Batman and Bruce to chart a romantic struggle within the character. And, because the struggle is within, the plot lines for our hero can be convoluted. On one hand, his image for the crime fighter is a bat—a natural agent of pest control; on the other hand, the Batman would not be possible without technology, from the suit to various vehicles and weapons, and of course, the use of "cell phone sonar" in *The Dark Knight*. Looking at countless screens processing data, Batman says, "Beautiful." Lucius Fox responds, "Beautiful, unethical, dangerous. . . . With half the city feeding you sonar, you can image all of Gotham. . . . This is wrong. . . . Spying on thirty million people is not part of my job description." Certainly, Batman will limit the use of this technology—to Lucius, for one instance—to find the Joker. But, the fact of the matter is that he acts, for a moment, as the technological leviathan. Ra's al Ghul, the Joker, Bane, and Miranda all intend to destroy the well planned

and technologically advanced city. The framework of *Batman Begins* is consistent throughout the trilogy: the order and technology produced by Wayne Enterprises (e.g., the centralized water and train systems that will be used to poison the population) become the tool for disorder and destruction. On one hand, Batman must preserve the city; on the other, he too has to be free of it.

The use of technology and the order of the city for evil or good hangs in the balance. Batman/Bruce—as a person of courage and good will—makes the difference. But to make a lasting difference Batman and the "technological" side of Bruce will have to be sacrificed. Just as Wayne Manor will burn to the ground at the end of *Batman Begins*, Rachel will die in a fiery explosion toward the end of *The Dark Knight*, and in *The Dark Knight Rises*, Batman may be obliterated by a nuclear bomb. The systems of technological development (Wayne Enterprises) and bureaucratic control (represented by Harvey Dent, for example) inevitably become tools of suffering and chaos. At the climax of *Batman Begins*, Batman (with Ra's al Ghul's broken sword) and Detective James Gordon (in the high-tech tumbler) stop Ra's al Ghul by destroying the train and railway—a train engineered and constructed by Wayne Enterprises. In *The Dark Knight*, the Joker uses technology with facility, but as the agent of chaos, he is "a man of simple tastes [who] enjoy[s] gunpowder and dynamite."[12] No wonder the Joker is a villain with a hero's cachet. He is the truly authentic, self-possessed individual, and no wonder the Joker recognizes the Batman as his true counterpart. The Joker basks in the contradictions of the real man who has to wear a mask.

The point here is that Batman's struggles to save Gotham appear, at first glance, to hold out the possibility of redemption for Bruce. But this first glance overlooks a deeper fragmentation. The Joker seems to be the perfect nemesis because he is set against the order of the city, and (as Ra's al Ghul hopes to use technology as the tool of destruction) he hopes to corrupt and use Harvey Dent, the agent of civil order. In this sense, all the villains of the Batman trilogy attack the industrial order that Bruce hopes to defend. The League of Shadows harnesses advanced engineering; the Joker exploits the civil service. Bane and Talia al Ghul corrupt both civil and scientific order in *The Dark Knight Rises*. As Batman must stop Ra's al Ghul on the train, he

12. The scene is with the gangster, Chechen, when the Joker burns a pile of money. He tells Chechen, "All you care about is money. This city deserves a better class of criminal, and I'm going to give it to them."

must disrupt the Joker's use of Dent.[13] Again, Batman makes the difference by force of will and his willingness to sacrifice his own good—to be divided and fragmented as a person. This point is clear in *The Dark Knight Rises*; the nuclear explosion (the destruction of the technological wonder) brings wholeness; it serves to free Bruce Wayne from all the trappings of Batman and toward a simple (romantic) life with Selina Kyle.

If the basic romantic struggle is within Batman/Bruce, there is a level of romantic reserve in the films—a tendency to keep the hero distant from romantic relationships. We know that Bruce loves Rachel and that Rachel loves him. But the "love" and Rachel herself are always guided and controlled by practical purposes and prudential reason. By the opening of *The Dark Knight*, Rachel and Harvey Dent are working together for the good of the city). Should we wonder that Rachel falls in love with someone that she works with? Alfred, at least, wonders where Bruce will fit in Rachel's life. This romantic reserve is Batman's burden. (Contrast *The Bourne Identity*, where Jason's relationship to Marie is unproblematic once they go on the run together.) The romantic reserve parallels Batman's refusal to kill or to extend punishment outside the law.

Batman doesn't ever manage to enjoy genuine superhero satisfaction. Justice requires cool objectivity. Contrast Superman. In the Christopher Reeve *Superman* (1978), Superman is able to save almost everybody, but he *must* save Lois Lane. He will reverse the laws of nature—the rotation of the earth—to do so. Lois's death would be a mortal wound to him. Superman is able to go outside the laws of nature to save Lois and to save himself from loss and grief. The contrast is striking between Lois, who clings to Superman, and Rachel, who stands on her own. In the Batman trilogy, Rachel is closely identified with justice itself, and she is also dispassionate. Consider the scene where Rachel realizes that she is going to die. She is willing to sacrifice herself for Harvey's sake, and as her death becomes inevitable, she becomes calmer, more rational. There is no screaming for help. Batman wants to save her, but she does not want to be saved. Batman intended to rescue her, but he is tricked by the Joker into saving Dent instead. But ironically, the Joker's trick accords with her wishes. She would rather have Batman save Harvey.

In *The Dark Knight*, Rachel's love is divided between the two men insofar as each shows promise for the redemption of Gotham, and her death

13. He so does by making the slain Harvey a hero, while he runs off as the villain, living a lie to take the blame for Dent's murders.

leads to the despair of both. In the hospital, Harvey screams in anguish; Nolan gives a closeup profile of Harvey, his undisfigured side; we see him contemplating his coin (charred on one side), and we see an image of Rachel in his mind's eye. Nolan gives us another close up as he screams—an impotent scream that, for us, makes no sound. With Rachel dead, Harvey—as Two-Face—turns against law and order and becomes an agent of brutal chance and disorder. Without Rachel, Harvey's world collapses. Batman's reaction is far more measured. When Alfred serves him breakfast he is distraught. If we would have had any expectations for this scene and Bruce's reaction to Rachel's death, they are already muted: we know that Alfred knows that Rachel had chosen Harvey. It is easier to see that Batman's despair is as much about the role and purpose of Batman as it is about Rachel.

Bruce: Did I bring this on her? I was meant to inspire good, not madness, not death.

Alfred: You have inspired good. But you spat in the face of Gotham's criminals; didn't you think there might be casualties? Things were always going to have to get worse before they got better.

Bruce: But Rachel, Alfred . . .

Alfred: Rachel believed in what you stood for. What we stand for. . . . Gotham needs you.

Bruce: Gotham needs its hero. And I let that murdering psychopath blow him half to hell.

Alfred: Which is why for now, they'll have to make do with you.

Bruce: She was going to wait for me. Dent doesn't know. He can never know . . . [At this point, Alfred surreptitiously takes the letter from Rachel off the tray, so that Batman will never know.]

The close connection between Rachel and unadulterated justice, as opposed to revenge, means that Batman must hold back his passions in not going outside the law and Gotham's institutions of justice. Rachel demands this limit to his desires. Likewise, although love powers the quest to destroy corruption in Gotham, there is a reserve—very few moments of intimacy between Rachel and Bruce or Rachel and Harvey (except at her death). Rachel is almost as distant as disinterested justice. Simply put, for Batman to be Batman, Rachel cannot mean everything to him.

Selina Kyle is different, and for this reason, she provides promise for Bruce's liberation. Her relationship to Bruce has contours that approximate a romantic comedy. When they first meet, Bruce startles and scares a person he thinks is a maid, who seems to be nosing about his bedroom. He shoots an arrow near her head. She screams, then recovers. She acts coy and inquisitive, and Bruce shows a hint of amusement when he discovers that she has opened his "uncrackable" safe and stolen his mother's pearls. Once the theft is discovered, Selina stops the timid maid act and becomes feisty. She kicks his cane from him; he looks up from the floor and stares in shock as she does a backflip out the window. This encounter sends Bruce to the Batcave for the first time in a very long time. He is coming out of his seclusion. Soon, we learn that Selina is feeling trapped, and he will be her chance for a new life as well.

In the Batcave, the conversation with Alfred that follows Bruce's first encounter with Selina will outline the romantic structure of their relationship.

Bruce: She's good, but the ground is shrinking beneath her feet.

Alfred: We should send the police before she fences the pearls.

Bruce: She won't. She likes them too much. And they weren't what she was after. [Notice that Rachel wanted Bruce to take up his father's legacy as a citizen of Gotham; Selina just wants his mother's jewelry and a new start for herself.]

Alfred: What *was* she after?

Bruce: My fingerprints. There was printer toner mixed with graphite on the safe. Gives you a good pull, and it's untraceable.

Alfred: Fascinating, you two should exchange notes over coffee.

Bruce: So, now you're trying to set me up with a jewel thief?

Alfred: At this point, I would set you up with a chimpanzee if it brought you back to the world.

Bruce: There's nothing out there for me.

Alfred: And that's the problem. You hung up the cape and cowl, but you didn't move on. You never went to find a life, to find someone

Bruce: Alfred, I did find someone . . .

Alfred: I know. And then you lost them. That's part of living, sir.
 But you're not living. You're waiting. Hoping for things to
 go bad again

From here, Alfred explains his dream of seeing Bruce start a new life far from Gotham. "Every year I took a holiday. I went to Florence. There's this café on the banks of the Arno I had a fantasy that I would look across the tables, and see you there . . . with your wife, maybe a couple of kids." We are able to see what Alfred imagines. Then he puts the conclusion of the Batman trilogy in focus, "I never wanted you to come back to Gotham. I always knew there was nothing here for you except pain and tragedy, and I wanted more for you than that. I still do."

The conversation between Bruce and Alfred provides the backstory that allows Selina's relationship to Bruce to be inserted in the narrative as romantic comedy. Even on the level of storytelling, romance for Bruce has to come from outside the already established narrative. First, Selina is intriguing, but from the other side of the tracks. She is enchanted by jewels and steals them. Bruce seems to have little care for possessions, but owns plenty. She acts only for her own self-interest; Batman is a servant of the people. In more than one way, they represent different sides of Gotham. Put even better, Bruce represents Gotham, but Selina represents herself. Yet, they are obviously attracted to each other from the start. It helps, of course, that she is smart, athletic, and beautiful, and he is dapper and heroic. Second, both Selina and Bruce need a new fresh start. As Bruce says of Selina, "the ground is shrinking beneath her feet." Throughout, she is motivated by a desire for the "clean slate" software that will erase her past—an escape route to a fresh start (as Bruce says when he returns to Gotham). Combine points one and two, "wrong side of the tracks" and "shrinking ground and the need for a fresh start," and we arrive at a third—a Pygmalion/*My Fair Lady* theme. Bruce "believes that there is more to Selina" than the thief who delivered all the wealth of Wayne Enterprises over to Bane.[14] He does not hold her past against her, and he thinks she is different inside. With him fighting by her side, the Catwoman even becomes a mirror image of Batman. And Bruce, in the end, will find himself in Selina.

14. It is also fair to suggest that the real "deliverer" of Wayne Enterprises was Miranda Tate, or Bruce Wayne's lax interest in the affairs of the company.

With Rachel and Selina, we find two sides to the romantic struggle—the struggle of Bruce to be himself. Rachel is the love that ties him to Wayne Manor, his father's legacy, and justice for Gotham. Rachel's love is woven together with the creation of Batman (to restore Gotham) and the eventual subsuming of Bruce's identity within Batman. At the end of *Batman Begins*, she tells Bruce that the mask that criminals fear is the real him. She explains that Batman will have to restore Gotham before the Bruce that she wants to love will reappear. We should pause here and note that Rachel, at the conclusion of *Batman Begins*, is introducing a third Bruce. There is: (i) the Bruce that she is touching and kissing, (ii) Bruce as Batman, which she claims is the real face of Bruce, and (iii) a Bruce of the past that she once loved and who could return. It is not clear why this Bruce of the past and the Bruce that she touches are not the same. Or, if they are not the same, what about the Bruce of the past needs to be retrieved? What is missing? The precise meaning of Rachel's words need not be clear. The point is that Bruce's life is still fragmented. From Rachel's kiss among the ruins of Wayne Manor through to her death in *The Dark Knight*, Bruce's continuing quest for redemption is fueled by his love for Rachel, as if the success of Batman in ridding Gotham of corruption would make the city safe for the two of them—to have a loving and harmonious home both at Wayne Manor and in Gotham. But is the very quest mistaken?

In *The Dark Knight*, the quest to find a home by restoring Gotham becomes the problem. In her letter to Bruce, read posthumously only by Alfred, she writes, "When I told you that if Gotham no longer needed Batman we could be together, I meant it. But now I'm sure the day won't come when you no longer need Batman. I hope it does and if it does I will be there, but as your friend." The tragedy is that she does not want him because he is the person she wanted him to be. At this juncture, Gotham (not Rachel) becomes Batman's tragic soulmate—the love that will mean his death. Batman and Gotham need each other, but in the end, they cannot be together if either is going to mature and flourish. For Bruce, a constellation of relationships has their center in Gotham: the romantic memory of his father, the belief that he belongs with Rachel, and the ongoing support that he receives from Alfred, as his surrogate mother. Batman's relationship to villains has its matrix in Gotham as well: his battle against the organized crime that pervades civic life, his eventual rejection of his stepfather figure, Ra's al Ghul, his attraction to and eventual tryst with the "wrong girl," Miranda Tate (Talia al Ghul), and especially his struggle with the Joker for his

and Gotham's soul. Gotham is the love that needs the life and requires the death of Batman.

In short, the romantic undercurrent of Nolan's trilogy is that Batman—the mask, the machine, the defender of order and the city—becomes the source of Bruce's alienation. As Bruce and Alfred discuss the rebuilding of Wayne Manor, saving Gotham seems to be possible although not yet attainable—like the ruins they can only imagine as Wayne Manor restored. But the very last scene of *Batman Begins* moves that hope even further out of Batman's grasp, as Lieutenant Gordon hands him an evidence bag with a playing card inside it—a joker. The Joker personalizes disorder and romantic antagonism against the city; he is the authentic villain who responds to the world intuitively, without a plan. The Joker will have to kill Rachel (a symbolic "have to") because she represents Bruce's father's house and is central to Batman's identity as the defender of order. In *The Dark Knight*, her death brings a crisis of purpose. His *raison d'etre* is gone. She is the one who caressed Bruce's face and told him the real Bruce wears the mask.

In *The Dark Knight Rises*, Selina Kyle becomes a catalyst for Bruce to re-engage with the world. Central to this rearrangement of Bruce's life is the fact that Catwoman is hardly a model citizen. She is a freelance criminal. She lives without ties; she is looking to be free of her past in Gotham, and with her, Bruce can be free of Batman and of Gotham as well. Rachel represents Bruce's tortured past, and Selina gives him the possibility of an unfettered future. She serves as his protector in the final battle, a witness to the death of Batman, and his lover, bringing new life to Bruce Wayne.

The Journey Home

In short, Nolan's Batman trilogy is a captivating struggle because Bruce's journey of self-discovery is also a nearly hopeless quest to redeem Gotham. To find inner healing, he also must seek a harmonious home. He leaves his home in Gotham after his failure to exact revenge for his parents' murders and the chastisement he receives from Rachel for even trying to go outside the law. Bruce begins to find inner strength and outward mastery over injustice by facing his fears in his journey through the underworld and his tutelage under Ra's al Ghul. With Ra's al Ghul, Bruce has found a home and a new like-minded family, it seems. But to be part of it, he must choose between the League of Shadows and Gotham. His hope to defend Gotham

means that he destroys the house of the League, and as a consequence, Wayne Manor will burn to the ground as well. The hero is homeless.

In *The Dark Knight*, Bruce lives in the "basement Batcave" as much as he does in his glassed-in penthouse. In *The Dark Knight Rises*, he lives in the rebuilt Wayne Manor as though he were a shut-in, physically and psychologically disabled and apparently unable to leave his home. In pursuit of Selina, Bruce ventures out into Gotham. They dance. But Selina (driven by her own desire for a new start) unknowingly becomes an instrument in the downfall of Wayne Enterprises and Gotham. Wayne Enterprises will be seized by Roland Daggett (Bane's puppet), and Bruce will be banished from Gotham. Leaving Gotham and thrown into the prison pit (the underworld again), he must find himself anew. As a new man, he will return to save Gotham, and the final act of rescue will be the liberation from Gotham as well—liberation for Alfred's dream of Bruce, enjoying a private life, with a wife and maybe a few kids.

Leaving home and coming back, therefore, sets an obvious frame for self-discovery, but struggles for Gotham and within Gotham are framed by identity questions as well. For example, we have noted that *The Dark Knight* puts Batman literally and figuratively on a collision course with the Joker (the character who has proven through the years to be Batman's greatest nemesis). The Joker is nothing if not self-possessed; he knows who he is. Masterfully played by Heath Ledger, the Joker baits Batman throughout the film, as the two characters engage in an elaborate *pas de deux* that highlights all of the mania and brokenness that the two characters share. Nolan intercuts scenes of the Joker with scenes of Batman until the last third of the film, when, with a number of confrontations between the two characters, the audience sees that, in many ways, the Joker's picture of Batman rings true:

Joker: Oh you. You just couldn't let me go, could you? This is what happens when an unstoppable force meets an immovable object. You truly are incorruptible, aren't you? Huh? You won't kill me out of some misplaced sense of self-righteousness. And I won't kill you because you're just too much fun. I think you and I are destined to do this forever.

Batman: You'll be in a padded cell forever.

Joker: Maybe we could share one. You know, they'll be doubling up, the rate this city's inhabitants are losing their minds.

Is Batman as insane as the Joker? It is arguable that he suffers from a complementary kind of mania and dissociation. The hero is a fragmented self.

At this point in the whole of the trilogy—in his tangle with Joker—the man under the mask has lost his moorings to any sort of "normal" life. Rachel Dawes is dead. Harvey Dent was Batman's hope for a person to "take over as Gotham's hope for the future," but he has been driven mad and becomes a murderer. Bruce Wayne has every intention of giving up the cowl, but is reluctantly drawn back to being Batman by the Joker's anarchistic plots. He sees himself again as the stopgap, this time against not the dark vision of "cleansing" represented by the League of Shadows in the first movie, but against the chaos and bedlam emptied over Gotham by the Joker. At this point, he is also driven by his sense of loss. Bruce Wayne the orphan has now also lost Rachel, his true love and the image of family and home. He is making a number of assumptions and decisions that cause the audience to question his hold on reality. He believes that Rachel loves him, and will choose him over Harvey Dent. The audience knows that this isn't the case, as we hear Rachel read the letter in a voice-over. Tricked by the Joker, he chooses the wrong warehouse, and fails to save her from the explosions.

Finally, in the climactic scenes, he chooses to maintain Dent's reputation by taking responsibility for the deaths that were at Dent's hands.

Gordon: The Joker won. Harvey's prosecution, everything he fought for . . . undone. Whatever chance you gave us at fixing our city dies with Harvey's reputation. We bet it all on him. The Joker took the best of us and tore him down. People will lose hope.

Batman: They won't. They must never know what he did.

Gordon: Five dead. Two of them cops. You can't sweep that . . .

Batman: No. But the Joker cannot win. [As Batman turns Harvey's head to the unscarred side.] Gotham needs its true hero.

Gordon: No . . .

Batman: You either die a hero . . . or you live long enough to see yourself become the villain. I can do those things . . . because I'm not a hero, not like Dent. I killed those people. That's what I can be.

Gordon: No, no, you can't. You're not.

Batman: I'm whatever Gotham needs me to be. Call it in.

We will see and hear—through images and voice-over—that Dent is "not the hero we deserved, but the hero we needed," and Batman, running from the law, is "the hero Gotham deserves, but not the one it needs right now . . . not our hero . . . [but] a silent guardian . . . a watchful protector . . . a dark knight." It is unclear what this turn and reversal of phrase, hero need/hero deserved, actually means. The consequences, however, are plain: Batman accepts exile; his heroic act is homelessness, as he purposefully disconnects himself from Gotham.

Nolan has intertwined the fates of Batman, Bruce Wayne, and Gotham, suggesting that the entity that is the city needs Batman as much as he needs to defend the city. It is that relationship that is one of the beating hearts of the third movie in the trilogy, *The Dark Knight Rises*. We could clearly discuss *The Dark Knight Rises* from a socioeconomic point of view, with Batman representing the fallen elite of Gotham, squaring off against the proletariat and their flag bearer, Bane. In this regard, Charles Dickens's *A Tale of Two Cities* comes into play as inspiration for Nolan. If we take this interpretation too far, however, it is difficult to see Batman as anything other than a representative of the old, decaying, and elitist culture that Bane is apparently rebelling against. The audience eventually discovers that Bane and Talia al Ghul are the surviving members of the League of Shadows, and that they have control of the nuclear device that has been trucked around the city since it was removed from its original location. It becomes clear that their plan is not simply an economic revolution—they want to destroy Gotham in the same way that Ra's al Ghul did, because they see the city as an embodiment of all that is evil in the world.

Bruce Wayne's decision to resurrect Batman after an eight-year retirement drives the movie forward to its conclusion. Batman arrives in the Batcave; Alfred disapproves.

Batman: Alfred, enough. The police weren't getting it done.

Alfred: Perhaps they might have if you hadn't made a sideshow of yourself.

Batman: You thought I didn't have it in me.

Alfred: You led a bloated police force a merry chase with a load of fancy new toys from Fox. What about when you come up against him [Bane]? What then?

Batman: I'll fight harder. I always have.

Alfred: Take a look. His speed, his ferocity, his timing. I see the power of belief. I see the League of Shadows resurgent.

Batman: You said he was excommunicated.

Alfred: By Ra's al Ghul. Who leads them now?

Batman: Ra's al Ghul is the League of Shadows. And I beat him. Bane is just a mercenary. We need to find out what he's up to.

He considers Bane as another enemy to be overpowered. He doesn't see the "power of belief" that Alfred does. That misstep leads to his nearly fatal injury (a classic image in the Batman comic book oeuvre), and his imprisonment in the same unnamed pit from which Bane and Talia have already escaped. It is definitely significant to note here that it is Bruce Wayne who is imprisoned, not Batman. It is Bruce Wayne who, confronted with images of Bane taking all of Gotham hostage, must literally climb out of the pit, from near death into the light. And it is Bruce Wayne who must climb out of the pit by relying solely on his own physical and emotional strength, without the assurance of the rope that held him back in his previous attempts. Batman certainly would have had various gadgets at his disposal.

Once Bruce escapes, he must confront the chaos that Bane has brought to Gotham. Kangaroo courts staffed by psychopaths like the Scarecrow pass judgement on both criminals and wealthy citizens. Over 3,000 police have been imprisoned in the sewer system. The rank-and-file population of the city lives in fear, cowering behind apartment doors and in makeshift shelters in public buildings. Even Army Special Forces troops are no match for Bane and his guerillas. And to top it off, the core of the fusion reactor stolen earlier is deteriorating, giving the city less than twenty-three days before the bomb destroys Gotham.[15]

Wayne, refitting himself as Batman, wades into the midst of this chaos, freeing the trapped policemen, initiating a plan for the residents of the city to escape, and reconnecting with both Selina Kyle and Miranda Tate. These reconnections are slightly different. In Selina's case, Bruce gives her the "clean slate" software in exchange for getting him into the refugee shelter and to the Wayne Enterprises staff (significantly including Miranda). As Batman, he offers Catwoman his "Batpod," asking her to clear a path for

15. Thanks to the judicious application of "movie time flexibility," that twenty-three days becomes eighteen hours quite quickly.

the citizens with the cycle's cannons. In this scene we see the wariness with which both characters approach their reunion.

Catwoman: You gonna wage a war to save your stuck-up girlfriend?

Batman: To start it, throttle—

Catwoman: I got it.

Batman: We have forty-five minutes to save this city.

Catwoman: No, I've got forty-five minutes to get clear of the blast radius, because you don't stand a chance against these guys.

Batman: With your help, I might.

Catwoman: I'll open that tunnel, then I'm gone.

Batman: There's more to you than that.

Catwoman: (with a shake of her head) Sorry to keep letting you down. (after a pause) Come with me. Save yourself. You don't owe these people anymore. You've given them everything.

Batman: Not everything. Not yet.

And with that, the two of them separate; Catwoman ostensibly to escape from Gotham, and Batman to begin his war, defeat Bane, and rescue Miranda Tate. That reconnection and (hopefully) rescue of Miranda, as mentioned above, is portrayed differently than the reconnection with Selena. In fact, the reconnection with Miranda is at once satisfyingly stereotypical and a wonderful plot twist. In the formulaic rescue, he fights his way through the mob that is the battle between Bane's mercenaries and the recently released policemen, confronts Bane and breaks his breathing apparatus, and almost miraculously smashes him into the building where they have been keeping Miranda hostage. In the twist, Miranda reveals herself to be Talia al Ghul, the daughter that Ra's al Ghul abandoned as an infant, and who escaped from the same prison from which we just saw Bruce escape. The film had previously set up Miranda as the more stereotypical romantic interest for Bruce; but here, she proves to be Talia, the evil mastermind behind everything—the destruction of Wayne Enterprises, the occupation of Gotham, the bomb, and through sticking a knife into his side, Batman's

killer. If nothing else, this violation of Bruce's trust and lapse of Batman's savvy prove that he still has personal healing left to accomplish.

While Batman heals (it was a knife to the ribs, after all), in a sequence of scenes adeptly directed by Jonathan Nolan and edited by Lee Smith, we see how the citizens of Gotham, if not healing, are clearly rising up against their oppressors. We see the small group of policemen led by Commissioner Gordon attempting to find the truck with the bomb. We see the larger group of policemen, all in their uniforms and led by Deputy Commissioner Foley wearing his dress uniform (a clear visual reference to Commissioner Gordon's challenge from an earlier scene), attack Bane's mercenaries. We see Detective Blake organizing the orphans to escape the island. The people are revolting against their oppressors.[16] The true citizenry, the heart and soul of Gotham, is rising up.

However, Batman does not make a particularly persuasive socialist revolutionary. His focus is now on a much more traditionally romantic, if stereotypical, hero's final journey. If only because he has the power (and the hovercraft), he is the one who must transport the bomb away from Gotham. He is aided in these final actions by Commissioner Gordon and Catwoman, as they finally stop the truck carrying the bomb. Batman responds to both of them in ways that, although they are expected by the audience, point toward the steps that he is taking to heal both himself and the citizens of Gotham.

Catwoman: You could've gone anywhere. Did anything. But you came back here.

Batman: So did you.

Catwoman: I guess we're both suckers. [She grabs him and gives him a long kiss.]

Granted, that interchange sounds a little too "Bogie and Bacall" for a twenty-first-century action movie; nevertheless, it does revive the banked coals of their relationship. It is probably more important to hear what Batman says to Commissioner Gordon just before flying the bomb out of the truck.

16. This is another instance where the movie is obviously making reference to the general economic instability at the beginning of the twenty-first century. The "99 percent" is rising up against the "1 percent," except in this case, the "1 percent" is represented not only by the evil capitalists who have taken over Wayne Enterprises, but also by the revolutionary oppressors represented by Bane and his mercenaries. It's also significant that the closed captioning for the movie refers to Bane's allies as "mercenaries."

Gordon: Shouldn't the people know the hero who saved them?

Batman: A hero can be anyone. Even a man doing something as simple and reassuring as putting a coat around a young boy's shoulders to let him know the world hadn't ended.

"A hero can be anyone"? Certainly in the last fifteen minutes of this movie we have seen numerous occasions when ordinary citizens (even including the police who storm the barricades) stand up against oppression. Those actions certainly classify as heroic. What Batman is saying here redefines heroism in a romantic and emotionally satisfying way, by defining a simple human act of compassion as heroic. Additionally, Commissioner Gordon's care and compassion given to a young Bruce (whose parents were just murdered), recalled here and shown again as an obvious point of emphasis, is identified as an act that shows that the "world hadn't ended." That moment of human compassion and interaction is clearly a moment that Bruce, as Batman, has been trying to recapture throughout his psychic journey. We really should not be surprised, given the form that these movies take, that these awakenings on the part of the hero happen as part of the climactic ending.

At this point, nothing is left for Batman to do but to fly the bomb out over the bay. As he does, camera work and the soundtrack make it clear that he has found peace. Why else would we see the face under the cowl finally relax, take a deep breath, and accept the future? Why else would the soundtrack shift to the sound of, as the closed captions put it, "angelic vocalizing?" Most importantly, why else would Commissioner Gordon read from Dickens's *A Tale of Two Cities* at Bruce's grave site?

> I see a beautiful city and a brilliant people rising from this abyss. I see the lives for which I lay down my life, peaceful, useful, prosperous and happy. I see that I hold a sanctuary in their hearts, and in the hearts of their descendants, generations hence. It is a far, far better thing that I do, than I have ever done; it is a far, far better rest that I go to than I have ever known.

As far as we know, Batman has indeed sacrificed himself for his "beautiful city and [its] brilliant people." Then we see Bruce alive with Selina. Through the course of the final movie in the trilogy, he has redeemed the broken reputation that he wrapped around himself at the end of *The Dark Knight*. He starts *The Dark Knight Rises* broken, attempts to save the city, is broken even further, escapes from the hellish pit by embracing his own fear

(and consequently even more of his essential humanity), defeats the demon Bane, saves the city, and gets the girl.

It is very tempting here to point to the penultimate scene of the movie as the confirmation of all that Bruce Wayne has finally won. It is the scene that Alfred describes earlier in the movie, where he sees a relaxed Bruce Wayne at a trattoria—relaxed, informally dressed, and smiling—sitting with a "wife" (i.e., Selina, who, if the audience looks closely, is wearing Bruce's mother's pearls). It is probably significant to note that Alfred described this as his "dream" for Bruce.[17] It's hard to know if this is Bruce's dream for himself. We do know that through the entire trilogy, he has used Batman as a tool; as a way to do the difficult things that Bruce Wayne couldn't do to redeem Gotham. In *Batman Begins*, Batman purges the city of both the godfathers of organized crime and of Ra's al Ghul's mission to destroy it. In *The Dark Knight*, he confronts a villain whose mania rivals his own, and at the same time transfers his role as Gotham's savior to a figurehead, Harvey Dent. Eight years later, in *The Dark Knight Rises*, Dent's "straw man" is revealed as a sham, and Bane's forces take over the city, ostensibly to remove the corrupt upper class from their positions of power. Despite all that has transpired, Bruce Wayne returns from the pit and must once more put on the mask and, as mentioned above, take the final steps on his journey to redemption. Whether his redemption is real or a dream, the fact that Bruce Wayne is redeemed is an emotionally satisfying conclusion to this saga. Nolan knows he has to give us that healing and wholeness for both Gotham and Bruce.

Appendices

The Stuff of Romance and Why Rachel Has to Die

Given the basic patterns of film romance, Rachel Dawes has to die, and for that matter, Miranda Tate, even if she were not the villain Talia al Ghul, would have to die too. Selina Kyle is a much more suitable match for Bruce, if only because her life has come to an impasse. If we use the words of the Joker, she has "no plan." She needs a new start, like Batman, and she and

17. It's also significant to note that Christopher Nolan has an affinity for dream endings for his movies that call a firm conclusion into doubt. Compare *Inception* (2010) as the most obvious example.

Bruce can shed Gotham and their Gotham-based identities (Batman and Catwoman) together. Together, they begin a new life and build a new home.

First, the stuff of romance: All or some of the following tropes and plot elements need to be in place. To cite Sam Baldwin from *Sleepless in Seattle*, there needs to be "magic." Along with the magic, Sam tells radio talk show host Dr. Marcia Fieldstone that when he met his former, deceased wife, it was like going "home . . . only to no home I've ever known."[18] To fit the narrative, the magic has to overcome barriers—for example, like the two people have never actually met, or one is in a relationship, or the other is not interested in a relationship, and so on. A second element complements the magical feeling of home. One or both of the would-be partners is trapped, either by a self-imposed constraints or by circumstance, and at least one of the pair needs to be liberated. Think, for example, of the stiff upper class in *Titanic*. The trap might actually be a dead end, a betrayal of trust, or some other crisis in one's own plan or predetermined course of life. On this point, the crisis might be simply a lifeless/loveless existence. Or consider how all the elements are present in *How Do You Know* (directed by James L. Brooks, Columbia Pictures, 2010), when Lisa is cut from the USA softball team; both are in dead-end relationships, George is fired from his company, and he will have to take the fall for his father's illegal business activity.

Finally, love makes each in the romantic pair better off and a better person. Consider *Pretty Woman*, which gives us a Pygmalion story with a happy ending. The lady of the streets—in *Pretty Woman*, a prostitute—is given a better life. She is lifted up not merely in station; she also becomes cultured, educated, more confident, and of course, more attractive. The man of business finds his heart and is able to reject his cold, utilitarian ways. In *How Do You Know*, Lisa realizes that she and George share a desire to be good and better people. To want to be better, simply put, summarizes all of the other elements of romance.

For all these reasons, Rachel has to be removed from Bruce's life, and apart from other requirements of the plot, it will just not do to have her stay a part of his story. We don't see any magic between Rachel and Bruce; we see at best responsibility and nostalgia. Rachel insists that what he does is good and that he become better. However, her love for him and his for her binds him to his father's path, to Wayne Manor and Wayne Enterprises. At the close of *Batman Begins*, she ties him to Batman and sets a condition

18. *Sleepless in Seattle*, DVD.

for their relationship—that if Batman succeeds in ridding Gotham of corruption, then perhaps she could have a future with Bruce. Also, although Miranda Tate is framed in *The Dark Knight Rises* as another possible love interest, the relationship is as doomed as the relationship with Rachel (even if she were not Talia al Ghul). Just before their tryst, as she uncovers a photograph of Bruce's parents, she assures him, "I'll take care of your parents' legacy, Bruce." Thus, Rachel and Miranda represent another fulfillment of the past, but Bruce needs a new start.

Bruce finds his new start with Selina Kyle. In fact, their connection is predicated almost entirely on shedding the old and starting anew. They do experience a bit of magic in the form of wit and banter. Bruce is obviously enchanted when he discovers that she has cracked his safe and is wearing his mother's pearls around her neck. She is beautiful, confident, athletic, and mysterious. Other than their verbal repartee, the film does little to develop an attraction between them, relying on their shared history from the "Batman comic book mythos." Instead, becoming better and the hope for a better life are at the center of their future together. When they first meet, we know that Bruce is despondent; he does not know how to continue on in Gotham. We learn that she also is at an impasse. She has burglarized Wayne Manor in order to purchase a "clean slate" computer program that will erase her criminal past from every database in the world. Selina, at this point, is driven by self-interest. She is cynical and cruel, going as far as to betray Batman and deliver him to Bane, who breaks his back and has him thrown into the pit (prison).

But when Bruce returns to save Gotham, after climbing out of the pit, he tells her, "I think that there is more to you." He asks her to help him save Gotham, and he gives her the "clean slate" device. He tells her that the device represents a fresh start for her. At first, she helps him only in as much as they can agree to a trade—a business transaction—the "clean slate" in return for helping Bruce liberate Lucius Fox. Soon after, she will want to escape before Gotham is destroyed. She returns, however, to rescue Bruce from Bane (killing him) and joining Bruce in pursuit of Talia al Ghul. When Batman decides that he must fly the neutron bomb over the bay and die in the process, Catwoman protests "You could have gone anywhere and done anything, but you came back here." His response: "So did you." She has started to become someone different, better. She quips, "I guess we're both suckers." And with that, they share a passionate kiss. So here we see why Rachel has to die—Rachel did not change, and did not need to shed

her past to find a fresh start. She and Bruce are bound by, and bound to, Gotham. With Selina, Bruce has an open road to a potential future.

Aristotelian Virtue and Batman's Moral Quest

Dr. Thomas Wayne is Aristotle's virtuous man. He is a generous patron, who uses his wealth to do magnificent (in his case, technologically brilliant) public service. On the train to the opera, he explains to Bruce, "Gotham's been good to our family, but the city's been suffering. People less fortunate than us have been enduring very hard times. So we built a new, cheap, public transportation system to unite the city, and at the center, Wayne Tower." He is a great soul, who aspires to and deserves the honor and admiration of Gotham's citizens. He is gentle, sociable, and temperate. More profoundly, he is wise, courageous, and just. Dying at the hand of an assailant, he instructs Bruce, "Don't be afraid." Thomas Wayne is the moral measure, not only for his son, Bruce, but also for the surrogate fathers that come into his son's life as well as for Gotham. The moral world of Christopher Nolan's Batman is moored to Thomas Wayne, his legacy, and his work in fashioning the city of Gotham. Ironically, in the end Bruce will be free of it, free from the public demands set upon the virtuous man, and free for what appears to a private life.

The Thomas Wayne of the trilogy is almost mythical, as he is held in Bruce's childhood memories and the high esteem of Rachel and Alfred (who functions as the nobleman's widow). We know his father from the slaps that Bruce receives from Rachel when she learns he that intended to murder Joe Chill, who murdered Thomas and Martha Wayne. Outside of the headquarters of the mob boss Falcone, Bruce supposes that he should thank Falcone for having Chill killed. Rachel tells Bruce that Falcone is destroying everything his parents worked for. "As long as he keeps the bad people rich and the good people scared, no one will touch him. The good people that stand against injustice, like your parents, they're gone." Bruce admits that he is not one of Rachel's good people. He reveals the pistol he expected to use to kill Falcone. Rachel slaps him, "Your father would be ashamed of you."

Later, Bruce throws his gun in the river and confronts Falcone. He provokes the crime boss by taking Rachel's (and his father's) point of view. "I didn't come to thank you. I came to show you that not everyone in Gotham is afraid of you." In response, Falcone gives a lecture that sends Bruce

into the underworld, far away from his soft, respectable life. Falcone tells him that, to know real life, he would have to go a thousand miles away where no one knows him as the "prince of Gotham." As Bruce Wayne, he can never know desperation and "the ugly side of life." Falcone threatens Rachel and Alfred, and he reminds Bruce that he has a lot to lose. As Bruce is roughed up by Falcone's bodyguards, Falcone dishonors Thomas Wayne. According to Joe Chill, he reports, Bruce's father begged for mercy moments before his death, "begged . . . like a dog." From here, Bruce's mission is clear. He will redeem his father's legacy and fight for the good people of Gotham. He will give criminals like Falcone something to fear.

Bruce will defend his father's legacy in Gotham by creating two selves, Bruce and Batman. In its moral frame, the plot function of the two personas is similar to the two selves of Jason Bourne. On one hand, we have the warrior who fights pervasive and seemingly indomitable corruption; on the other, we have the pilgrim who searches for who he is and tries to find his way through the love of a woman. The goal for the pilgrim is to find himself, while the mission of the warrior is to set the pilgrim free. The warrior has a surrogate father (again analogous to Jason, in this case his Dr. Albert Hirsch and Treadstone). Ra's al Ghul and Henri Ducard initiate Bruce into the super-vigilante group the League of Shadows. When Bruce is told to execute a man and is informed of the League's plan to destroy Gotham, Bruce escapes, and in his battle for freedom, his surrogate father, Ra's al Ghul, is killed. If we didn't get the point, he will be an instrument of his surrogate, vigilante father's death again, when he refuses to save Ducard (who is revealed as the real Ra's) at the end of *Batman Begins*. In the decisive battle of *The Dark Knight Rises*, Ra's al Ghul's heir will infiltrate Gotham in order to complete her father's work.[19] One father's moral legacy confronts another, the vigilante against Aristotle's virtuous patron of the city.

Apart from the final sacrifice of Batman to Talia's nuclear bomb, there are earlier indications that Batman will have to be sacrificed to his father's legacy and the good of Gotham. At the end of *Batman Begins*, Rachel expresses her love for Bruce and her respect for Batman, but she is clear that she will not begin a romantic relationship with Bruce until Batman is no longer needed in Gotham. Presumably, the path of a romantic relationship between the two will be to maintain Wayne Manor and the family's

19. Talia al Ghul's double identity, as Miranda Tate, sets up a potentially tragic, Oedipal-esque situation where Bruce unknowingly beds the daughter of the surrogate father who he has slain. Miranda, of course, knows what she is doing.

patrician duties in the city. *The Dark Knight* concludes with the symbolic sacrifice of Batman (i.e., the sacrifice of the Batman as a symbol of good). The sacrifice is set up by a momentary victory in the battle for Gotham's soul. The Joker has failed to set a shipload of Gotham's good citizens against a shipload of prison inmates. He intended to force one group to choose (by triggering a bomb) to annihilate the other. As the two groups weigh the choice to kill or be killed, Batman battles the Joker, gains the upper hand, and eventually saves the Joker from falling to his death. When the Joker proposes that their antagonism will be interminable, Batman declares victory: "This city just showed you that it is full of people ready to believe in good." The Joker counters, "Until their spirit breaks completely, until they get a good look at the real Harvey Dent." At the conclusion of *The Dark Knight*, Batman's honor will be sacrificed to preserve Dent's reputation as the "white knight" of Gotham.

It is ironic that, in the climatic sacrifice of Batman in *The Dark Knight Rises*, Bruce is freed, not to take on his father's role and duties in relationship to Gotham, but to be free for a private, non-patrician life. In the closing scenes, we find Bruce and Selina a thousand miles away where no one knows him as the prince of Gotham. Wayne Manor becomes an orphanage. It is conceivable, in contrast to the end that we have, that we could have seen him and Selina setting up house in Wayne Manor as they welcome orphans into their family. This kind of end would have provided symmetry: the orphaned boy would be surrogate father to orphans, and as father and guide, he would teach them a sense of justice, like his father and unlike Ra's al Ghul. This symmetry would also fit for Selina Kyle, who broke out of a juvenile correctional facility at sixteen years old. But instead, a new beginning for them is framed by a private table for two in Florence (their own little Renaissance). It speaks to the power of insular, romantic images in our culture that it is hard to notice the irony that Bruce is now free of social responsibility and the moral framework that otherwise holds Christopher Nolan's trilogy together.

4

Bella's Ascension

A key to both romance and action tales is that we—who are engaged in these stories—want the central characters to get what they want. We want Jason Bourne to uncover and destroy Treadstone; we want to see him with Marie in the end. We want Batman to save Gotham; we want Bruce Wayne to live an idyllic but ordinary life. We want Bruce to have it all. We want the hero to overcome obstacles that are set up within the narrative. However, the dramatic tension of the *Twilight* films is built largely out of our resistance to what the hero wants. She seems to want too much. For much of the films (perhaps all the way to the middle of the fifth film), we want Bella to grow up and change her mind. Her desires seem shortsighted (adolescent) and self-centered. Throughout the *Twilight* films, the question lingers: what happens when this romantic hero gets what she wants? In effect, the films present an unobstructed romantic drive that we, as audience, want to resist.[1] The saga sets out to convince us that the drive is right and its hero knows, intuitively, what she is doing. Through its elements of action, the *Twilight* saga gives us a victory of romance, that at first we do not want to admit, but in the end, we celebrate.[2]

1. We are willing to grant that this positioning of the audience is a basic difference between the book series and the film series, as the films attempt to reach a wider audience than do the young adult novels.

2. Dialogue and quotations in this chapter are gleaned from the DVD versions of the films.

An Unlikely Hero

Tragedy? Erich Segal's 1970 novel *Love Story* begins with these words: "What can you say about a twenty-five-year-old girl who died? That she was beautiful and brilliant. That she loved Mozart and Bach. The Beatles. And me." She dies; Oliver is broken, but love endures. In contrast, Stephenie Meyer's series of four novels, *Twilight, Eclipse, New Moon,* and *Breaking Dawn*, could begin like this:

> What can you say about a high school senior who died—because she was bitten by a vampire? That she loved emo music? That she became beautiful and powerful? That she loved a werewolf? That she loved a vampire more? That by being reborn as a vampire, in the end she got them both and everything else she wanted?

Without being too terribly facetious, it's easy to think of Bella as a petulant child who falls into every tar pit she can find, only to come out of all of her trials miraculously better, stronger, faster, and more in touch with herself and the world around her. The *Twilight* films seem to be deficient in misfortune and heartbreak—too much like a fairytale—a complete, teenage wish fulfillment.[3] We have nothing to want the hero to have. In fact, we would like to take something away.

As we (Blaugher and McCarthy) began working on our film project, we shared this perspective—that the story satisfied many of the romantic notions of adolescent teen girls, but couldn't possibly be considered in the same breath as Jason Bourne or Batman. It appeared to us that Bella's very petulance is what keeps her from achieving any sort of insight, understanding, or anagnorisis. Compare, for example, Jason Bourne's self-discovery when, having mortally wounded an assassin (the Professor), Jason learns that he is an assassin as well. He learns that his life was lived very much alone and that Treadstone will have his life too in the end. In contrast, *Twilight* gives us a high school girl, who feels alone (but is befriended by many) and is taken with an incredibly handsome vampire (who also doesn't "belong" in the high school). She longs to become a vampire, and in the

3. Another interesting facet of Bella's character is the level of "wish fulfillment" that happens in her bedroom. The teenage girl audience for the books and movies has to be clearly taken with her ability to summon beautiful boys to her bedroom at the drop of a hat. These boys confess things to her; they tell her things that, frankly, she already knows. At the same time, both Edward and Jacob are absolutely safe "bedroom partners" since a physical relationship between Bella and either of them is blocked—clearly something that calms the parents who have bought the books or taken the girls to the theater.

end, she discovers that she is right. She's a mopey, hormone-driven, flannel-wearing child of divorced parents, who daydreams of an immortal life with beautiful and sophisticated vampires. How could a character like this one be anything more than a simple stereotype, skillfully crafted to elicit maximum emotional response from readers and audience members, but, in the end, not terribly deep or complex?

It is not difficult to argue that the movie is juvenile, not necessarily bad, but immature by design. We could note that the seventeen-year-old Bella Swan is being played by then seventeen-year-old Kristen Stewart, suggesting perhaps that, as far as Hollywood is concerned, the emotions of a seventeen-year-old girl can be best re-created by a seventeen-year-old actor. Consider Roger Ebert's analysis.

> Come on now, what is "Twilight" really about? It's about a teenage boy trying to practice abstinence, and how, in the heat of the moment, it's really, really hard. And about a girl who wants to go all the way with him, and doesn't care what might happen. . . . If there were no vampires in "Twilight," it would be a thin-blooded teenage romance, about two good-looking kids who want each other so much because they want each other so much. Sometimes that's all it's about, isn't it? They're in love with being in love.[4]

We could note (as Ebert does later in the review) that the movies have a ready-made audience, "16-year-old girls and their grandmothers" who are already members of Team Jacob or Team Edward, having read the books. We could note that along with most critics suggesting that though the movies were shallow, they also suggest that the source material lacked depth as well—Stephenie Meyer's novels.

Twilight carefully follows the formula of a teen romance. Consider Bella's first words in voice-over: "I've never given much thought to how I would die. But dying in the place of someone I love seems like a good way to go." We then see a young deer, running from an unknown pursuer. Occasionally we see a figure that is not the deer, and finally we see a human-like figure tackle the deer. The audience then hears Bella again in voice-over, explaining why she is moving from the desert southwest into the mist of Forks, Washington. If we weren't aware that this is a vampire movie, what we see is the traditional awkwardness of a split family in a teen movie or young adult novel. Bella has been taken out of an environment with which

4. Ebert, "Twilight."

she is familiar, and her anxiety about living with her father is obvious and palpable.

The anxiety increases as we see her first day at her new school. The beat-up pickup truck that Charlie bought her as a homecoming present is out of place, even in the small town of Forks. The student body (at least the students we see) all know that Bella is the "new girl," appealing if only because she's different. Nevertheless, Bella is taken in by this small group of new friends.

It's lunchtime when we are introduced to the family that Bella will eventually embrace—the Cullens. It's a set piece right out of every romance novel and teen movie, as the Cullen "children" enter the cafeteria, complete with music, in slow motion, and with appropriate backstory. Finally, Edward gets his entrance, complete with close-ups, as Bella and Edward furtively glance toward each other. The signals are obvious to any even partially seasoned moviegoer—those two will fall in love.

At first glance, we saw only a standard teen movie formula, but then we watched the movies carefully and repeatedly. We could go into detail about our "transformation," as we slowly began to warm to the characters and the idea. In short, however, we can say that the heart of the movie's depth is that the order of the world is at stake. At second glance, it might seem that the teen romance is simply layered with the teen horror film, as vampires lurk in the shadows. But some vampires, we learn, struggle to become good people. Roger Ebert notes that "[Bella] is, like many adolescents, a thanatophile."[5] She is driven, sexually, to death. There is no question; Ebert is right. But what Bella finds in death is a struggle to live a good life, to be noble and compassionate, to foster life and protect it. She finds questions and struggles that she is too young to understand.

The Cullens, from the start, are a mystery not only to Bella but also to us—given our well-formed expectations for vampires in film. Even if audience members are not aware that the Cullens are vampires, the scenes of high school life are intercut with scenes of some degree of menace, as we see a marauding gang of three attack various fishermen and workmen and we hear the legend of Jacob's Quileute tribe and their cautious truce with the "ancestors" of the Cullens. From this point on, the audience is pretty clearly allowed to separate the "good" Cullens from other, more violent, more evil vampires that exist in this world. Although we don't immediately learn why the Cullens can be "good" vampires, every piece of information

5. Ibid.

we get about them shows or tells us that they are something more than what we have traditionally learned to expect from the undead.

Eventually, we see that the Cullens represent the possibility of wholeness, unity, and enduring love—not an adolescent love, but an arduous struggle of fidelity to others and the world and to becoming the kind of person who can love in such a way. Edward claims to be soulless, and repeats to Bella his worry that if she were to be a vampire she would lose her soul. (As a teenager she says that she doesn't care.) This horror of soullessness is sad, but we see the opposite. The patriarch, Carlisle, is a well-respected doctor. Edward has already taken on the role of Bella's protector, very early on saving her from serious injury in the high school parking lot. The town sees nothing odd about the Cullens' predilection for avoiding sunlight, accepting the story that they go hiking or camping when the weather is good. The ruse works because everyone knows that the Cullens are devoted to each other. The Cullen vampires are not only attached to each other, as family, but paired up, except for Edward. (As family, they lack one member.) Their lives are integrated with nature and to the world around them. They even hunt as members of a natural food chain. Although they have a natural desire to consume and destroy people, they successfully live in peace—more than peace, as Carlisle is a healer. Whatever the metaphysical state of their souls, the Cullens are soulful and spiritual. They are compassionate, reflective, self-critical, and wise. If Bella's teenage longings are bodily, the Cullens represent transcendent desires. They are virtually gods.

So, if from the first beats of the film, Bella and Edward seem destined to connect, and if the two of them follow many of the patterns of behavior that we expect from a "teen movie," there is still more at stake—not simply their beauty and bodily desire, but a quest of the soul. Edward runs away from Bella. She pursues him. Other students ask her out, but she only has eyes for Edward. He tells her that he's bad news; she denies that he could ever be bad, although everyone knows that the bad ones are attractive.

Bella: You know, your mood swings are kinds giving me whiplash.

Edward: I only said it'd be better if we weren't friends, not that I didn't want to be.

Bella: What does that mean?

Edward: It means that if you were smart, you'd stay away from me.

Bella: Okay, well, let's say for argument's sake that I'm not smart. Would you tell me the truth?

Edward: No, probably not. I'd rather hear your theories.

Bella: I have considered radioactive spiders and Kryptonite.

Edward: That's all superhero stuff, right? What if I'm not the hero? What if I'm the bad guy?

Bella: You're not. I can see what you're trying to put off, but I can see that it's just to keep people away from you. It's a mask. Why don't we just . . . hang out?

Interesting that, in the combination of movies covered in this book, Bella refers to the "other side" of our examination—superheroes. It is even more interesting that Edward refers to himself as the "bad guy," as if he is still in the "vampires are bad" world in which most of us live. It is Bella who sees him as something other than bad, as a potential friend, as a tortured soul, as a possible mate. Although Bella seems adolescent, could it be that her attraction to Edward comes from within her, from an innate wisdom about who he really is; not merely a handsome and mysterious teen, not mere vampire, but something far more.

Bella, as well, is more than she at first appears. As *Twilight* progresses, it falls into a rhythm of alternation between traditional "teen movie" scenes and scenes of gothic vampire behavior, with Bella clearly the intersection between the two. Indeed, if the vampire element was removed, and this was only a teen movie, Bella would be the "new and different" girl who causes everyone to see their friends and families in new ways. She moves to Forks in the first place because she wants to give her mother freedom to travel with her new love. She plays matchmaker for her human friends. She acts as homemaker and housekeeper for her father. She is clearly a catalyst for change in the human world. It is her ability to catalyze and change the vampire world, however, that drives the primary plot of this movie as well as the succeeding ones. Bella brings new visions and new blood (pun most definitely intended) to all of her relationships.

Bella is undoubtedly a hero, but an unlikely and exasperating one. She is exasperatingly adolescent; she cannot articulate what she wants and yet she is driven by intense longing. She appears to be a victim of her unformed desire. She wants what isn't good for her, and when she can't have it, she is miserable. These convoluted and seemingly ill-formed desires are the site for a set of psychic and spiritual battles. By contrast, in *The Hunger Games*,

Katniss Everdeen is also plagued by teenage, romantic indecisiveness. But this annoying element of her character is mitigated by the fact that she hates the Capitol, goes into battle in the Hunger Games, seeks revenge for the killing of Rue, and kills (or wants to kill) bad people. Jason Bourne is the victim of an identity crisis, but the crisis is met and complemented by his expertise in intelligence gathering and killing. Likewise, the wounds of childhood trauma form the internal structure of Nolan's Batman trilogy, but we are able to enjoy his weaponry and martial arts. Love is mixed with hate. With Bella, we have only longing and love. She neither fights nor hates nor seeks revenge. Her weapons and victory are purely romantic. The loving individual and love and nature stand together against the powers of the world.

Weapons of Love

The mess of romance—the barriers to and inscrutability of love—is the main challenge for the heroes of *Twilight*. Among the various intersections of relationships—families, high school friendships, fatherhood, community—the relationship that is most important, of course, is the one that is blossoming between Edward and Bella. During the trip to Port Angeles, when Bella is accosted by the gang of boys and Edward saves her, we see one of the most important facets of the bond building between them—that despite the fact that Edward can read minds, Bella's mind remains closed to him.

Edward: And then you . . . nothing.

Bella: Is there something wrong with me?

Edward: See, I tell you I can read minds, and you think there's something wrong with you.

Bella: What is it?

Edward: I don't have the strength to stay away from you anymore.

Bella: Then don't.

Finally, with the help of a book and the Internet, Bella puts the pieces together. She confronts Edward with the truth of his identity in the first of many scenes that occur in the primeval forest that is conveniently available whenever the two of them need to be alone. It is important to note that,

even in this particular fantasy world, the reactions that each of them have to the other run counter to what the audience expects. She is unafraid of him; in fact when his diamond skin is revealed in the sunlight, she calls him beautiful. He is afraid of her, afraid of his inability to read her mind, but even more importantly, fearful of what he might do if he succumbed to the passion welling inside of him.[6]

As their relationship develops, it is very important to note how chaste their relationship is. Again, in a typical teen movie, the two lead characters would be driven by their inherent sexuality to attempt to consummate their relationship.[7] When they meet in Bella's bedroom (Edward confessing that he's watched her sleep for the past few months), there is an expectation on the part of the audience that this is the moment that they will finally give in to one another. However, although Edward and Bella display depths of passion and desire, at this point we are led to believe that any physical consummation would result in Bella's death. This plot device requires that Bella remain a child in two senses. First, she remains a virgin, and second, she is heedless to the consequences of a sexual relationship. Edward is the adult who worries about consequences. He cannot lose control, despite Bella's clear readiness to do the deed (and there are still four-and-a-half movies to go).[8]

Once James, the "tracker vampire," has caught Bella's scent, we see another facet of Bella's character that will continue to grow through the course of all five movies. Edward and the rest of the family have what seems to be a "standard operating procedure" when confronted by other vampires—retreat and cover their tracks. Despite the threat to her own life, however, Bella insists on going to her home and protecting Charlie before she protects herself. This concern for others—this empathy that Bella continually displays—is a central part of her character as a heroine. She consistently thinks about the impact of her actions on others. She acts instinctively, but always with a sense of protecting other people.

6. On this point, we can't help noting that we, the audience and critics, are the ones who have an innocent view of love. Edward worries that succumbing to passion will lead to consequences neither he nor Bella can handle. In our moviegoing romantic frame, we know things are different—passion always leads to good things. Who is being unrealistic here?

7. Depending on the MPAA rating, that consummation might happen more than once, or might have to wait until the end of the movie.

8. In *Twilight*, when Bella brings Edward to meet her father, he's cleaning a shotgun.

Bella is on the run. She will end up in Scottsdale, Arizona, where James will find her and we finally see the battle of vampires, good and bad. As Bella is leaving her house in Forks, it is clear in hindsight that this escape begins her path toward the complete union with Edward that is the ultimate culmination of the story. She leaves her father for his protection. Yet, at the same time, she is actually beginning to break away, telling him that the life he leads is not the life she wants. "Same people, same steak, same berry cobbler every night? That's you, Dad. Not me." She tells Edward that the words she used were the words that her mother used when she left her father. As they drive, they pass a small café as her human high school friends are leaving. Bella may not know the path that she is on, but she knows that the life she led is gone.

Love leads Bella away and carries her through. She appears to be ill-equipped to survive and foolishly puts herself in harm's way. Cornered by James, and with James threatening her mother, Bella escapes from Alice and Jasper, going to her old ballet studio to confront him. It is there that we hear again what Bella said at the very beginning of the movie, "I've never given much thought to how I would die. But dying in the place of someone I love seems like a good way to go." In this case, it's her mother who she is protecting—just another instance of Bella disregarding her own safety to protect another person. The climactic moment of this first movie is yet again another instance of Bella's character being the means through which we see changes in expected behavior. James has bitten her, and as Carlyle says, they could let the transformation occur and Bella would become a vampire. It is as much to prove his love for human Bella as it is a test of his own will that Edward sucks James's venom out of her arm—another case of the love between them changing both of them.

Twilight ends at that quintessence of set pieces for teen movies, the high school prom; however, it is clear that Edward and Bella are no longer part of that world. Despite all the celebration and joy, Edward and Bella seem out of place and uncomfortable. After a quick trip through the ballroom, they make their way outside to a beautifully decorated gazebo. There, Bella tells Edward what the audience certainly already knows—that she wants to be with him regardless of the cost to her. She loves him so thoroughly that the transformation into vampire is a necessary sacrifice. She would give up her humanity to be with him. Edward hesitates, and persuades her to maintain the status quo. We have four movies to go, and more to learn about the vampire world. At this juncture (like Edward removing James's

venom from her), Bella's transformation would be about only her and her love for Edward. We have to learn that Bella's life as a vampire will be for others; it will mean a transformation for the Cullens and new possibilities in the vampire world.

The second movie, *New Moon*, expands the vampire world as well as the supernatural world around Forks, Washington, as we are introduced both to the werewolves of the Quileute tribe and the ruling clan of vampires known as the Volturi. Before we see werewolves or vampires, however, we see a reiteration of Bella's problem. She's getting older (all of 18), while Edward admits to being 109. Her aging is haunting her dreams (she dreams of herself as an old woman while Edward remains the same), and so it is not surprising that she doesn't want to broadcast the fact of her birthday. We also see a further development of the split that the movies develop between Edward and Jacob, when Jacob brings her a small dream catcher as a birthday present, while Edward complains that he was not able to get her a present.

Certainly more serious than the Bella-Edward-Jacob triangle that comes straight out of teen movies are the growing complications inherent in the growth of this relationship between human and vampire. Even in Meyer's "vampire cosmology," the human world and the vampire world exist in a very tenuous relationship. When Bella cuts herself at her birthday party at the Cullen home, initiating Jasper's bloodlust and the scuffle that leads to even more of Bella's blood being spilled, the explanations regarding vampire life that we hear from Carlyle invert our expectations. As a doctor, Carlyle, even though he's a vampire, has dedicated his life to helping people—humans who are normally vampire prey. He puts it this way: "[helping people] brings me happiness, even if I am damned regardless." Bella responds that he couldn't be damned, that his damnation would be "impossible." He acknowledges Bella by saying "you've always been very gracious about us." This talk of damnation and grace between a vampire patriarch and a young woman who, up to this point, has displayed no particular religious proclivities, would be absurd in any traditional fantasy. In the world of the *Twilight* Saga, however, it makes perfect sense for Bella to be the character dispensing grace to a family of the most soulful vampires one could imagine.

Supernatural Love

Bella is more convinced that she is meant to be a vampire than she is of marrying Edward (which also is forever). She wants to be a vampire; he wants to marry her. She resists him; he resists her. The two sets of desires compete for priority, and for most of the plot line, Bella's desire is cast as immature. Edward is clear-headed and wise. He wants the best for Bella, while Bella seems to want to risk her life needlessly. Her quest for immortality seems so immature that it is inconceivable that her transformation into a vampire could be a gift and a grace. But it will be in the end. Bella will be instrumental in giving to the Cullens and the vampire world a deep connection to growing and expanding human loves. Despite their superiority in clear physical and even spiritual ways, the Cullens long to be like us; to live and to grow. For them, Bella links her natural love with the supernatural world and in the process quenches a supernatural longing.

Throughout the *Twilight* Saga, we know what is at stake: Bella's soul. In *New Moon*, when pressing Edward to change her into a vampire, Bella seems to have figured out, at least in a small sense, why Edward will not do it. Carlyle asks her to think about what she would do if she was in Edward's position—"if you believed as Edward does, could you take away his soul?" We hear the following conversation when Edward returns Bella to her home.

Bella: You can't protect me from everything. At some point, something's gonna separate us. It's gonna be an accident or an illness, or old age, as long as I'm human. And the only solution is to change me.

Edward: That's not a solution. That's a tragedy.

Bella: You're not gonna want me when I look like a grandmother.

Edward: Bella, do you not understand my feelings for you at all?

Bella: Carlyle told me how you feel about your soul. I don't believe that. So don't worry about mine.

Edward: You should go inside.

Bella: It's still my birthday. So can I ask one thing? Kiss me?

Whether in a teen movie or the *Twilight* Saga, the kiss between Bella and Edward that follows is filled with passion and desire. The scene ends exactly as we expect it should. Both say, "I love you." Of course, because we

must maintain the tension between the two characters, the scene of their breakup follows close behind. It is significant at this point only to note that Edward says (although he clearly does not believe) that Bella is not part of his family, because that seems to be the piece of evidence that allows her to believe him, even if only for the time it takes him to leave.[9] Bella slips into a near catatonic depression that, at this point in the saga, appears to be only tedious, exaggerated, and melodramatic teenage angst. Only in *Breaking Dawn* can we look back and see (although, perhaps, still not excuse the histrionics) that Bella's soul—the purpose and meaning of her life—had been lost from view.

Edward's absence eventually leads Bella to Jacob, and the rebuilding of the motorcycles is clearly a metaphor for Bella's rebuilding of trust in others. Unfortunately for "Team Edward" fans, this friendship also builds the relationship between Bella and Jacob. As she says, when she's with Jacob, the hole in her chest feels like it is closing. In Meyer's intricate plotting, vampires and werewolves are natural enemies. For instance, Jacob tells Bella that the only beings that werewolves do kill are vampires. He also says that werewolves only exist when vampires are in the area. Therefore, at this point in the story, the entire Forks, Washington region is a battleground between two ancient supernatural groups of beings, and, due to her relationships with Edward and Jacob, Bella is squarely in the middle of that battleground. At this point, it looks as though Bella's well-being—despite her own wishes—rests with Jacob.

But Bella refuses to commit to Jacob, and she certainly cannot commit to Edward. She seems stuck in a self-imposed limbo between the opposing forces. Jacob has a carnal nature, exactly what Edward lacks. Jacob is "of nature," Native American (as the film stereotype goes), often shirtless, undomesticated. Edward is sophisticated, always dressing in a highly fashionable way, and domesticated in an organic setting worthy of Frank Lloyd Wright's organic architecture. However, Edward not only lacks a human bodily nature, but also, to be with Bella, he needs to fight against his one, dominating carnal desire. Jacob is at ease with nature; he represents the battle of human nature against the vampires. Indeed, both Jacob and Edward live a supernatural existence, but one that is opposed to the other.

9. Edward's departure brings about one of the longest sequences of "teenage funk" in recent film history. Bella becomes lost in the woods. Bella stays in her room through at least two seasons, emerging only for a "girls' night" in the spring, where her funk leads her to a motorcycle gang. At least in this scene we discover that some sort of "ghost Edward" is protecting her.

At this point in the saga (*New Moon*), we are led to believe that Bella is torn between their supernatural opposition. In the end, we learn that she is meant to bring them together.

This unity appears to be deadly and is deadly for everyone but Bella all the way to the end. The scene in *New Moon* in which Bella searches for the meadow that was the "special place" that she and Edward shared is fraught with peril. First, the meadow is brown and lifeless, as opposed to the flower-filled green space that she imagined it would be. Second, she confronts the vampire Laurent, who has come to kill her for Victoria. Finally (and again just in a moment of real peril), Bella is miraculously saved, this time by the pack of werewolves. It's here that she recognizes that one of the werewolves is Jacob. At this point, it appears that Jacob is her only hope of avoiding the deadly menace of vampirism. As Bella is drawn further into the supernatural world, she becomes more and more comfortable as a warrior; more and more comfortable in the center of things. Initially, her naïveté seems to simplify what for the vampires and the werewolves is eons of conflict. At this point, it's pretty clear that she doesn't yet understand the power that she will eventually have. Nevertheless, when Alice shows up at her house, it's clear that Bella negotiates the "truce" between Alice and Jacob.

Woven into the conflict of supernatural force is teen romance. Edward's misunderstanding of the telephone call, and his assumption that Bella has died, finally, in *New Moon*, gets us out of the fog of the Pacific Northwest—and takes us this time to Italy and the Volturi.

Bella: I had to make you see me once. You had to know that I was alive, that you didn't have to feel guilty about anything. I can let you go now.

Edward: I never acted out of guilt. I just couldn't live in a world where you don't exist.

Bella: But you said . . .

Edward: I lied. I had to lie. But you believed me so easily.

Bella: Because it doesn't make sense for you to love me. I mean, I'm nothing. I'm human. I'm nothing.

Edward: Bella, you're everything to me. You're everything.

Bella and Edward exchange a long lingering kiss in close-up. The music swells. He's shirtless. What mortal girl could want more? Except of course at this point, she really isn't a mortal girl any longer—as the romantic moment

has cosmic implications—as Bella is drawn into the punishment and torture that the Volturi are planning for Edward (and by way of representation, the Cullens and what they embody). Their romantic love is fixed amid the battle of unseen, supernatural forces—principalities and powers—that exert a potent yet hidden force upon the world.[10]

We should not be surprised that the girl who confounds our expectations at every turn does so again, as she is immune to the Volturi's powers. We should also not be surprised when she offers herself as a substitute sacrifice for Edward. Alice has foreseen Bella's eventual transformation. (We see it as another scene of natural beauty with Edward and Bella running free in the forest in Washington.) For our purposes, however, the fact that she is willing to sacrifice her life for Edward's is of prime importance, for it is a clear image of the hero sacrificing herself for love. Even though Aro speaks of vampires being "soulless monsters," Bella's claim that he knows nothing of Edward's soul is clearly more persuasive. Despite the fact that the next moves in the plot surround the necessity for Edward to transform Bella, it is at this point that the eventual outcome is clear—Bella and Edward are simply fated to be together—forever. What is unclear at this point is how Bella's eventual transformation will continue to change the supernatural world.

The final scenes of *New Moon* give us a glimpse of some of those changes. Jacob, Edward, and Bella meet in the woods, and begin to negotiate a new "treaty." The central condition of the old treaty is that the Cullen vampires cannot hunt humans in the Quileute forest. If they do, the treaty is broken. Obviously, if Edward bites Bella, everything would come crashing down. When Bella confesses to Jacob that, even if she loves him, she loves Edward more, she has laid it out to the two of them (and also to us) that the bond that she shares with Edward is unbreakable. From that point forward, the only things that remain as any sort of roadblocks to Bella's eventual transformation and transfiguration are, remarkably, things that reflect the human traits that all of Meyer's supernatural beings have—like souls and moral centers and "old-fashioned" notions about marriage.[11] The Cullens actually vote on Bella's change (which passes with only Rosalie's negative vote). It's hard to imagine that a group of vampires would *vote* on changing

10. Consider Ephesians 6:12 (King James Version): "For we wrestle not against flesh and blood, but against principalities, against powers, against the rulers of the darkness of this world, against spiritual wickedness in high places."

11. Clearly, Edward's insistence on marriage before "changing" Bella is a reflection of his moral code. It's refreshingly old-fashioned—perhaps we could say eternal—in terms of traditional notions of natural law (which is a divine ordering of human ends).

a human into a vampire, but this is just another example of how Bella is changing the world.

Metamorphosis

The third movie in the series, *Eclipse,* continues to balance the "real" world with the supernatural. At the same time that a gang of homegrown vampires is terrorizing Seattle, Bella and Edward are discovered back in their meadow—which is once more covered in flowers. Their discussion—Edward insisting on marriage, and Bella insisting on being changed—has continued from the end of *New Moon.* They've made a bargain that Bella will not be changed until after she graduates from high school, although clearly Edward wants the commitment of marriage. Meanwhile, Jacob and the rest of the werewolves are protecting their land from Victoria the vampire. Bella's quest for Edward's love threatens to fragment her world. The world that is present and real hangs in the balance as she lingers on the threshold of change.

Eclipse, being the central movie of the series, has at its core what we could argue to be the eventual resolution of the Bella-Edward-Jacob triangle. We learn early on that Jacob has not imprinted on anyone yet (imprinting being the way that werewolves pair off for life), so there remains a possibility, however small, that Bella might reject Edward for Jacob. Edward, on another hand, is clearly hesitant about transforming Bella into a vampire. It's as if he does not want to take her humanity away from her. While most vampires value humans as food, the Cullens value human life itself. The looming war between vampires is about how each part of the vampire world relates to the human world. Once the threat of the gang of vampires in Seattle begins to be discovered, the werewolves and vampires begin the uneasy alliance that will eventually be resolved at the end of the entire story. The alliance between Jacob and Edward, between carnal wolves and ascetic vampires, has at its heart the common cause of protecting Bella, who is now the center of both supernatural universes. The alliance itself puts each group on the threshold of radical change.

At this juncture, we begin to learn a little bit more about the other vampires in the Cullen household. Rosalie's story, in particular, gives us some insight into her "No" vote in the previous film. She tells Bella that, after Carlisle transformed her into a vampire, she took revenge on the men who had raped and beaten her nearly to death. Even though the transformation

"saved" Rosalie from a human death, from that point forward she was "frozen," with no possibilities for any traditional future—one that would be unknown, unexpected, and open to the future. Rosalie is trapped, set apart (like a god) from change in the world. If we knew at this point what we know at the end of the *Twilight* Saga, we would recognize that one of the things that Bella gives the vampire world is a sense of possibilities for the future. In a world of eternal return, Bella will be the matrix of progress and growth. Now, however, Bella's future is couched in the same terms as Rosalie's—frozen, unmovable, with no hope of change or an ability to improvise. Every day would be essentially the same as the one before. This is the fear that Edward has, and why he doesn't want to change her. The audience sees this in direct opposition to the future she could have with Jacob—flesh and blood, warmth and even heat, a full and wholesome passion.[12]

When Edward and Bella are alone together at the Cullen house, Bella attempts to renegotiate the terms of her promise to Edward. On one hand, it seems like a very typical "teen movie" trope—teenagers alone, no one else in the house, and the possibility of sex is right in front of them. Edward knows, however, what we discover later on: that sex between a vampire and a human can be life-threatening to the human. Again Bella is the instigator, while Edward holds back. In love with a chaste vampire, we have the best of teenage film romance—dangerous and forbidden love (with a vampire) *and* also the safety to feel and express desire without limitation. Finally, with Edward maintaining his very old-fashioned and traditional rules of courtship, he presents Bella with a ring and proposes again. This time, she accepts. This exasperating contradiction between forbidden romance and innocent, virtuous love is more than a means to gratify Bella's teenage wish fulfillment. It is the victory of love, a full love, where eros (Bella's wanting) meets and is fulfilled in Edward's agape (his giving, sacrificing love).

This same love wins out between Edward and Jacob. As *Eclipse* moves toward its climax, a scene that displays the shifting Bella-Edward-Jacob relationship is their interaction prior to the battle, when they've hidden Bella on top of the mountain. It seems almost laughable, but the vampires and the werewolves apparently forgot that Bella wasn't impervious to the weather. In their defense, nature has been almost entirely amenable to Bella's needs up until this point. Their (werewolves, vampires, and Bella's) connection to nature has been as romantic as the love triangle. Nature,

12. Change is also the point of Jessica's commencement speech; that for the graduates, the future has yet to be written.

during the mountaintop scene, is as contentious as Edward and Jacob. The testosterone-fueled conflict between them to keep Bella warm is almost comical. More importantly, however, it clearly shows the growing trust between Edward and Jacob, a trust that is obviously centered in their love and concern for Bella. She is both the source and the test of love.

The next morning can be seen as one of the defining moments of the relationship between the three main characters. Immediately before the battle, Bella has a chance to be alone with both Edward and Jacob, as if she is testing the strength of the bonds between both men and her. Bella demands that Jacob kiss her. The scene is full of ridiculously traditional romantic imagery—close-ups of two beautiful performers kissing, intercut with longer shots where their forms are seen against gorgeous mountain scenery. Coupled with the swelling background music, the audience might expect Bella to "come to her senses," realizing that the life of a vampire is not what she wants. When she returns to Edward, however, we get the clearest definition of their relationship, spoken in simple monosyllables:

Bella: You saw . . .

Edward: No, but Jacob's thoughts are pretty loud . . .

Bella: I don't know what happened . . .

Edward: You love him.

Bella: I love you more.

Edward: I know.

Despite all of the complications in their relationship, simply put, Edward and Bella love each other. It is a sentiment that can't be argued, can't be torn down, and can't be denied. And somehow, Jacob belongs in the middle of it.

Love is the epic struggle; it has a larger-than-life purpose. It is about Bella's destiny, and more than that. The battle on the mountaintop between Edward, Victoria, and Riley is a mirror image of the legendary battle between the Quileute and the "cold ones," where the wife of the Quileute chief sacrificed herself to save the tribe. Here, Bella does exactly the same thing, cutting herself to enrage Victoria and Riley, and allowing Edward to gain the upper hand. The final scenes of the movie very clearly depict the parameters of the relationships. Despite Jacob's pleas from his sick bed, like his insistence that he will wait for her until her "heart stops beating," as well

as her acknowledgment of her love for him, the last scene puts Edward and Bella together in their meadow.

Edward: August 13?

Bella: Yeah. It's a month before my birthday. I don't need to be another year older than you. Alice said that she could get the wedding together by then.

Edward: I'm sure she can. There's no rush.

Bella: It's my life. I want to start living it.

Edward: And so you're gonna let Alice plan the whole thing? I mean . . . who knows who she's gonna invite?

Bella: Does it matter?

Edward: I just don't know why you're doing this.

Bella: What? The wedding?

Edward: No—you're trying to make everyone else happy, but you're already giving away too much.

Bella: You're wrong. [She is standing and walking away from Edward.] This wasn't a choice between you and Jacob. It was between who I should be and who I am. I've always felt out of step, like literally stumbling through my life. I've never felt normal. Because I'm not normal. I don't want to be. I've had to face death and loss and pain in your world, but I've also never felt stronger and more real, or myself. Because it's my world, too. It's where I belong.

Edward: [smiling] So it's not just about me?

Bella: No. Sorry. I've made a mess trying to figure this out, but I wanna do it right. And I wanna tie myself to you in every way humanly possible.

Edward: Starting with a wedding.

Bella: Actually, something a little more difficult first. And maybe even dangerous. We have to tell Charlie.

Edward: It's highly dangerous.

Bella: It's a good thing you're bulletproof. I'm gonna need that ring.

[Edward places the ring on Bella's finger, and the camera
pulls back to reveal them in an embrace; the credits roll.]

It's here that we see Bella's recognition of her rightful place in the super-
natural world. As she says above, she has always felt awkward and out of
place in the real world. Spending eternity with Edward gives her the chance
for a relationship and a life that she's always has understood, if only subcon-
sciously, was available to her. Loving Edward is the fulfillment for Bella of
her true place in the universe.

A New Way in Cosmos

We can easily belittle Bella for her adolescent sentiments and innocent no-
tions of love. Certainly, the *Twilight* Saga has exasperating moments of teen-
age angst. As a teenager, Bella is utterly convinced of decisions about love
and her future that appear irresponsible and self-destructive. The series of
films is clearly oriented to young viewers in the sense that the hero's teenage
decisions always turn out to be right. There is more to the films, however,
and more than just young people have been captivated by them—witnessed
by over three billion dollars in sales worldwide.[13] The wider appeal of the
Twilight Saga, we propose, is that, when all is said and done, we want what
Bella wants: to find our place in the world, to find a place that fosters family
life and a wider set of relationships in community. Further, Bella achieves
these good goals of life not by violence and enmity, but by becoming who
she wants to be, by loving and looking out for the good of people we love.
In short, Bella has a purpose that connects her life to the order of things.

In making this order-of-the-world connection, the fourth and fifth
movies in the series, *Breaking Dawn, Part 1* and *Part 2*, finally move the au-
dience out of the mundane world and into the supernatural. In a voice-over,
Bella muses that "Childhood is from birth to a certain age. And at a certain
age, the child is grown and puts away childish things."[14] Of course, *Breaking
Dawn, Part 1* begins with all of the *tsuris* attendant upon Bella and Edward's
wedding. Jacob is upset; Charlie is nonplussed. Renee seems vindicated;
Alice is wrapped up in wedding planning, and Bella's feet hurt, thanks to
Alice's choice of shoes. On the night before the wedding, when Edward

13. "Box Office History for *Twilight*."

14. The beginning of a poem, titled "Childhood is the Kingdom Where Nobody
Dies," by Edna St. Vincent Millay.

again shows up in Bella's bedroom, she reminds him of the truth of his character—that he is a person "capable of courage and sacrifice and love." If we have ever had any doubts, we are now in a world where vampires not only have souls, but are as human as any of us, perhaps more deeply human in the sense that they have eternity to undergo the process of humanization.

If Edward is that kind of character, that character is someone who the audience wants to be. And, if the audience wants to be like Edward, they are clearly empathizing with a kind of character—a vampire—who, in many previous iterations, is nothing but a soulless killing machine. The fact that Bella is willing to forgive him all of his previous sins is clearly a sign of Bella's ability to change the supernatural world. Just like Julia Roberts's character in *Pretty Woman*, Bella makes her mate a better man. Indeed, at the wedding reception, Edward confesses, "I've been waiting, what seems like a very long time, to get beyond what I am. And with Bella, I feel like I can finally begin." If Bella's love can move a vampire beyond who he is, her power is great indeed.

From this point forward, we are no longer in the "real" world; from the honeymoon forward, everything that happens to Edward and Bella (and for that matter, all of the other characters) happens in the supernatural world.[15] At the time of the wedding, Bella's power is still not great enough to transform Jacob. When he shows up at the wedding, even though Edward has clearly shown him forgiveness (naming him as "best man"), Jacob's desires still drive his jealousy. Dreams intersect with reality. Wish fulfillment (Jacob killing Edward, for example) is discussed with the earnestness of any other fact. But all of this will change for Jacob through the very event he dreads most, the sexual union—a procreative union between Edward and Bella. Vampires mating with humans, creating new life, is clearly something that no one has expected—not Bella and Edward, not the rest of the vampires, not the Brazilian housekeeper. Edward even begins calling the fetus a "thing," a point not missed by Bella or the audience. Although we are entering into supernatural territory, the supernatural beings do not understand and even fear what is happening through Bella. In a typical horror film, the borders of the natural and supernatural are breached; the supernatural intrudes into and disrupts the human world. It cannot be controlled. In

15. The audience at this point also has to notice the physical transformation of Kristen Stewart. Seventeen when filming began on the first movie, when *Breaking Dawn* was filming, in 2001, Stewart was twenty-one, and was clearly maturing from a teenage girl into a woman. This transformation is evident throughout both of the *Breaking Dawn* films, and connects with how Stephenie Meyer describes Bella through the books.

Breaking Dawn, we witness the reverse. The supernatural is thrown into disorder by the intrusion of the human.

Bella's heroism comes through by allowing life to takes its course. It is not our intention to engage a pro-life/pro-choice debate here, but the way all of the characters react to Bella's pregnancy is very telling. The Brazilian housekeeper, after touching Bella's abdomen, says simply, "Death." But whose death? Even her connection to the legends of the past cannot help her see into the future. Edward's reactions, albeit as frankly harsh as they are, are in character if we consider that his primary focus has been Bella from the time they met. He certainly can't go back on his promises at this point; he must protect Bella from the "thing." Rosalie, who up to this point was most skeptical regarding Bella's worth, becomes her fiercest protector. For all of his reliance on modern medical science, Carlisle doesn't know what the baby is; as he says, this has never happened before. Even Alice's foresight can't see Bella's or this baby's future. Legends give them nothing to go on. Perhaps most importantly, not one of the other characters gives Bella a chance to survive the baby's birth. Bella is the only one with the confidence to continue the pregnancy. The character who doesn't know how she knows things knows more about her strength than the combined wisdom of legends, vampires, werewolves, and modern medical science put together. Bella simply refuses to put an end to generativity.

Most of Bella's story causes great consternation to her loved ones, but for us—the audience—her reaction to events follows a familiar trajectory. A very traditional love story is being told, in spite of its supernatural elements. For example, Jacob obviously has to leave the pack and become his own wolf—plainly a "lone wolf." The wolves obviously misunderstand the threat that Bella presents, and so not surprisingly, they stage another attack on the Cullen house. The plot—the "ordered sequence of events" (if we're being Aristotelian)—fits together in a way that is emotionally and viscerally satisfying, even if it isn't particularly intellectually stimulating. It is as if the way this particular story is being told to the audience is "critic proof," so to speak. We know that by this point in the history of these films, traditional movie critics have recognized this fact. We want to resist, but the narrative succeeds because it is "fitting."

The story fits with our deep hopes that our love makes a difference in the world. Not only does Bella's pregnancy redefine the audience's expectations regarding the human-vampire relationship, it also allows Jacob to see the Cullens with fresh eyes. Jacob's path through these movies has been to

some degree problematic, because once we realize that he is the "odd man out," there needs to be a reason for him to be a part of the story. Meyer's largest intended audience, the pool of teenage girls that are the linchpin of her success, know what Jacob's fate will be. A movie audience without that knowledge, however, at some level, has to be drawn into Jacob's role in the story. When he breaks with the rest of the pack of werewolves and begins to function as Bella's protector, he is literally disconnected from both of his previous families—the Quileute tribe and the werewolf tribe; a wolf without a pack. Seth and Leah breaking away from Sam and siding with Jacob begin to establish a part of Jacob's new family. It is his relationship with the Cullens, however, that must be redefined so that he can eventually take his place in the new order that will be established. Not surprisingly, it begins by Jacob protecting Bella, but it grows as he discovers the inherent humanity with which the Cullens have been imbued. As he says: "This really is a family. As strong as the one I was born into. . . . I know what I have to do." And the chivalrous knight takes his position in the forest, ready to defend his new family.

Love is victorious. On one level, the next major plot point is a little ridiculous. We've been led to believe that werewolves can only imprint on other werewolves, or possibly humans. When Jacob imprints on the newborn Renesmee (however overtly silly that scene might be), the new world order continues to develop. From Jacob's perspective, however, as well as from the audience's point of view, it is Jacob's reaction to the imprinting that is visually arresting. The protector knight kneels to his new lady love (despite the absurdity of seeing him kneeling to a newborn baby).[16] In fact, in voice-over, Jacob—while describing what imprinting is—says that he would do anything for her; that he would be "her friend, her brother, her protector." Is it surprising that he doesn't say "lover"? In the huge scheme of things in Meyer's supernatural world, probably not. Certainly Jacob has proved his worth as "protector knight." Perhaps Renesmee is a better candidate to be Jacob's future muse. Perhaps our "love focus" needs to be on Bella and Edward. Perhaps—but what is clear is that any type of romantic love or eros is eventually subsumed within the kind of self-giving love that Jacob's imprinting on Renesmee represents.

16. To add to the ridiculousness, perhaps, we learn soon after this that, once a wolf imprints, the person on whom the wolf imprints is eternally under the protection of the entire pack. As Edward says, "it's their most absolute law," which also is a great help in resolving Jacob's third wheel status in the plot. They now, in effect, can double date.

Although we have not to this point seen what happens when a human transforms into a vampire (at least from the point of view of the person transforming), the movie places Bella's transformation into the "life flashing before her eyes" category. We see a montage of scenes flashing back through this movie and the previous three movies, depicting high points in Bella's relationship with both Jacob and Edward. Perhaps more importantly, however, we also see scenes of Bella interacting with her parents. As the montage progresses, it moves back in time, and the final images before her heart stops are images of herself as a baby being held in the arms of her parents. It could be argued that this represents Bella saying goodbye to the human world, and finally becoming the vampire that she's always wanted to be. Given what we know about the character, however, it is more persuasive to suggest that Bella's transformation, and those last visions that she has, represent all of her relationships—past, present, and future. Also, all of these relationships represent her extended family. Bella is poised to become the "vampire matriarch" that is her eventual fate.

Breaking Dawn, Part 2 completes Bella's transformation, as well as the transformations that need to happen in the human world, the larger vampire world, and the werewolf world, as Bella reimagines the world on her own terms. That reimagining, however, does take a bit of time, and the first thirty minutes of the movie show Bella becoming accustomed to her new powers. Because she has just recently been transformed, her hunger is greater, her strength is greater, and her desire for Edward can finally be fulfilled to the level that they both always desired. Bella seems to have been born to be transformed into a vampire—which shows the audience a human being that has all that she ever wished for and more. But her transformation is about more than her own wish fulfillment. She is the medium for important changes in the world beyond.

Once she enters fully into the vampire existence, the renegotiations must then take place with the werewolf world and with the human world. The movie audience has yet to learn the full extent of Renesmee's power, so it is not surprising to see Bella place all the blame on Jacob for the new bond between her daughter and him, even as Jacob claims that the imprinting was unexpected for everyone.[17] Bella also has to renegotiate her relationship to her father Charlie. The Cullens expect to do what they've

17. In fact, this scene gives the audience one of the purely comic moments in all five films, when Bella is upset when she hears Jacob's nickname for Renesmee—"Nessie." To bring the Loch Ness monster into things at this point can only be seen as comic.

always done—to move away from Forks, thus hiding the fact that Bella has been transformed into a vampire. Interestingly, the renegotiation begins here with Jacob, and his transformation into his werewolf form in front of Charlie surely shows Charlie that there are more things on this earth than he can dream of knowing. When Charlie finally sees Bella again, and comments that Bella "looks like my daughter, but doesn't," the audience gets a sense that Charlie's love for Bella might be enough, at this point, to keep his questions at bay. More importantly, however, it is easy to see that Bella's love for Charlie not only keeps her thirst at bay, but is also a display of the new powers that Bella is bringing to the Cullen table. It would seem that paradise is at hand.

But because the whole *Twilight* saga is framed by romantic tensions, we know that paradise cannot come easy; challenges to unity are always ready to lay siege to the family. The Cullen cousin, Irina, sees Renesmee, and because of her own history, misidentifies her as an "immortal child," one of a type of vampire in vampire history—vampire children with unquenchable thirsts—who were more powerful than the vampires who had created them. Because the military were forced to intervene in the past, and because of Irina's misunderstanding, the Volturi come to America to kill Renesmee. In response, the Cullens travel the globe, recruiting "witnesses," vampire allies who, having witnessed Renesmee's true power, can attempt to persuade the Volturi of their mistake. It becomes clear quickly, however, that the Volturi are not interested in détente; rather, they have been looking for an excuse to rid themselves of the problem of the Cullens. As the Cullens' allies become aware of this fact, the battle lines become clearly drawn—the ragtag revolutionary Cullen vampires versus the old Volturi empire.

Bella is the center point. One scene in the movie that is expanded on in the book is the scene between Bella and J. Jenks, the human lawyer/fixer who Jasper has enlisted to create passports for Jacob and Renesmee. In the movie, Bella walks through a holiday decorated hallway on the way to meet with Jenks. In the book, Bella catches a reflection of herself in a shop window as she moves through this hallway. She stops, because she cannot believe that the woman who looks back at her is her. These moments, when the movie audience sees how Bella is maturing, both as a vampire and as a woman, are distinct indicators of the deeper nature of the change that Bella is experiencing. In all of her powers, she is becoming the correct mate for Edward, a loving mother to her daughter, and a formidable opponent to

the Volturi. As Edward says, Bella is the reason that all of the vampires are there to help them.

The climactic battle takes up nearly the last forty minutes of the movie; it's a battle that Stephenie Meyer chose not to put in her novel. At the time of the making of the "special features" portion of the DVD, Bill Condon, the director, acknowledged that the battle was placed in the movie to satisfy the movie audience. Simply having the Cullens and the Volturi discuss and negotiate their differences (as happens in the book) would not be enough. What the cinematic battle does allow, among other things, is for the audience to see exactly how Bella's "empathetic shield" is manifested during the battle. Upon discovering this impressive power, she seems almost disappointed that it is only a "defensive" one. However, when her family is threatened, she is the one who blocks the Volturi from killing a number of Cullens. For a moment she wishes that she had some aggressive weapon to offer, but her defensive "empathetic shield" is yet another occasion when Bella cannot help being who she is meant to be—a protector goddess.

The cinematic battle is satisfying, even if it is formulaic. Carlisle Cullen is the first to die in the battle, and Edward almost immediately takes on the role of patriarch, leading the charge into the Volturi line. At the end of the battle, Bella and Edward together kill Aro. The message is clear; Edward and Bella will share the new leadership. The entire battle is staged to allow the audience to witness various specific deaths, both of Volturi and Cullens. The general chaos of the overall battle is visually mitigated through these more specific confrontations. Thus, we are allowed to cheer when enemies are vanquished and to mourn the loss of our favorite secondary characters. The editing of this scene is indeed compelling. The snow-covered vista on which the battle takes place is seen in close-up, medium shots, and from a distance, as are the characters. We see some slain by the hands of others, and some swallowed by the earth.

But consistent with the romantic vision of the *Twilight* Saga, nothing is really lost. The audience discovers that all of the battle was the vision of Aro's future that Alice sees if the battle was allowed to take place. Aro, then, has patience to allow the truth of Renesmee's condition to be revealed; she is half vampire, half human, not an "immortal child." With the truth laid open, détente is reached, and we are prepared to see the final scenes of the movie. As we have emphasized, Bella gets everything she wishes for. She's an immortal vampire, tied to her proper mate for eternity. Edward seems to be convinced that he is more than a soulless monster; in this case,

his "more" is to be as much of a traditional father and patriarch as he will allow (i.e., he doesn't want Jacob to call him "Dad"). Jacob and Renesmee are shown as a loving adult couple with the added implication that they represent the "next generation" of the Cullen/Quileute combined clan.

Finally, we have the following exchange between Edward and Bella, as they lounge in their sunlit and flower-strewn meadow:

Bella: I want to show you something.

Edward: What?

 [Bella extends her protective shield to Edward, revealing scenes from their life together. It should not be missed— the protective shield also preserves the memories and meaning of their lives. This is Bella's power and gift.]

Edward: How did you do that?

Bella: Been practicing. Now you know. Nobody's ever loved anybody as much as I love you.

Edward: There's one exception. [Bella nods, suggesting that she knows who he's talking about.]

Edward: Will you show me again?

Bella: We've got a lot of time.

Edward: Forever.

Bella: Forever.

As the music swells, we see a parade of vampires and werewolves as a "visual set of credits," and the movie ends. Given the world that Meyer has created, this is most definitely a "they lived happily ever after" of the most romantic order. Edward and Bella's love has conquered every obstacle. If the audience has given themselves over to the story, they cannot help but be moved. All sorts of problems fall away as the audience is swept up in their love. Does it matter that they are vampires? Certainly not. Does it matter that the human world that they've left will die off? Not at this point. Do these two have a future? They won't grow old together, but we are most definitely convinced that they will be together forever.

Conclusion

Does Bella Swan Cullen heal her own soul? It could certainly be argued that the soul that needed to be healed was not hers, but Edward's. Through the course of the movies, she convinces him, through the purity of their love, of the purity of his soul. Her persistence, her undying confidence in their relationship, and her full belief in Edward's goodness outweighs much, if not all, of any traditional vampiric character that might be attached to Edward. Does Bella Swan Cullen save the world? Again, we have to accept the parameters of the world that Meyer has given us. In that world, Bella is the nexus for the coming together of the Cullen vampires and the Quileute werewolves against the forces (the Volturi) that would render them extinct. Even more to the point, the "world" that Bella brings to a new level of understanding is the world of the Cullen vampires; the family that Bella has knit back together. With hope for a "forever future," all's right in that world.

Appendices

The Good Guys: Cullens are Good Americans

There is very little doubt throughout the *Twilight* films that the Edward and the Cullens are on the side of the good. For the purposes of plot, the films employ a classic horror film strategy, but in reverse. One basic strategy in horror is to make the audience aware of a danger while the characters in the film don't have a clue. This is inverted in the films. For example, concerning Bella and the vampires, Edward is constantly reminding her of the dangers that he and the vampire world represent. The human-eating vampires, of course, are lurking in the background, always ready to strike. The films, however, let the audience know that Edward is trustworthy. He is handsome, self-critical, lives by a clear moral code, and has superhero skills. As an aside, this inverted framework is often reason for annoyance. What looks possibly like horror (there are vampires after all) often turns out to be more like a Christopher Reeve *Superman* film—with Edward as Superman (and in school as Clark Kent) and Bella as Lois Lane. In any case, the *Twilight* films present the Cullens as people we can trust, like baseball and apple pie.

The Cullen "teenagers" are identified as outsiders, in a dreamy kind of way. The teenage, high school setting is a classic horror set-up, so that

oversexed and otherwise distracted, self-involved young people are not only unaware of dangerous monsters, but blissfully so in a flawed (immoral) kind of way. *Twilight*, at the start, introduces us to "human" teenagers who are preoccupied with who to date and who is dating whom, but they are good people (not oversexed) and not at all cliquish. The high schoolers welcome Bella into an already inclusive group; she accepts their hospitality but also keeps her distance. It is the Cullens who constitute an identifiable clique and do their best to shut everyone out, including Bella. She, of course, wants in. Should we worry for her?

Although the Cullens are outsiders, we get clear indications that they are on our side. For example, the first date that Edward takes Bella on is to play baseball with the rest of the Cullen family. While playing, the three vampires who have been terrorizing the area glide in through the fog. The image of the Cullen family, dressed in a combination of casual elegance and old-time baseball uniforms, is in direct opposition to the costumes worn by the three interlopers—leather plus "thrift store shabby chic." In fact, this image of the Cullens as "American" vampires is continuously opposed by the various forces that work against them. Whether the Italian coven of the Volturi or the grungy rock and rollers in Seattle or the allies that the Cullens gather for the final battle in *Breaking Dawn: Part 2,* there is always a clear visual distinction that separates the Cullen family from the vampires of the rest of the world. On the side of the Cullens, the ragtag bunch of vampire witnesses stands against the European "sophistication" of the Volturi. This confrontation is obviously meant to hearken back to the American Revolution. As one of the vampires says, "The Redcoats are coming!" In the conflict of supernatural forces, we have the Cullens and their friends to take up the flag for us.

Nineteenth-Century Romanticism and the Moral World of the *Twilight* Saga

The Cullens are spiritual beings who continue to inhabit the material world after death. They would, perhaps, be recognized by a nineteenth-century spiritualist as persons in living in a spiritual realm (having passed on) who can communicate with those of us who are confined to our earthly, bodily existence. In the case of *Twilight*, the point of connection between spiritual and material, supernatural and natural, is Bella. *Twilight* author Stephenie Meyer utilizes an ingenious diversionary tactic in creating spiritual beings

who are vampires. Human contact with vampires is, obviously, deadly. But instead of being "soulless," the Cullens are sensitive, caring, protective of human life, and heroically able to resist their natural desire for human blood. They are in conflict with vampires who give in—indeed exist by—their desire to destroy natural, human life. Add in the animosity of werewolves, who live bodily and instinctually and despise vampires, and the transcendent, spirit-filled Cullens are embattled on all sides. Bella, the heroine, brings unity and peace for the Cullens and to the natural and supernatural worlds through her daughter, Renesmee, who is part human and part immortal. The christological analogy—fully human and fully divine—is clear.

It is fair to suggest that much of the attraction to the supernatural tropes and themes of the *Twilight* films comes from the very "anti-contemporary" nature of how that supernatural world is portrayed. It is important that the Cullens are nostalgic, Victorian people, while they are also progressive, vegetarian vampires. Despite the glass and steel house in which they live, or the fashionable way they dress (most of the time), the Cullen family is portrayed as very old-fashioned. In the films, they are consistently monogamous and moral in their pairing off, despite the traditional portrayal of vampires as brutal, sexual beings. Edward is the reticent one in his relationship with Bella; he talks nostalgically about courting her as if that would be his preferred method of wooing. When they finally get to the wedding, the vows that they take are exceedingly traditional; they would not be out of place in many churches. The Cullen family is constituted by loving couples who far exceed the vow, "Till death do us part."

There are enough scenes of "lovers in nature" in these movies to make some audience members recall the pre-Raphaelite paintings of John Everett Millais (1829–1896). The Cullens live as part of a natural ecosystem, within nature and yet transcending it—bringing out its beauty, just as their skin glitters in the sunshine. The chaste patterns of courtship that Bella and Edward go through might be familiar to every fan of Charlotte Bronte. The pastimes of the Cullens—their love of art, music, and aesthetics—place them outside of our contemporary lives; it's as if they come from another time, and that's because they do. Before the additions of Bella and Renesmee, the "youngest" Cullen became a vampire in 1930. As counterparts to Bram Stoker's *Dracula* (1897), the Cullens represent Victorian America—elite, cultured, well-mannered, and distant from the upward striving of the industrial, manufacturing, buying-and-selling middle class. Carlisle,

the Cullen patriarch, works as a physician out of compassion rather than need or financial gain. The rest of the household is engaged in high-minded leisure.

Likewise, the moral world of the *Twilight* Saga is elevated, noble, and transcendent; there is a deep sense of goodness of nature and yet an elevation of nature to the supernatural. The series gives us little gritty realism, and no cynical or broken protagonists. Cullen vampires aspire to be more than vampires—to overcome their soulless and destructive natures. If one were to watch *Twilight* with the volume at zero, one might suppose that the Cullens are near celestial beings who inhabit the earth, drawing near to the beauty of nature. If we had not been told, we would not think of them as the same species as the Volturi or Victoria's marauding minions. Other characters have the same noble aspirations. Because of his love and loyalty to Bella (and later Renesmee), Jacob eventually overcomes his natural aversion to vampires, for her safety and her good. Bella, of course, desires to be more than human. Dramatic tension is created because it seems that she will become less than human if she were to become a vampire. But in fact, she becomes the link between natural and supernatural. The human becomes immortal, and the immoral is able to participate in human becoming (through Renesmee).

In short, the moral and religious world of *Twilight* is about noble people who strive to become more than their mere natures, to live in harmony with others, and to reach toward a transcendent good. These aspirations are not the makings of a typical Hollywood picture, and it is remarkable that the *Twilight* Saga has enjoyed its degree of success.

5

Katniss's Rebellion

Katniss Everdeen, the "girl on fire" who cannot control her own life, can still influence the lives of so many in Panem, the fictional post-apocalyptic America created by Suzanne Collins in her popular young adult trilogy, *The Hunger Games*, as well as the movies adapted from the novels. However, based on Collins's description of the character, she shares little in the way of physical resemblance with Jennifer Lawrence, the actor who portrays her in film. Specifically, Katniss is described in the novels as small and dark-haired; Lawrence, in real life, is tall and blonde. Katniss sees herself as less than physically imposing, despite her prowess as a bow hunter; Lawrence radiates a physicality and athleticism that communicate strength and power.[1] The films narrate the development of Katniss's sense of power and self-possession, but they are less about whether Katniss has

1. The "powerless teen girl with boy trouble" seems to be part of many young adult novels targeted primarily at young women. Both the *Twilight* series and *The Hunger Games* trilogy give us first person narrators who are at first unaware of their own particular power, who live apart from "traditional teen lifestyles," who nevertheless find themselves the object of the affections of at least two desirable male characters, and who find their own particular pathway to central positions of power in their worlds. The wielding of that power does indeed separate them; however, it is interesting to see these similarities in books targeted at teenaged women. The contemporary situation—social and economic position—of women is a natural setting for heroic struggle; that is, we—modern culture—can conceive of a woman's independent action and self-possession, but there are still obvious social and economic barriers for her (barriers that are not set before men).

extraordinary abilities and more about who is going to use them (and use her) and to what end.[2]

There is certainly a sense in which *The Hunger Games* series places teenagers within an adult drama, faced with adult problems and violence meant only for a restricted audience, but the allure of the films is actually the inverse. Basic questions and tensions of teenage development, like who am I and who will control my life, are presented as problems for us all. Within the medium of film—advertisements, trailers, big-screen images, tabloid teasers about actor's lives, YouTube interviews—*The Hunger Games* can be what it disparages. That is, at first glance, the series looks like the violence and spectacle of *Mad Max* set within the media-manipulated reality of "reality competition," like *Big Brother* or *Survivor*, except one is killed rather than voted off the island and some of the tribes/coalitions are obviously villainous from the start (the "Careers"). Within this pop culture and media driven "reality," *The Hunger Games* presents a hard realism, where media "reality" and the leviathan that generates it are inescapable yet pernicious and tyrannical. Entertainment pacifies and reduces us all to juveniles.

Within this pessimistic realism, *The Hunger Games* presents a romantic struggle. In a world of artificial images and manipulation, our hero acts spontaneously and authentically. She is at her best outside the city, in the forest, with bow in hand. She dreams of living off the land. What appears at first as a teenager's misanthropic desire to get away turns out to be desire for a better world. As a young person, she represents frustrated and suppressed idealism and hope for society, which has been crushed under the weight of a jaded and cynical world. Intertwined with this political repression and cruelty, Katniss struggles with decisions concerning romantic love—not teenage anxiety about who to date, but questions about love that will clearly shape who she is and who she will become. As the films progress, the questions of love become inextricably political questions. By the end, both romance and romantic social struggles are resolved, but with a reserve that seems to put *The Hunger Games* in a different universe than *Twilight*. In any case (and much more evident in film rather than print), Katniss Everdeen—our hero—finds her pastoral home apart from the city, and she not only manages to save the city from destruction, but also gives it a chance for a new beginning (not far from the conclusion of *The Dark Knight Rises*).

2. Dialogue and quotations in this chapter are gleaned from the DVD versions of the films.

Image and Authenticity

The Hunger Games begins with contrasting images of the Games. It opens as Caesar Flickerman, the flamboyant host, is interviewing Seneca Crane, the gamemaker. They are caricatures: Caesar's blue hair, blue eyebrows, and matching suit are comic; Seneca's hair, parted in the middle, and sculpted beard, are on the edge of grotesque. His looks create the expectation that what he says, like an unctuous pickup line, will make us cringe. From their hyper-stylized interview, the scene shifts as we hear Prim, Katniss's sister, screaming. She has had a nightmare. Katniss comforts her as if she were her mother, and then she heads out of the dim and gray house, with dim and gray clothes, bow in hand, into the wilderness, beyond the borders of the district—where she is forbidden to go. During the first time through the movie, we don't know that the basic conflicts of *The Hunger Games* films are presented in these initial contrasting images: Capitol vs. the districts, the Games vs. Katniss, the manufactured vs. organic life, the person vs. the media image, et cetera. We also don't know, at this point, that the center of these conflicts are the images themselves. Katniss's personal gifts and her weapons are found in her authenticity. She rebels against a world of contrivance, machines, political machinations, and media images. She wants to be real.

Katniss's quest for authenticity is believable, in part, because she is a teenage girl. Living under the oppressive government, the poverty of District 12, and the terror of the Hunger Games—amid these grand political and economic realities—Katniss just does not want to be told what to do. She rebels against the inexorable fact that who she should be will be imposed upon her. Controlled not only by armed "peacekeepers," she is also oppressed by her dim gray clothes, house, and future. She flourishes in the woods, not only beyond the reach of the Capitol, but also apart from the struggles of her family and the adult responsibilities that she bears. Just before the reaping (the lottery for the Hunger Games), Katniss and her would-be beau, Gale, meet in the woods. They talk about escape into the wilderness, and two things make the idea sound impossible: the Capitol would hunt them down, and even if they could make it, they cannot turn away from their responsibilities to support their families. At this point in the story, their plan seems fanciful, daring, and romantic—the kind of plan that teenagers talk about together, but avoid in front of adults who would squash it with their appeals to reason and practicality.

However, when the reaping actually occurs, and against the odds, Prim's name is drawn from the bowl, Katniss's improvisatory and reflexive action of volunteering as tribute is unmistakably and genuinely heroic. It's an action that seems perfectly in character, and it is clearly the inciting incident that leads to the rest of the story. Why would this girl, unsure of her own power, volunteer for something so rash? Is this true heroism? Is this an incident that shows the possibility of an individual standing up to the kind of oppressive power wielded by the Capitol? Whatever else it might be, it is Katniss's first act of rebellion against the government, the first in a long list of actions that, whether intentional or improvised, displays the rebellious attitude that is at the center of her character. Complaints and criticisms have been (and ought to be) levied against *The Hunger Games* films for putting teenage characters in a situation where they must murder other teenagers. But who Katniss is as a hero—her angst, her fight against convention and contrived images on all sides, her impulsiveness—is fitting and natural because she is young and in the process of figuring out who she is in the world.

The movie moves quickly from the reaping through the training of the tributes until it reaches the point of individual interviews in front of the gamemakers—the point where image is almost everything. At this point, the movie slows down to give the audience the scene of Katniss shooting the apple out of the mouth of the suckling pig. That action can be seen as a "mini-rebellion," with Katniss doing something unexpected. The rebellion is presented, partly and subtly, as lashing out because she is being ignored. It is partly tantrum, but also it's one of the first places where we see Katniss as a physical force to be reckoned with. We see that, along with the very reflexive and improvisatory quality of her character, she has authentic power—that her survival will not so much hinge on skill in the martial arts as it will on her struggle "to be herself"; to be authentic.

At this point in the saga, her character is actually built upon traditional masculine hero tropes: the wilderness, the physicality of the bow as a weapon, her inner strength, her impulsive yet decisive and effective action, her ability to stand alone, most confidently (at least in appearance). Unless the audience is familiar with the books and the way Suzanne Collins constructs the internal life of the character, we have seen little at this point that feminizes Katniss Everdeen.[3] If control of the "image" is a basic struggle of

3. Whether it's volunteering to replace Prim or sending an arrow into a roast suckling pig or running headlong into battle, Katniss is at her best when she follows her heart

The Hunger Games series, there is also a struggle of film presentation and reception—how to retain and yet to break with expectations about a hero as a teenage girl.

In the scene of the interviews with Caesar Flickerman (the media circus of the Games), two things happen which help to define Katniss's character. During her interview, not only do we see the hesitant and shy Katniss become slightly more comfortable in front of the large Capitol audience, we also see her in a very traditional evening gown, giving the audience yet another image of the character. We have seen her in her father's jacket as a traditional hunter; we saw her in a Depression-era dress at the reaping. We have seen her in the unisex workout attire of the training scenes; we have seen her in the casual elegance of the Capitol apartments. The "girl on fire" dress of the interview gives us the first glimpse of an image that the movies will keep returning to—the evolving image of the Mockingjay. This "made for TV" image is traditionally feminine and very formal. As the movies progress, the ways in which Katniss is costumed for the audience (both the movie audience and her Panem audience) become more and more significant. About Cinna, her stylist, Katniss complains, "He made me look weak." Haymitch counters, "He made you look desirable, which in your case can't hurt, sweetheart."

Once the Games actually begin, we have no time to worry about the building of Katniss's public relations persona. From this point until nearly the end of the first movie, the audience is most concerned with Katniss's battle for survival. It is interesting to note that the entire Games are televised, running around-the-clock, seemingly with no "sign-off." Thus, it could be said that nearly everything we see of the Games is what the gamemakers want their audience to see, as well as what the movie director wants the movie audience to see. The movie director is careful to show us Katniss as a protector, making sure that we see her treatment of Rue (another tribute) as emblematic of her treatment of her own sister.

When Rue dies, a number of issues are at play. Rue, as a character, is crafted to present a layering of personal and social relations. She is smaller and physically overmatched among the tributes, the same age as Katniss's younger sister, black, and from agricultural District 11, which is suggestive

instead of her head. This is not to say that she doesn't have an active mental life. Indeed, in the books (all written in first-person narration), the reader continually confronts Katniss's hesitation when she *thinks* about what to do next. Indeed, her inner voice is as immature and tentative as any sixteen-year-old girl's. Nevertheless, the character we see on screen is very much a traditional "hero;" introspective, brooding, and ready for action.

of a slave plantation. Rue cries for help when she is trapped in a net/snare. When Katniss disentangles her, they embrace much like Katniss and Prim did after Prim's nightmare on reaping day. Marvel (one of the Careers) appears—a ruthless, confident, well-off District 1 tribute—and launches a spear at Katniss, who dodges and kills him with an arrow. Marvel's spear, however, mortally wounds Rue. Katniss's killing of Marvel is instinctive, immediate, and defensive (to protect rather than attack). She reacts to Rue's death in a way that is instinctive in an entirely different way—slowly, deliberately, and oblivious to surrounding dangers. For her, the Games stop as she honors Rue, gathering flowers and decorating Rue's corpse, almost as if she's creating a late Victorian painting—feminine, amid a natural landscape, and set against the ugliness of the industrial-artificial world.[4] Along with the three-fingered salute from District 12, these actions begin the rebellion of the districts against the Capitol: a crafted image, yet one of authentic feeling, feminine, and set against mechanisms and utilitarian calculations. Whether Katniss knows it or not, this is the place where she becomes the face of the revolution.

At this point, as the apparent rallying image of the districts, Katniss's authenticity is put into question precisely at the level where she is supposed to be the most real: the heart. Apart from wolf-mutts or brutal tributes, Katniss has to face the challenge of cooperating with and extending the illusions of the Games. Only by risking matters of the heart can she fight at the level of how the very game is constructed. The gamemakers continually manipulate the game, and Katniss keeps pace. When they announce that two tributes from the same district would be allowed to win, she immediately goes to find Peeta. The movie pretty clearly wants us to see that the growing intimacy between Katniss and Peeta, whether conscious or organic, bothers Gale. He has to wonder if it is real or not real. The kiss is

4. Mention should be made of the character of Effie Trinket, who is a cog in the image-saturated world of the Capitol. Effie operates as a director and stage manager for Katniss and Peeta on the tour. The first time she sends them out in front of the cameras, she calls it "feeding the monster," happily acknowledging the perverse power of the images she creates. She writes them scripts, then is upset when the two of them improvise. This double-edged sword of televised rebellion, and the ways it can be used and misused, are heavily entwined around Katniss's story. When we see Effie without her outlandish costumes and heavy makeup, broken down and cast out of her life in the Capitol, she looks anemic—like the life has been taken out of her. By the end of the saga, it is clear that she has to escape from both the Capitol and from the rebels to achieve any kind of healing. At this point in the story, however, we have only glimpses of the effect that the Games, as well as all of the media machinery surrounding the Games, have had upon her.

unexpected, initiated by Peeta, but accepted and embellished by Katniss; in the film, it is not clear, on Katniss's part, whether we have love or strategy or a fortuitous confluence of both. The battle of image and authenticity is at the core of Katniss's rebellion, and at the heart of this battle are questions of true love.

When *The Hunger Games: Catching Fire* opens, the audience sees many of the same images that began the first movie—Katniss and Gale in the woods, hunting. This time, however, the light is the same gray that pervades all of District 12, rather than the bright sunlight that we saw in the forest in opening scenes of the first movie. The relationship between Katniss and Gale is tense, as if the changes wrought by the Games have had a direct effect on their relationship. Those changes are clarified when, in a tense moment between them, we hear that Katniss is preparing to embark upon the "Victory Tour" that is standard procedure for the winner of the Games. The tension is exacerbated when Gale kisses Katniss, revealing the depth of feeling that he has for her. The battle for Katniss's affection seems at this point in the movies to be between the "made for TV" relationship with Peeta that was developed during the Games and the apparently more "realistic" romance developing with Gale. Although two boys are fighting for the heart of one girl, the stakes incumbent upon Katniss's choice are clearly larger than in a traditional "teen movie." In this world, deciding between Peeta and Gale will have deadly consequences for all three of them.

Because Katniss and Peeta changed the intended outcome of the Games, with their televised "love" winning over the traditional battle to the death, it's not surprising when President Snow makes an unexpected visit to Katniss's home. Katniss greets him with a mechanical, "What an honor." He replies that they should agree not to lie to each other, and she agrees, pragmatically, that it would save time.

Snow: Sit down, Miss Everdeen. I have a problem, a problem that began the moment you revealed those poison berries in the arena. If that head gamemaker, Seneca Crane, had had any sense, he would have blown you to bits then and there. But here you are. I expect you can guess where he is.

Katniss: Yes, I think so.

Snow: After that fiasco, there was nothing left to do but to let you play out your little scenario. And you were very good. That whole love-crazed, besotted schoolgirl routine. Impressive. Truly. . . . In several of them [the districts],

people viewed your little trick with the berries as an act of defiance. Not as an act of love. And if a girl from District 12 of all places can defy the Capitol and walk away unharmed, what is to prevent them from doing the same? What is to prevent, say, an uprising? That can lead to revolution. And then, in a fraction of time, the whole system collapses.

Katniss: It must be a fragile system, if it can be brought down by just a few berries.

Snow: It is, but not in the way you imagine.

. . .

Snow: I want us to be friends.

Katniss: What do I need to do?

Snow: When you and Peeta are on tour, you need to smile. You need to be grateful. But, above it all, you need to be madly, prepared-to-end-it-all in love. You think you can manage that?

Katniss: Yes.

Snow: Yes, what?

Katniss: I'll convince them.

Snow: No. Convince me. . . . For the sake of your loved ones. [At this point, Snow reveals to Katniss the surveillance footage of the earlier kiss between Katniss and Gale.]

What do we learn here? If nothing else we learn of the remarkable ubiquity—the breadth and depth—of the Capitol's surveillance program. The highly evolved technology that created hovercrafts and three-dimensional modeling of monsters in the arena also allows the Capitol to spy on its citizens. It is an example of the soulless Capitol extending its control over Panem; yet at the same time, by the end of the four movies, the rebels' control of the media is just as omnipresent as was the Capitol's. False images come from all sides, and President Snow demands of Katniss that she become part of the illusion. He demands that she present her contrived love for Peeta in a way that will convince even him that it is real.

Romance as Rebellion

The real and artificial, natural and coerced are intertwined throughout the films. Again, there is a realism in the confusion: teenagers like Peeta, Katniss, and Gale—innocent in matters of love, yet thinking of themselves as wiser than the rest—can be expected to experience convoluted feelings and to not know, in the end, what they want. The wide popularity of *The Hunger Games* draws on the adolescent tendencies of our popular culture. Along with our stress over our aging bodies, we do not continue on easily into mature love and lasting relationships (at least at the level of popular culture). Katniss's love tangles fit with her overall vertigo. Incredible burdens, physical and psychological, are so common to film that we (the audience) might overlook the fact that Katniss is suffering post-traumatic stress syndrome. She dreams about her murderous actions during the Games. Her strong façade crumbles with every speech and with every rebellious act she witnesses on the Victory Tour. She attempts to stay on the Capitol's script and to convince Snow that she will play the game. At the same time, she cannot help but (by her very presence) support the rebellion. It is clear that the seeds of an uprising already have been sown; in fact, it has grown much faster than Katniss could have imagined. Likewise, her love for Peeta and for Gale is pulled in opposing directions by forces she cannot seem to control.

So once again, Katniss changes the game, doubling down by suggesting that, instead of simply playing the part of "star-crossed lovers," she and Peeta get engaged. Peeta is positively unenthusiastic; he suspects sarcasm. His response to her proposal is "That's not helping." In fact, in an earlier scene between Katniss and Peeta we see that he is willing to go along with the "performance," as long as he can find some truth in it.

Peeta: You don't have to apologize to anybody. Including me. I know it's not fair of me to hold you to things you said in the Games. You saved us. I know that. But I can't go on acting for the cameras, and then just ignoring each other in real life. So if you can stop looking at me like I'm wounded, then I can quit acting like it. And then maybe we have a shot at being friends.

Katniss: I've never been very good at friends.

Peeta: For starters, it does help when you know the person. I hardly know anything about you except that you're stubborn and good with a bow.

Katniss: That about sums me up.

Peeta: No, there's more than that, you just don't want to tell me. . . . You see Katniss, the way the whole friend thing works is you have to tell each other the deep stuff.

As often as Katniss attempts to change the rules, the Capitol is one step ahead of her. And, since at this point the Capitol controls the media as well as the message, it is not surprising that the seventy-fifth Hunger Games are stacked against her.

Once President Snow's plan to eliminate living tributes by having them participate in the Quarter Quell is made public, it looks like the goal of each tribute will be survival. But for Katniss, her survival is not the primary option.

Haymitch: There she is. Finally did the math? And you come to . . . what? Ask me to . . . die?

Katniss: I'm here to drink.

Haymitch: Finally, something I can help you with. What's it say that Peeta was here forty-five minutes ago begging to save your life and you only just now show up?

Katniss: It means we have to save him.

Haymitch: You could live a hundred lifetimes and never deserve that boy.

Katniss: Come on, Haymitch. Nobody decent ever wins the Games.

Haymitch: Nobody ever wins the Games. Period. There are survivors. There's no winners.

Katniss: Peeta has to survive.

This scene, followed by a scene between Katniss and Gale where Katniss kisses Gale lovingly (if not terribly passionately), further muddies the relationship waters between the three primary characters. For the movie audience, at this point, it is unclear which of the two young men Katniss loves more. Frankly, at this point, who she loves more is secondary to whether or

not she can summon the will to continue to rebel against the Capitol and the Games.

Once Katniss and company return to the Capitol to prepare for the Quarter Quell, we continue to see more of the moves and countermoves that new gamemaker Plutarch Heavensbee enjoys so much. Every move that President Snow makes is countered by Katniss or by one of the other twenty-three tributes—while every regret that the tributes express regarding even continuing the games falls on deaf ears. Even Peeta's last-ditch lie regarding Katniss's pregnancy is not enough to stop the games, even in the face of growing public opinion against them. The wheels of fate are turning toward another bloodbath. Love—real or simply performance—cannot stand against the Games.

Once the games begin, at first blush, it appears that President Snow will win. It is quickly apparent that this particular arena is constructed not just as a set on which the Games are played, but as a series of deadly traps for the tributes, the "species" that Snow seeks to eliminate. The tributes attack each other with one small difference—it is clear from the outset that Finnick Odair, by virtue of him wearing Haymitch's bracelet, is an ally of Katniss and Peeta. For a movie audience unfamiliar with the books, this alliance is questionable, since, although the idea of alliances was broached earlier, once the fighting starts, any alliance seems somewhat dubious.[5] The alliance with Finnick and Mags, however, proves valuable; Mags even sacrifices herself to the poison fog so the other three can escape. We begin to see exactly what carefully chosen allies will do for Katniss, as well as for the idea of rebellion. In fact, as the Games progress, Katniss's allies continue to protect her, saving her from other tributes as well as from a variety of life-threatening dangers.

As the group of allies prepares for their final battle, Katniss and Peeta have a moment alone. It starts in a way that is hardly romantic. Katniss and Peeta are discussing what to do if their small band of tributes defeats the rival group (the surviving "Careers"—both tributes from District 2). They don't want to be around when members of their group will have to turn on each other. The gamemakers will allow only one survivor. So Katniss and Peeta decide to carry out Beetee's plan of attack with the others and then slip away once the rivals from District 2 are dead.

5. Another potentially interesting visual cue is the costuming choice that was made for the tributes. The tight-fitting wet suits that they wear make them appear even more "superheroic."

Peeta: Katniss, I don't know what kinda deals you made with Haymitch, but he made me promises too. [He removes his locket.] If you die and I live, I'd have nothing. Nobody else that I care about.

Katniss: Peeta . . .

Peeta: It's different for you. Your family needs you. [Peeta hands Katniss the locket; she sees that it contains photographs of her mother, Prim, and Gale.] You have to live. For them.

Katniss: [after a pause] What about you?

Peeta: Nobody needs me.

Katniss: I do. I need you. [They share a lingering, and honestly passionate, kiss.]

In the movies, this is the moment where Katniss fully realizes the depth of the feeling she has for Peeta. It is also the moment where both characters realize how much they would sacrifice for the other. In this series of films, in which violence is a standard response and the media culture is intertwined through all aspects of human relationships (the audience sees immediately that this intimate moment has been broadcast to all of Panem), this is a pure moment of classically romantic interaction. Here, two characters confess their feelings for each other. Here, the "inciting incident" of that confession creates a cause of action. And, from this point forward, Katniss has a reason to fight that goes beyond her warrior station.

Fight she does, to the very end, choosing not to kill Finnick but to fire her arrow into the center of the electrical storm. In so doing, she denies President Snow his triumph and displays to the whole of Panem the resolve and courage of the Mockingjay. Of course, in the context of the entire saga, the resolve that Katniss has found is not enough. The climactic scene of the movie is replete with images of triumph and resurrection in the midst of the destruction of the arena, as a living, yet supine and cruciform Katniss is lifted to the heavens (into a hovercraft). It appears that, at this point, Katniss has found some sort of peace and victory over Snow and the Games. But if only because this is the second film in the series, we know that this victory and peace cannot last.

Indeed, it lasts only a few seconds, and in the next scene, Katniss awakes in the hold of the hovercraft, ready to fight to the end. All of her

senses tell her that she has been captured. When it is revealed that she is the one who has been rescued from the arena, and that Peeta is the one who has been captured by the Capitol, she breaks down and lashes out wildly at Haymitch, out of control. When she wakes again, it is with Gale at her side. When he tells her the fate of District 12—firebombed into oblivion by Capitol hovercrafts—the audience gets the last shot of the movie, a close-up of her face. She stares at the screen as her expression shifts from obvious horror to something else. It is worth watching in slow motion; after the horror, there seems to be a hint—a fleeting hint—of a grin, perhaps madness (with a desire for revenge?), that then shifts to what looks like resolve.

When *The Hunger Games: Mockingjay, Part 1* begins, the audience is placed so close to Katniss's point of view that we are unsure of what is real and what is imaginary. Katniss is in the throes of what is clearly an acute attack of post-traumatic stress. Hiding from her keepers, she is repeating things that she does know—her name, the fact that Peeta was captured, and so on. The unseen keepers, saying "we can help you sleep," establish quite early the therapeutic regimen to which Katniss is being subjected: confinement, drugs, and hospitalization. In fact, it's hard to know from the first two scenes of the movie exactly what is real. Is Katniss hiding from her keepers? Is that first scene part of her drug-induced nightmare? What is plainly real is the carpet bombing of District 12, the results of which Katniss sees when she is taken there in an attempt by Heavensbee and President Coin to show her the vengeful savagery of the Capitol.

Heavensbee and Coin have ulterior motives, however. Even if she has been saved from President Snow, she is now in the hands of the rebellion and its manipulation of her image. Seeing Katniss broken, Coin wonders if Peeta should have been rescued instead. Heavensbee reassures her; Katniss's passion need only to be incited—not by ideals and strategies, but by making it "personal" and letting "her see what the Capitol did to 12."

Coin: She can't handle it. The Games destroyed her.

Heavensbee: This is the only choice you have. People don't always show up the way you want them to, Madame President. But that anger? That anger-driven defiance? That's what we want. And we can redirect it. We need to unite these people out there that have been doing nothing but killing each other in an arena for years. We have to have a lightning rod.

They'll follow her. She's the face of the revolution.
Let her see it. Let her go home.

Coin: Send her.

Heavensbee and Coin want Katniss to be something different. But we (the audience) see that the real "face of the revolution" is a traumatized teenage girl, haunted by the ghosts of tributes she killed in the arena, by the ghosts of all the dead residents of District 12, by the machinations of the Capitol (the just-cut white rose in her surprisingly still-standing home in the Victor's Village attests to President Snow's evil surveillance), and by the plans of the rebellion under Coin.

Heavensbee's assessment of Katniss, that it has to be made "personal," rings true, but not in a way that fits easily with his plan. Katniss is a romantic hero, a woman of the untamed frontier.[6] Her passion and improvisation stand apart from causes and political ends. On the one hand, Peeta is held prisoner in the Capitol; on the other, Katniss becomes more distant from Gale as he takes on a larger role in the revolution.[7] When she finally negotiates her demands for taking on the Mockingjay persona, she asks that Peeta, Johanna, and Annie Cresta (Finnick's true love) be rescued and that they be granted full pardons. Given that all of Panem has just seen Peeta ask for a cease-fire on the part of the rebellion, public opinion is not on Katniss's side. However, when she makes her demands, she does so with the fervor that Heavensbee wants from the Mockingjay.

It is significant to note the contradiction between the true emotion that Katniss shows, and the way in which Heavensbee wants to display that emotion to the rebels. As he says: "That's it! That's her! Isn't that who I promised you? Right there! She wears the costume, gunfire in the background. A hint of smoke. Our Mockingjay." Heavensbee sees her passion as a part of a performed event, with costumes and sound effects conveying the message that he wants to send. For Katniss, her passion has little to do with the rebellion, and almost everything to do with saving three friends. Even in the midst of her own brokenness, Katniss's reflexive actions toward others are transparent, not clouded by strategies and ulterior motives. For

6. Dargis, "Tested by a Picturesque Dystopia: 'The Hunger Games,' Based on the Suzanne Collins Novel."

7. Her conflicted feelings for Gale and Peeta can be seen when, immediately after a conversation with Gale, we see Katniss having a nightmare in which Peeta climbs into bed to comfort her. Even though we know he's being held captive, the setting of the dream is clearly District 13.

example, the first attempt to create "media-ready Katniss" does not meet with much success. But when Haymitch asks the group about moments when Katniss "genuinely moved" them, the moments mentioned are those in which Katniss acts from the heart—volunteering as tribute for Prim, singing to Rue as she dies, and so on. As Haymitch asks the group, "What do all these events have in common?" Gale answers, "No one told her what to do." Beetee suggests, "So maybe we should leave her alone." But Heavensbee concludes, "The opportunities for spontaneity are obviously lacking below ground. So what you're suggesting is we toss her into combat?" In fact, it is when she is "tossed into combat," defending the makeshift hospital to which she is sent simply to make an appearance, that we see the reactions that make Katniss the lethal weapon that she is. In the process, she gives the rebellion the video footage they have wanted.

The "moves and countermoves" of the rebellion are as much, if not more, media driven than they are military, with the Capitol and the rebels broadcasting as much propaganda as they can. It needs to be said that both sides have two very powerful weapons; Katniss for the rebels, and what turns out to be a brainwashed Peeta for the Capitol. Peeta's broadcasts, it is assumed, have an effect at least in the Capitol, and it is apparent that what the rebels are doing is having a direct impact upon most of the population in the outlying districts of Panem. We see rebels in the forest district attack a squadron of peacekeepers, as well as an even larger group destroy the dam in District 5 that supplies electricity to the Capitol. *Mockingjay, Part 1* ends with all the game pieces in movement. Coin is rousing the troops for the coming war. We learn the nature of Peeta's brainwashing and that the Capitol has allowed him to be "rescued" so that he can be used as a human weapon against Katniss. Peeta has actually been made into the false image of the Capitol.

Love has lost. *Mockingjay, Part 2* picks up just where the first part ended. The Katniss-Peeta-Gale triangle is still in play. Katniss's voice has been silenced, due to Peeta's attack—an irony hopefully lost on no one who recognizes the strength of the media weapon that is the Mockingjay. The results of Peeta's brainwashing ("highjacking") are shown immediately, as we see that the boy who pledged to stand beside Katniss forever now sees her as nothing more than a weapon created by the Capitol to be used against the rebels. Any feelings that Katniss has for him are turning to hopelessness and despair. In Gale's case, the changes are more subtle, but perhaps more troubling. He clearly has been rethinking his relationship with Katniss. As

a rebel who puts loyalty to the cause first, he questions her fidelity, based on her inability to choose between him and Peeta. His experiences of the destruction and escape from District 12 have made him harsher, more calculating and cold, and ready to strike back at the Capitol with deadly force. As the Capitol has brainwashed Peeta, rebellion has taken Gale's mind and attention from Katniss.

Katniss's Reason

Katniss's independent, heroic course of action is tied up with love and a desire to have a future with both Peeta and Gale. It may seem that her inability to decide between the two is caused by an inability to deliberate, choose, and set out a course of action. In this view, she is indecisive, stereotypically female, fickle and undependable, and in this case immobilized by a difficult choice. This image of a woman fits with Gale's comment that kissing Katniss is like kissing a drunk person: "It doesn't count." Katniss's authentic spontaneity and concern for the suffering of others put weight behind Gale's accusation. But in Gale, we find the developing utilitarian logic of the rebellion, evinced in his explanation of the "two-tiered explosion," where a first bomb draws people in to help the wounded and a second bomb kills them all. When Gale describes the double explosion, Katniss's responds, "I guess there are no rules anymore about what a person can do to another person."

In her response to Gale, we see something quite different than the emotion-driven heroine. Here, it is Gale (along with Coin and the rebellion) who has allowed pain and loss to change his thinking. His reasoning is clouded by his suffering. In contrast, Katniss stays true and consistent with her sense of justice and compassion. She stays true to her willingness to face suffering with her own sacrifice. Hardly unreasonable, Katniss's reasonableness and wisdom are romantic only (but truly) in the sense that her logic opposes the cold, utilitarian calculation of the rebellion and the Capitol. It often appears that on the other side of cold logic is blind passion. And to the very end, this blind, irrational reaction is in play. To the very end, it looks like Katniss is driven by a blind desire for vengeance against Snow; such desire is the standard film trope for moving a hero to extreme and decisive action. And while this blind desire sets a dramatic course, it will be the test (the temptation) of Katniss's heroism, but it will not be the measure. In the end, Katniss will be the one alone, perhaps, among all others (except

Heavensbee) who is able to see clearly what is going on and how to act decisively in response.

The contest between passion and wisdom, reason, and justice is in play throughout. For example, when Katniss confronts the train escaping from the bowels of the mountain in District 2 and is held at gunpoint by one of the escapees, we see how she has drawn her battle lines. For her, the rebellion is intensely personal as she defines all of her moves and the rebels' moves as directed toward President Snow.

Loyalist: Give me one reason I shouldn't shoot you.

Katniss: [long pause] I can't. I guess that's the problem, isn't it? We blew up your mine. You burned my district to the ground. We each have every reason to want to kill each other. So if you wanna kill me, do it. Make Snow happy. I'm tired of killing his slaves for him.

Loyalist: I'm not his slave.

Katniss: I am. That's why I killed Cato. And he killed Thresh. And Thresh killed Clove. It just goes around and around. And who wins? Always Snow. I am done being a piece in his game. District 12, District 2. We have no fight. Except the one the Capitol gave us. Why are you fighting the rebels? You're neighbors. You're family. [The Loyalist drops his pistol.]

Katniss: [standing, turning to the crowd] These people are not your enemies. We all have one enemy. And that's Snow. He corrupts everyone and everything. He turns the best of us against each other. Stop killing for him. Tonight, turn your weapons to the Capitol. Turn your weapons to Snow.

The scene is setting up a dramatic trajectory: Katniss seems to be focused on exacting vengeance upon Snow. On the other hand, however, it is not that simple. Katniss is stepping back from visceral reactions to violence and asking the loyalist to do the same. At this moment, in her attempt to stop the cycle of violence, her heroism is Ghandi-esque and worthy of Martin Luther King Jr. That is, she is committed to suffering violence in order to unmask and expose oppressive power, personalized in Snow. In response to her appeal for peace, a loyalist shoots her with an automatic weapon in what looks and sounds like a deadly shot. In this scene, there is a hint that Katniss's thinking is not as simple as it might appear. Is she set on personal

revenge (to save herself and kill another), or is she willing to sacrifice her own life to end the cycle of violence set in motion by President Snow?

The answer at this juncture: the gun shots do not kill (she is not sacrificed), but her wounds do serve to keep our focus on Katniss's desire for revenge against Snow. The injury sends Katniss back to District 13 and into close proximity to Peeta once again. She is leery of getting too close to him. Even when prodded by Haymitch to go to his hospital room, Katniss hesitates. When she does approach Peeta, the audience shouldn't be surprised when they refer to their first meeting. Sadly, the moment of their past that could be the key to unlocking the essence of Peeta's memories has been brainwashed and changed as well.

> **Peeta:** I remember you in the rain. And I burned it [the bread] on purpose. To give it to you. I remember my mother hitting me. I was supposed to give it to the pig.
>
> **Katniss:** That was the first we'd eaten in days.
>
> **Peeta:** Why would I take a beating like that for you?
>
> **Katniss:** Because you were kind and generous. And people said you loved me.
>
> **Peeta:** Did people say you loved me?
>
> **Katniss:** They said that's why Snow tortured you. To hurt me.
>
> **Peeta:** Snow says that everything that comes out of your mouth is a lie. All I know is that I would have saved myself a lot of suffering, if I would have just given that bread to the pig.

In performance, this scene plays out almost like a "rejected first boyfriend turning away from girlfriend" scene from any John Hughes-style teen movie (e.g., *Sixteen Candles* or *Pretty in Pink*). If not for what the two characters have already been put through, as well as the hospital setting, an audience could easily see this being just another complication on the road to the reconciliation that these two characters have got to take. Nevertheless, thanks to all that is at stake outside of this hospital room, plus what we have learned about the character of Katniss Everdeen, things are just not that simple.

In fact, the changes in Peeta, coupled with Coin's desire to keep her behind the scenes (and, not inconsequentially, alive), drive Katniss toward her decision to go to the Capitol and kill President Snow. It should be noted

that this decision seems to be based on vengeance. It is not the Mockingjay making this decision for any political calculation or public relations message. Should we be concerned that the young girl who kills reflexively and defensively is evolving into a cold-blooded murderer? Whatever the reason, the decisions that Katniss makes from this point forward seem to fit that standard framework; the hero is driven by vengeance against her evil counterpart. As Katniss moves further down this path, it becomes more difficult to believe that her actions will help to save or heal. She seems to have departed from her moral code. Perhaps Johanna's words to her before she sneaks away to go to the front lines are significant: "Anybody can kill anybody, Katniss. Even a president. You just have to be willing to sacrifice yourself." Does Katniss see her actions as leading to a path of personal sacrifice for the sake of others? Or does a desire for revenge make her indifferent to any other considerations? At this point, it's hard to know.

As she sneaks away (from political necessity and the Mockingjay message), it's hard to believe, in the media-obsessed culture of Panem, that she could leave District 13 without being seen. The audience sees quickly, though, that she was indeed seen, or was at least seen as she disembarked from the cargo container and walked across the tarmac toward the soldiers milling about. The audience is meant to get two messages in this short scene. As the soldiers and others gathered at the airport recognize her, they respond to her with the three-fingered, left-handed salute that has become the people's sign of respect for the Mockingjay. Even if she started this journey as a personal vendetta, it quickly becomes apparent that she is carrying the hopes and dreams of these rebel soldiers. At the same time, we see how Coin and Heavensbee respond to her: co-opt and control. The issue at stake is who conceives and executes the plan against the Capitol, and these engineers of war and media images, Coin and Heavensbee, see Katniss as irrational, adolescent, and unmanageable.

Coin:	What is she doing?
Heavensbee:	I don't know. It's so frustrating when she goes rogue.
Coin:	This isn't just adolescent. It's insubordination.
Heavensbee:	Put her on the first hovercraft back.
Coin:	Don't be ridiculous. She can't come back now. She's mythic.

Heavensbee:	At the front lines, surviving a gunshot wound. Couldn't have staged it better myself.
Coin:	Hmmm, I know. She's going to stay where she is. And whatever she's doing, we conceived it. It was our plan all along.
Heavensbee:	Course it was.
Coin:	Mr. Heavensbee, you're the gamemaker. I want everyone to know, whatever game she's playing, she's playing for us.

Through media images, they will control Katniss and the meaning of her actions; that is why this particular revolution will be televised.

"Squad 451" is composed of elite fighters and a camera crew, with orders to follow behind the front-line soldiers and broadcast to the country these famous rebel faces marching to the Capitol. It's an aptly named "Star Squad"—telegenic, deadly, and not at this point in too much danger. This group is obviously configured for its propaganda value; however, it's not exactly what Katniss was expecting, and she still has her own plan to break off from this group and go off on her own to assassinate Snow. Peeta's arrival complicates things even more, and not just because the third leg of the Katniss-Peeta-Gale triangle has arrived. With reason, Katniss and the rest of the squad fear that Peeta's still unstable condition will make him nothing but a liability, despite his propaganda value.

We learn quickly that there's another, more political, reason for Peeta being there. In a conversation with Boggs, her squad leader, Katniss learns that Coin wanted Peeta to be rescued from the arena rather than Katniss, and that Coin doesn't trust Katniss because she can't be "controlled." For Boggs, Coin's political future is tied to Katniss.

Boggs:	She doesn't need you as a rallying cry. These propos can be done without you. There's only one thing you could do now to add more fire to this rebellion.
Katniss:	Die.
Boggs:	That's not gonna happen under my watch, Katniss. I'm plannin' for you to have a long life.
Katniss:	Why? You don't owe me anything.
Boggs:	Because you've earned it.

Boggs presents us with another instance where other people recognize Katniss's power, even if she still doesn't.

The "improvisatory power" that we have seen in other heroic characters surfaces very quickly in Katniss after this scene, when Boggs and one of the other soldiers are killed by an unexpected "pod" (one of the booby-traps set by the Capitol gamemakers to attack the rebels). Katniss jumps into the fray immediately and attempts to save Boggs, but it's too late. Just before he dies, Boggs transfers control of the holographic map that the squad has been using to Katniss, rather than his second-in-command. When another pod is tripped, the squad is forced to retreat into an abandoned Capitol apartment building. When Jackson (the second-in-command) demands that Katniss give her the map, Katniss bends the truth, saying that Coin sent her on this mission to assassinate Snow, as well as stating to her that Boggs said that she (Jackson) would assist Katniss. Even Cressida (the television director) confirms this "bend" of the truth, saying that this was Coin's plan all along—to televise Snow's assassination. We didn't see that conversation, but since we do know that Coin is trying to control things from behind the scenes, this is not out of the realm of possibility.

Katniss's ability to chart her own course is precisely at stake. Once the peacekeepers destroy the building in which Katniss's squad was originally hiding, it takes only a few moments for the Capitol to broadcast a message of her supposed death. Hard on the heels of this news report is a broadcast from President Snow, in which he describes her as "not a thinker, not a leader; simply a face plucked from the masses." That broadcast is then interrupted by President Coin, breaking into the Capitol's broadcast to testify to Katniss's power as a leader due to the very fact that she was a member of the "masses . . . a small town girl . . . who . . . rose up and turned a nation of slaves into an army." It is important to note, here, that in response to Snow's claim that Katniss is not a thinker, Coin simply asserts that she is the proper "face of the revolution." Katniss's cynical comment—"I had no idea I meant that much to her"—displays the growing contempt that Katniss feels for Coin, toward all of the publicity-driven media machine, and the cold strategy-making of both Snow and Coin. On one hand, her "wild side" will simply not be civilized. On the other hand, she sees that contending views of civilization, Coin on one side and Snow on the other, are not civilized at all.

We (the audience) see the hope of a counter society (apart from Coin and Snow) during the underground journey to Snow's mansion. We

witness the depth of commitment on the part of the individual members of the squad. We could assume that some of them might believe that Katniss is on a mission for Coin and are following orders as good soldiers are wont to do. A contemporary audience, however, would have to believe that other members of the squad would be more than a little cynical about this expressed mission. Granted that Katniss has a reason for revenge, nevertheless the mission is a little selfish, given the military power that the rebels could point toward the Capitol. So, why do they follow her? Why do they put themselves into such danger? A sense of patriotism? A sort of "rebellion against the evil overlords"? Or rather, does Katniss Everdeen inspire this sort of loyalty in the people around her? Beyond the image-making, people trust her because she is good.

Following the consistent framing of Katniss's "politics" and moral code in relationship to Peeta (and Snow) and Gale (and Coin), Katniss—with Gale looking on—has to reassure Peeta about their relationship. Peeta asks, "You're still trying to protect me. Real or not real?" Katniss responds, "Real. That's what you and I do. Keep each other alive." The camera then cuts from Peeta to Katniss to Gale, who has a pained expression on his face, and then back to Katniss. The battle between the squad and the "zombie mutts," complete with triumphant background music, gives the audience any number of "feels." We see the squad in heroic battle against inhuman monsters; we see Finnick Odair sacrifice himself. We see a desperate situation as the squad is reduced to five (Katniss, Peeta, Gale, Cressida, and Pollux, the Avox cameraman). Most importantly, we see Peeta falling back into catatonia, Katniss grabbing him, and the following ensues.

Peeta: Leave me! I'm a mutt!

Katniss: Look at me! Look at me! [Katniss kisses Peeta] Stay with me.

Peeta: Always.

This interchange hearkens back to the relationship that they had during their first Games—two people, at the point of physical exhaustion, hopelessness and desperation, and against stratagems and utilitarian logic, recognizing how important they are to each other. They survived the first Games, together, against any possible chance, by acting against the rules of the game. Katniss refuses at this point as well—consistent with her character—to succumb to mere survival or personal victory. Rather than cut

their losses for political or personal ends, she stays committed to her real purposes.

What's left of the squad finds a hiding place in Tigris's basement, and faced with the failure of their mission, Katniss reveals the truth.

Katniss: I made it up. All of it. There is no special mission from Coin. There's only my plan. Everyone that's dead is dead because of me. I lied.

Cressida: We know. We all knew.

Katniss: The soldiers from 13?

Cressida: They did too. Do you really believe that Jackson thought you had orders from Coin? She trusted Boggs and he clearly wanted you to go on.

Katniss: I never meant for this to happen. I failed . . . I killed them. I killed Finnick. I'm sorry, Pollux. I'm so sorry.

Peeta: Glimmer, Marvel, Mags, Clove, Wiress, Rue. What do all of those deaths mean? They mean that our lives were never ours. There was no real life because we didn't have any choice. Our lives belong to Snow and our deaths do, too. But if you kill him, Katniss . . . if you end all of this, all those deaths, they mean something. Cinna, Boggs, Castor, Jackson, Finnick. They chose this. They chose you.

This declaration has to come from Peeta, because he is the one who had been brainwashed by the Capitol. He sees that, for Katniss, killing now was never a personal vendetta or independent path (going rogue) for selfish purposes. She is the alternative to the image-making and falsehoods. For those who died—Rue, Boggs, Finnick, and even Glimmer and Marvel—Katniss represents a different way, an authentic hope: something to die for.

It is unfortunate almost to the point of absurdity that following this revelation of truth about Katniss, we have a conversation from the John Hughes movie *oeuvre*.

Peeta: I can't sleep.

Gale: Yeah, I haven't slept in days, either. [After a pause] I should've volunteered to take your place in the first Games.

Peeta: No, you couldn't have. She'd never have forgiven you. She needed you to be there to take care of her family, and you did. She can't lose you. She really loves you.

Gale: And the way she kissed you in the Quarter Quell. She never kissed me like that.

Peeta: Just part of the show.

Gale: No. No, you won her over. You gave up everything for her. Well, it's not going to be an issue much longer. I doubt all three of us are gonna make it out of this. And if we do, then . . . it's her problem who to choose, right?

Peeta: Right.

Gale: I do know that Katniss will pick whoever she can't survive without.

While Katniss appears to be asleep, we see that she is awake, and can hear the exchange between Peeta and Gale. Is the whole plot line reduced to a love triangle?

Throughout *The Hunger Games* films (from the middle of the seventy-fourth Hunger Games onward), Katniss attempts to carve out a space for distinctive "political" action in relationship to Peeta and Gale. So, their conversation about romantic love inevitably follows Peeta's "politiciza-tion" of Katniss's personal role, and Katniss must overhear the conversation in order to draw her back to the personal. The Capitol attempts to take away Peeta, and the rebellion shifts Gale's attention and loyalty. Unlike Bella Swan, whose original "pairing off" with Edward undergirds all of the *Twilight* story, Katniss does indeed have a difficult choice that is still to be made. If it weren't for the rebellion, both Peeta and Gale would represent almost stereotypical choices. Peeta is sensitive, an artist, whose place is in the town. Gale is physical, a fighter, whose place is the wilderness beyond the borders of District 12. Peeta would be her way up; Gale her way out. However, in the larger scheme of things, their conversation—how they frame the question, "Who will she pick?"—is mistaken and ironic. The real question is which one of them will choose the course Katniss has already chosen, which one of them will follow their course beyond both Snow and Coin.

Katniss, listening while pretending to sleep, probably does not realize the irony either. Her distinctive course has yet to be articulated, and it will

be presented to us at the climax of *Mockingjay Part 2*. Here, she has to listen and wonder. Is Gale's statement, "whoever she can't survive without" said cynically, with a just grain of truth? Or is it an honest assessment? If it is cynical, it potentially reflects on Katniss's conscious "manipulation" of both of them. We know that she is inherently media savvy, and understands even at a subconscious level what effect many of her actions have on others.[8] Yet, it is fair to suggest that even at this late point in the story, Katniss has not fully comprehended the depth of her effect on Peeta and Gale, nor on the rebellion and those who want to rally around her as an alternative to the image-making. For Katniss, it is possible to suggest that even now, she thinks that she herself is driven more by personal vengeance than by a full understanding of her political power; more by her attempt to decide between Gale and Peeta than by her own course, which will present a clear choice to each of them.

What is there to be said about the chaos of the scene of Katniss and Gale advancing to Snow's palace? In the fog of war, is it really fair to try to determine who shoots first? We see peacekeepers being blown off buildings, ostensibly by the rebels. We see Capitol citizens rushing to the palace, buoyed by the promise of food, medicine, and protection. We see lots of shooting, but we really don't know who is shooting whom. We see Gale captured by peacekeepers, and we hear him pleading with Katniss to shoot him. We see a Capitol hovercraft drop the familiar parachutes that deliver comfort in the Games, but in this instance those parachutes deliver death to the children who have been placed into the first circle around the palace. And following all of that, we see Katniss's sister, Prim, being killed in a secondary explosion, an explosion that literally transforms Katniss into a "girl on fire." The chaos of war is not resolved in any traditionally "romantic" move, and consequently there's no opportunity at this point in this story for Katniss to be a traditional heroine. Rather, she is very nearly just another casualty of war.

8. Much of this understanding is more apparent in the books than in the movies. The first-person narration of the books allows the reader to hear Katniss's thoughts about things like kissing Peeta during the Games. She pretty clearly understands the effect that their "made for television romance" has on the Capitol sponsors.

The Triumph of the Romantic

There's more to the movie, however. Katniss is brought to the mansion in preparation for her killing Snow.[9] She discovers him being held prisoner in his greenhouse, with his roses. He tells her that the Capitol was not responsible for the bombs that killed Prim and the rest of the children. To be fair, that is in keeping with his character; as he says, he does not kill children indiscriminately. He also places the blame on Coin, noting the masterful public relations stroke of broadcasting the explosions live. Is Katniss, or the audience, supposed to believe Snow, who to this point has been a master deceiver? But, as he says to Katniss, "I thought we agreed never to lie to each other." Whether these revelations are truths or lies, this conversation sows nothing but more doubt on the morality of any of the "governments" involved in the rebellion. Although there has been radical regime change, it seems little has changed for Katniss and her political purposes.

The morality of the victors is made apparent in the scene in which Coin suggests, rather than executing all of the Capitol citizens who held any responsibility or positions of power, that a "symbolic Hunger Games" be held, with children from the Capitol substituting for the traditional tributes, and feeding what Coin sees as the districts' need for revenge. Coin has brought the surviving tributes (Peeta, Beetee, Annie, Johanna, Enobaria, Haymitch, and Katniss) together to vote on this plan. Peeta, Beetee, and Annie, rather predictably, vote "no." Johanna and Enobaria, also rather predictably, vote "yes."

Katniss has to make a decision where she will stand in relationship to the new government. It would seem to any empathetic audience member that Katniss, having been through everything we've seen her go through to this point, would vote "no." However, with the one request that she has had in her heart through this entire movie granted, that she be permitted to kill Snow, Katniss votes "yes." Why? Katniss says that her vote is "for Prim." It would seem that her primary motivation remains vengeance, this time not just for herself, but for her sister. It is not hard to wrap our minds around a heroine who is driven primarily by vengeance, but for this character, given what she has stood for, we would expect this kind of vengeance—continuing the Hunger Games—to be out of the question. We (the

9. The scenes of Katniss walking through the mansion show us that whatever else the rebels might be, they are extremely well mannered. The mansion is untouched; no looting, no graffiti, no broken windows; quite surprising, but perhaps a signal that little has changed.

audience) are willing to believe in vengeance even though we should know that Katniss would have her doubts about killing Snow for Prim. Snow has just denied responsibility for her death. It's also hard to wrap our minds around Haymitch's vote. He simply states, "I'm with the Mockingjay." As he has grown as a character through the films, he's become much more of a surrogate parent for Katniss, or at least a trusted advisor. Normally, he would protest. Nevertheless, he looks at her as if her "yes" vote was a great surprise, swallows hard, and votes to continue the Games.

Whatever the real reason for Katniss's affirmation of the Hunger Games, it does heighten the dramatic tension that is basic to all *The Hunger Games* films, and is at the core of Katniss's character and heroism. Will a desire for personal vengeance require the suffering and sacrifice of others, for her sake? Or will her "personalism," her rejection of strategies and utilitarian calculations, require and establish a different way and an alternative "politics"? Katniss's "yes" to the Hunger Games is so implausible that we can see, retrospectively, that something else is in play, and the movie shows us what that is, as well as Katniss's realization of her purpose. In the end, she goes to the center of the Capitol, alone, with her own plan. Here we can look back to Johanna's send off when Katniss set out to assassinate President Snow, "Anybody can kill anybody, Katniss. Even a president. You just have to be willing to sacrifice yourself."

On her way to the center of government, the chariots from the previous movies are gone (although the rebels seem to have gotten their hands on the kettledrums), and Katniss, in full Mockingjay regalia, marches down the "Avenue of the Tributes," bow in hand, followed by a group of people who, if only because of their costumes, seem to be rebel citizens—the masses. She reaches the circle where the chariots would stop, only this time she is met by the six living victors, by President Snow somehow attached to a marble column and smiling to suggest that he is a willing victim (a scapegoat?), and by President Coin standing above all of them on the podium where Snow would, under his regime, deliver his pronouncements. Coin's speech is full of irony.

> Welcome to the new Panem. Today, on the Avenue of the Tributes, all of Panem, a free Panem, will watch more than a mere spectacle. We are gathered to witness an historic moment of justice. Today, the greatest friend to the revolution will fire the shot to end all wars. May her arrow signify the end of tyranny and the beginning of a new era. Mockingjay, may your aim be as true as your heart is pure.

As Katniss draws an arrow from her quiver, the film cuts between a number of close-ups—Katniss to President Snow and back again. The music swells. Katniss takes aim at Snow.

Then, in what we have previously labeled as an "improvisatory moment" along the heroine's path, Katniss looks up, then fires her arrow directly into President Coin's chest. But is this improvisation? Or rather, is this just the movie's manifestation of a decision that Katniss made when she was sitting with the other victors, voting on Coin's plan for a new Hunger Games? In either case, the act is clear-sighted and deliberate. If she had killed Snow she would be hailed as a hero. In killing Coin instead, she has to accept that it will mean her own death. Katniss has chosen her own path, rather than a path prescribed to her by any of the characters who wanted to control her. She clearly does not kill Coin in a fit of passion, as her shift in aim, from Snow to Coin, seems more than a little deliberate. Also, the fact that she has taken the suicide capsule with her ("nightlock") intending to use it following assassinating Coin points to the deliberate nature of her actions. It is perhaps more to our point in the context of our argument to suggest that in the anti-romantic world that Collins and the movies have created, Katniss has finally taken control of her own destiny. She is no longer driven by outside forces. She is no longer doing what anyone expects her to do: Peeta looks at her in shock and horror, and undoubtedly, she has destroyed Gale's hopes. She establishes a new world from within, in a way others could not have imagined. It hard to say whether she "saves" Panem, but considering Heavensbee's satisfied grin, we can suspect that she has. In any case, she certainly gives the world a new beginning.

Katniss' life and story could end at this point: She sacrificed herself to oppression and war. But that is not the kind of story that will satisfy us. We need to see Katniss healed and restored. After she assassinates Coin, she is taken into custody, but it is surprising to us (and obviously to her) that she is not imprisoned. Rather, she is placed in the palace under guard. When the guards disappear and Haymitch appears, we have to wonder what will happen next. Haymitch's first words begin to reveal the consistency of Katniss's character. "Well, I'll say this for you, Katniss, you don't disappoint." He has a letter for her from Plutarch, but Katniss refuses to look at it. So Haymitch reads it aloud.[10]

10. Phillip Seymour Hoffman died before filming could be completed. The letter that Woody Harrelson reads is composed of the material that Plutarch would have said to Katniss. The letter also clarifies much of what many of the "adult" characters expect from Katniss.

Plutarch Heavensbee—the gamemaker—saw Katniss as Panem's best hope, precisely because she was not controlled by the "game." Here, we witness clear confirmation, from the sage of the film series, that Katniss has not been acting erratically or impulsively, but has been following a predicable course (even if only he had eyes to see). "Katniss, maybe the country was shocked tonight by your arrow, but once again, I was not. You were exactly who I believed you were." He explains that any contact with Katniss, at this point, would lead to political speculation and perhaps cause undue stress upon the country's free election for president. Plutarch notes, with confidence and as reassurance to Katniss, that Paylor has "become the voice of reason" and is certain to carry the election. Then he turns to Katniss's role in this new beginning.

> I'm sorry so much burden fell on you. I know you'll never escape it. But if I had to put you through it again for this outcome, I would. The war is over. We'll enter that sweet period where everyone agrees not to repeat the recent horrors. Of course, we're fickle, stupid beings with poor memories and a great gift for self-destruction. Although, who knows? Maybe this time we'll learn. I've secured you a ride out of the Capitol. It's better for you to be out of sight. And when the time is right, Commander Paylor will pardon you. The country will find its peace. And I hope you can find yours.

Although the letter recognizes Katniss's independent action, it does continue to show that political manipulation was and is at play. In response, Katniss mumbles, "What now?" Haymitch responds, "Home. We go home."

Of all people, it is left to Effie Trinket to say what needs to be said to this broken young woman: "It's your job to take care of yourself now, Katniss." And what that will entail is part and parcel of the last scenes of the movie—Katniss's final healing. The first steps in that healing are small steps. Katniss and Haymitch return to the Victor's Village of District 12, and Katniss moves back into her old home. After some passage of time, Buttercup, Prim's cat (against all odds), reappears in the kitchen. Katniss's first response is to scream at the cat that Prim is dead. After weeping, she holds the cat tight to her chest. In the next scene, we see her hunting in the woods, undoubtedly returning to old comfortable routines. Returning from (what we might assume) a hunting trip, she comes across Peeta, planting primroses that he says he found at the edge of the forest. Overcome with emotion, Katniss embraces him.

It's evident from this point forward that Katniss has begun to heal. A normal life begins, as Katniss, Peeta, and Haymitch perform all of the "little things" that are part of a routine. Finally, the moment that the movie audience has been waiting for happens, as Katniss makes her way to Peeta's bed. As she slides in next to him, we hear the words we've been waiting for. Peeta asks, "You love me. Real or not real?" And Katniss answers, "Real." We come to the final scene in the movie, where a CGI-aged Katniss and Peeta sit in a meadow (which is becoming a standard life-is-good trope), playing with their two children.[11] The baby in Katniss's arms starts to fuss, and she calms it with these words:

> Did you have a nightmare? I have nightmares, too. Someday I'll explain it to you. Why they came, why they won't ever go away. But I'll tell you how I survive it. I make a list in my head of all the good things I've seen someone do. Every little thing I can remember. It's like a game. I do it over and over. Gets a little tedious after all these years, but there are much worse games to play.

So, in the end, has Katniss Everdeen saved the world? It's hard to know if she's saved even this tiny little part of the world that she and Peeta and their children live in. It's also hard to know whether she and Peeta have found healing, given that she still has the nightmares. It's fair to suggest, given the atrocities that Katniss and the other tributes suffered at the hands of the Capitol, as well as the manipulation she suffered at the hands of the rebellion, that Katniss may never be fully healed. It's also fair to suggest, as Plutarch mentions in his letter, that this world may only be healed for a short time, and that humanity's baser instincts will eventually come to the surface yet again. However, in this place, for this moment in time, Katniss Everdeen has found peace and redemption. And that maybe all that any of us, even for a moment, can hope to find.

11. The novel tells us that this meadow is the overgrown graveyard of District 12. Apparently, this is something that the movie did not want to communicate quite so clearly.

Appendices

The Hero and the Heroine: Are Their Quests Different?

"The Hero's Journey" is a commonly used shorthand phrase that refers to the work of twentieth-century mythologist and scholar Joseph Campbell, whose work in comparative world mythology has been used in discussions of modern and contemporary psychology and sociology, in literary analysis, in storytelling workshops, and in numerous books, symposia, and websites devoted to teaching the craft of screenwriting to aspiring artists. Campbell is probably most recognized by contemporary audiences through his books *The Masks of God* and *The Hero with a Thousand Faces*, and through the documentary that he made with Bill Moyers for PBS, *The Power of Myth*. In that documentary, the point of reference that Moyers uses most frequently is George Lucas's *Star Wars* films, and the journey that Luke Skywalker takes through what we now identify as "the three movies in the middle" has come to be identified as the classic example of the journey that Campbell describes in his work.

If, as Campbell suggests, mythology and storytelling in numerous world cultures tells similar stories of the quest that a hero takes toward self-knowledge and reintegration with their community, it's also not surprising to note that his work focuses almost entirely on masculine heroism. After all, his major work grows out of its time—the mid-twentieth century, with foundations not only in the traditions of anthropology at the time, but also the psychological work of writers like Karl Jung and Sigmund Freud. Other comparative mythologists worked to uncover stories focusing on the female, but if only because Campbell's writings fit so well with the critical and cultural theories of the time, the scales tipped toward Campbell's approaches.

Obviously, from the last half of the twentieth century forward, culture has changed. And with those changes comes a renewed interest in mythologies focused on the feminine. That work is much too deep and broad for us to recount in this book. Nevertheless, in two of our four sagas, the central character is a woman, and in our longer examinations of the movies, the fact of their "womanness" is a major part of our critical analysis. It is fair, then, to spend some small amount of time thinking about how a heroine, simply through her femaleness, could possibly take a different path through her quest than would a male hero.

Since the turn of the twenty-first century, the Internet has been rife with versions of Joseph Campbell's theories that attempt to articulate a "Heroine's Journey" that fits, or doesn't fit, the pattern of his "Hero's Journey" while using female characters. Most of the Internet material that comes immediately through a Google search seems to focus either on the changes in a "Heroine's Journey" that writers (novelists, screenwriters, essayists, and so on) should use in creating female-centric stories, or on various self-help modalities for women. Depending on when the text on the website was written, various examples of heroines are used. In the last ten years, not surprisingly, a heroine most often used as a positive example is Katniss Everdeen.

It may be too simple a question to ask at this point, but why not Bella Swan? Does Bella compare unfavorably to Katniss as a heroine? Is Bella's path through her life somehow less than Katniss's path? Comparing the two heroines to the generally accepted principles of the "Heroine's Journey" might be of some help. A post on the website Fangirl.com (www.fangirl-blog.com), "The Heroine's Journey: How Campbell's Model Doesn't Fit," is a conveniently titled starting point.

In this post, B. J. Priester (the author) writes that a huge difference between Campbell's hero and modern heroines is that the hero rarely, if ever, even acknowledges women as a part of his quest unless they fulfill the classical roles of "Goddess" or "Temptress."[12] Another major difference is that the hero very often sets out on his quest alone, without too much regard for the family/community he is leaving, and without too much concern for how his actions have much of an impact on the family/community to which he will return. In Priester's construct, the hero's journey is primarily a journey of self-realization, and not one that extends its reach too far beyond the individual. This is not to say that a hero's journey couldn't be focused on his community as well, just that his primary motivation tends to be self-directed.

In contrast, the "Heroine's Journey" that Priester develops has the following characteristics:

- a strong female character who stands on her own as a woman rather than any kind of "accessory";

- a character who acknowledges and depends on the characters around her;

12. Priester, "The Heroine's Journey: How Campbell's Model Doesn't Fit."

- a character who lives in a contemporary world, rather than referencing any past mythologies.

His example? Katniss Everdeen, as well as other strong female characters like "Buffy, the Vampire Slayer" and *Alias*'s Sydney Bristow. Our question is: Does Bella Swan fit those characteristics noted above? Bella might not begin the *Twilight* Saga as a strong woman, but by the final movie, she has clearly grown in strength and, although she stands alongside Edward, she is most definitely not just an accessory. Bella also depends on the characters around her, although an argument could be made that her "Team Edward/Team Jacob" indecision is an example of a little bit too much dependency. Bella's world is also a contemporary world, even as it references vampire and werewolf legends. Finally, Bella's journey (as we have mentioned previously) is one in which her self-realization of her power is directly connected to her role in uniting the vampire and werewolf communities against the Volturi. In fact, the insecure teenager that starts her story with *Twilight* has become, by the end of *Breaking Dawn, Part 2*, a confident and powerful woman, as well as the "new matriarch" of the Cullen vampire family.

It's also possible to examine Nolan's *Batman* trilogy and the *Bourne* trilogy for evidence of those two heroes doing more on their quests than simply realizing who they are. Although that journey of self-realization is literally important for both Batman and Jason Bourne, the actions of both characters through the course of their stories also have directly positive impacts on their communities. Jason Bourne, with the assistance of Nicky Parsons and Pamela Landy, uncovers the corruption in Treadstone, Blackbriar, and various other offices of the CIA. Bruce Wayne takes on the identity of Batman initially to purge Gotham of the criminality that led to the death of his parents, but by the end of *The Dark Knight Rises*, Batman has become the emblem for the overthrow of oppression (that oppression represented by Bane) and the restoration of a positive moral order.

Are we suggesting that our heroes are as "feminist" as our heroines? No. It is, however, interesting to note that in all four cases we are examining, the differences between the "Hero's Journey" and the "Heroine's Journey" that are noted by various commentators are differences primarily of degree. All four characters achieve self-knowledge at the same time their quests change the worlds in which they live.

The Moral World of *The Hunger Games*

In assassinating the president of the revolutionary government (Coin), Katniss Everdeen finally puts an end to the Hunger Games. To make this point clear and indisputable, we witness President Coin asking the surviving tributes to vote on whether or not the Games will continue. The implication is clear; Coin might not be much different than Snow, except that President Snow and Katniss had agreed not to lie to one another. In an effective move of deception, Katniss signals to Coin that she is on the new president's side. Katniss affirmatively votes to hold another Hunger Games, in order to exact symbolic revenge upon the elite of the Capitol and real terror upon their children (who will be the new tributes for the Games). Her vote seems to be a *quid pro quo* in exchange for the privilege, granted by Coin, of her appointment as Snow's executioner. She will, of course, execute Coin instead.

It should give us pause that the hero—the one known for her authenticity and forthright character—brings the story to a conclusion by feigning fidelity and by killing in a way that would otherwise be considered villainous and cowardly. Katniss kills Coin not in self-defense or the defense of another, not in the heat of combat; she shoots the president deliberately (watch Katniss's eyes in the scene), as Coin stands defenseless, weaponless and arms open (as if to expose her heart). To make matters worse, Peeta is confounded and shocked. It seems that Katniss has taken the side of the Capitol. President Snow (the evil one) reacts to Coin's death with maniacal laughter. What does this climactic event reveal about the moral world of *The Hunger Games*? Despite our heroine's quest for authenticity, is her world a bottomless pit of images and illusions piled upon more images and illusions?

Our answer is, "yes and no." On the side of "yes": the grounding of authenticity in Katniss as a person and her relationships is consistent throughout the films. Authenticity is the consistent theme, not only as the core of Katniss's character, but also in the sense that who she is and her relationship are always contested: "You love me. Real or not real?" The denouement of *Mockingjay, Part 2* makes it plain that there is, in the end, a stable setting to know what is true; that is, outside the city, in the meadows of the old District 12, Katniss and Peeta enjoy life with their children. The scene give us something true to hold on to. However, this same scene gives us a hint that the final answers to the questions of moral realism and authenticity might be negative. The meadow is a dreamlike place, far outside

the city and society, outside the structures of government and commerce. Sunny meadow with loving couple: real or not real?

The meadow scene and its domestic tranquility highlight the romantic themes that we have been identifying throughout the book. To find redemption and healing, Katniss and Peeta need to live outside of society, in a private realm, detached from common life. We don't know how they secure food and clean water, where they get their clothes, or what they do when the roof starts to leak. The reality of their love, in other words, is set within a place set apart from the realities of life. Perhaps, this romantic end is necessary because the hero's attainment of this other-worldly life is what we need from film. The theater is our place, apart from the world, where we witness good but troubled people struggle against the leviathan. They lose a great deal, but they find restoration—an almost heavenly redemption—in the end.

6

How It All Ends

In two days in July 2016 (specifically, July 18 and 19) the USA Network broadcast two movies that show the destruction of London—*GI Joe: Retaliation* and *Star Trek: Into Darkness*. In fact, various London newspapers, websites, and so on posted variations on the "What Did London Do To You?" theme. Should we make something of the fact that both movies were sequels? Probably not. Nevertheless, it is at the very least interesting that London, England is one of the geographical touchstones for CGI destruction.[1] It's also fair to note that in two huge action films of 2016— *Batman V Superman: Dawn of Justice* and *Captain America: Civil War*—a major plot point is the destruction that follows in the wake of superhero/ supervillain clashes. In both, the point is made that "collateral damage" at the hands of heroes is sometimes too easily dismissed, and that these super-powered heroes need to be responsible for their actions. What ought it cost the world to be saved—to see evil vanquished just long enough for a return of some other villain in a sequel?

Save or destroy or a little of both? If we are following an archetypal storytelling pattern, then is the question of the relative "success" of the hero moot? Shouldn't we simply expect that the hero will embark on some sort of quest, possibly fail in a number of attempts, and then finally achieve some sort of success, insight, or maturation based on the results of the journey? In our world, this personal journey is most often depicted in a framework of romantic love and a romantic characterization of the real, authentic self who stands against a world of utilitarian calculations and machines.

1. "Film-makers, what has London ever done to you?"

Certainly, we will watch horror films where good people are under attack by marauding, bloodthirsty vampires. But there is something even more pernicious about a self-appointed, organized vampire government, which gains a near monopoly of vampire superpowers and plots to annihilate any rivals to its power (for a less super-powered example of this, see *The Purge* series of films). In this case, the success of the hero will be to sustain and perpetuate a loving vampire community in contrast to the hard and cold vampire world.

There is a story told now and again about a man who, living under the oppression of a world-dominating empire, gathers people with a message of love and forgiveness and then heads into the empire's stronghold, defenseless and alone. For centuries, hopes had been alive among his people that an anointed one would be raised up, in order to throw off corruption, greed, and war and set the world right—for all peoples. As drama builds toward the climax, our hero enters the city—he goes straight at the empire's seat of oppression—drawing on his people's memories, images, and hopes of a warrior king. At the decisive moment of confrontation, however, he does not appear to deliver on this people's expectations. He is executed. The gathered people are scattered; it looks like the bad end has come. Yet, against all expectations (again), he lives again, to gather his people again and to announce that everything has changed; God's way of love and forgiveness has won—so thorough a victory of love that the empire will not be destroyed, but allowed to play itself out and fall under its own quest for power, as empires are wont to do.

There is in our time a desire to see evil powers vanquished and, at the same time, to see our broken heroes healed by love. We do not claim that the films that we treat in this book are imitations or repetitions of the gospel story. Quite the contrary, these films draw on a whole host of images and heroic patterns, religious and secular, and we have not tried to separate out their archetypal genealogies. Our concern has been to show that, in our time, some basic religious needs and desires are still in play and that there is a type of film that combines world-saving action with struggles for deep human connections, a desire to stand with others authentically and to be embraced in their love. In our time, the confrontation with the powers of oppression is depicted on a grand scale in film; corruption is deep seated and the battles magnificent. Love, in contrast, takes on a romantic, interpersonal (private), and other-worldly, simple cast. These two plot trajectories—cosmic agonism and interpersonal peace—are set in an

irresolvable tension by their very nature. In film, however, we are able to see them resolved and undone, again and again.

Action

It is difficult to think about contemporary popular cinema without thinking about the concept of the big-budget blockbuster action movie. Despite the huge number of hits that you get when you search "definition of action film" on Google, however, there is not a good single definition of the phrase. Film scholars, film critics, film students, and just about anyone with a high-speed internet connection seem to want to define the phrase for themselves. The Wikipedia entry could be considered a starting point:

> Action film is a film genre in which the protagonist or protagonists end up in a series of challenges that involve violence, close combat, physical feats and frantic chases. Action films tend to feature a resourceful hero struggling against incredible odds, which include life-threatening situations, a villain, or a pursuit which generally concludes in victory for the hero.[2]

Beyond those broad strokes, however, it is sometimes difficult to interpret how various film critics and websites define the specific genre of "action film," or for that matter how many different kinds of "sub-headings" fit under that large umbrella. For example, is the *Twilight* Saga also a set of horror movies? Is *The Hunger Games* franchise science fiction? Are the Bourne movies spy thrillers? And, as a quick review of Internet lists would have it, Nolan's *Dark Knight* films are variously comic book movies, adventure movies, science-fiction movies, and/or action movies. Clearly the genre admits a lot of participants into its boundaries.

Perhaps a better way to compare the films treated in this book to the broad category of "action films" is to pinpoint how our heroes match up to action heroes in general. In "From Swashbucklers to Supermen," David Ehrlich gives a very quick walk through film history, from silent film acrobats like Buster Keaton and Harold Lloyd to contemporary actors ranging from Tom Cruise to Liam Neeson and even to Sigourney Weaver.[3] As much as it would appear that the article was designed to coincide with the release of 2015's *Mission Impossible: Rogue Nation* and with a conclusion that Tom

2. "Action Film."
3. Ehrlich, "From Swashbucklers to Supermen."

Cruise's Ethan Hunt is the high point of contemporary action heroes, the article does make some very salient points for our discussion. For example, Ehrlich includes early silent film actors like Keaton and Lloyd, especially with reference to their physical abilities, so that the character of the action hero requires a definite physical presence (within intended emphasis on physical). These heroes can do things that the audience can't physically accomplish, and they can do it with a flair and panache at which we can marvel but not achieve.

Ehrlich also identifies some of the "categories" into which these characters can be placed: "swashbucklers" like Douglas Fairbanks and Errol Flynn, "lone wolves" like John Wayne, "vigilantes" like Clint Eastwood's Dirty Harry, "every-heroes" like Bruce Willis's John McClain from the *Die Hard* series, and even the newest generation of superheroes from DC and Marvel Comics. It's fair to suggest that, for the characters we are discussing in this book, only Batman/Bruce Wayne fits cleanly into any of these categories. Jason Bourne could be considered an "everyman," but between his Treadstone training and the way he uses that training, he's pretty clearly close to being "superheroic." Both Bella Swan and Katniss Everdeen take on roles and responsibilities similar to those that we see from Ellen Ripley (Sigourney Weaver) in the *Alien* movies, but if only because of the romantic plot threads in which both of our characters are entangled, neither Bella nor Katniss seem to rise to a level of strength and power necessary to kill monstrous aliens in outer space. They have to negotiate an earthly romantic path as well as a heroic path.

Indeed, all of our heroes have to negotiate romance amid their epic battles and acts of heroism. Their heroic acts, at least those that are part of the "action" side of their movies, are actions that are part of their mission of "world saving." In many traditional action movies, the hero fights alone, performing their heroic acts by themselves (for example, Bruce Willis's John McClain fights alone, Dirty Harry trusts no one, Steve McQueen's Bullitt doesn't even have a partner). In every case in our movies, the heroes are assisted in their fight by the community, or some part of the community, that they are defending.

The most obvious example of this collaboration and common work, especially in the way the movie story is constructed and the films are edited, is the *Batman* saga. At the very beginning, it is made clear that, despite their wealth, the Wayne family had a long history of supporting the infrastructure of Gotham. The identity of "Batman" was created by Bruce not

only to engender fear in the criminals, but to nurture hope in the hearts of the citizens. At the end of *The Dark Knight*, Batman famously allows Harvey Dent to become "the hero that [Gotham] needs," so that Gotham can be healed. Perhaps most obviously, the last beats of *The Dark Knight Rises* display the growing sense of purpose in the citizens of Gotham. The police march on Bane's army. Blake (Joseph Gordon-Levitt) and the orphans go from door to door, collecting citizens to escape the potential catastrophe. And, it is certainly significant that the most self-interested (non-altruistic) character in the movie, Catwoman/Selina Kyle, returns (calling herself a fool) to help Batman rather than escape. The saving of the world that is Gotham comes about because the city finally gets the true hero that it both needs and deserves.

As *The Hunger Games* movies move through from beginning to end, the character of Katniss Everdeen, and her relationship to the growing rebellion in Panem, follows very much along the same path as Batman. Indeed, it becomes clear by the end of the first movie that Katniss is the heroine that Panem needs. In fact, we quickly learn that Katniss is needed both by the Capitol and by the rebels. It's an easy step to suggest that Katniss's personal rebellion through the *Mockingjay* movies is a rebellion against what both the Capitol and the rebellion want her to be. Nevertheless, given the state of things in this particular dystopia, it is clear, even with a figurehead as powerful as the Mockingjay, that a rebellion would not be possible without the participation of all of Panem's rank-and-file citizens. That obvious point is made clear at any number of points in the saga, from the adoption of Katniss's "three-fingered salute" to uprisings against Peacekeepers to blowing up dams and finally to full military revolution. Katniss's actions help to save her world, but the rest of her world has to fight as well.

The world that Bella Swan saves is much smaller than Katniss's Panem or Batman's Gotham. Although it's unclear how many vampires there are in this particular world, we can probably assume that the population base is narrower. Still, no matter how powerful Bella has become as a "young vampire," the Cullen clan still needs the assistance of like-minded vampires and the Quileute werewolves to defeat the Volturi (even if that defeat, despite the "action film nature" of the battle, is really only in Aro's imagination). In many ways, nearly the whole of *Breaking Dawn, Part 2* (aside from those parts of the movie that deal with the evolution of the relationship between Bella, Edward, Jacob, and Reneesme) can be seen as the building of a new, more powerful vampire alliance, as well as building an unexpected

vampire-werewolf alliance. It's possible to suggest that Bella's true hero-ism lies in taking her place as the young matriarch of a new supernatural community.

If we follow the logic used to discuss the other three series, then, un-fortunately, we have to conclude that Jason Bourne does not "save" a world. He certainly receives hardly any assistance from a larger community. As we have noted, Bourne's assistance comes from individuals: Marie, Nicky, Landy, Heather Lee (in *Jason Bourne*). On the other hand, as we have men-tioned before, once he deals with Marie's death, he achieves a great deal of clarity about who or what his enemy is. We have called it "the leviathan," as if to suggest that the object of Bourne's quest could be seen as an ancient monster. It is fair that Bourne could be seen to be as monomaniacal in his quest as Captain Ahab is in his for Moby-Dick, but the outcomes are obvi-ously different. In Bourne's case, the leviathan actually created him, training David Webb to be the lethal assassin Jason Bourne. As Bourne gets closer to discovering the truth of his identity, he also gets closer to the center of that corrupt leviathan, or in this case the corrupt espionage community.

Perhaps it is as much a function of the omnipresence of that espionage community, and of the all too human motivations of many of the leaders of that community, that shows the ultimate futility of Bourne trying to save that world. In a very realistic sense, the world that Jason Bourne can save is the world that he can control, and when that world is destroyed (with Ma-rie's death), Bourne can become the avenging hero, but we have to wonder whether or not he will ever find peace when so much of his larger world is out of his control. The realism of the *Bourne* saga, from the lack of CGI ef-fects to the gritty handheld camera work, makes the films particularly com-pelling for an audience. Bourne is not a comic book superhero or a vampire or a dystopian science-fiction character. Rather, despite a fair number of plot points that stretch credulity, Jason Bourne can easily be seen to exist in our world (and for that reason we know it cannot be saved).

In fact, many of the character traits of all of our heroes can be seen as quite realistic. Everything from Bruce/Batman's medical conditions to Kat-niss's poverty to even Bella's depression can be seen in our world. However, it is not our intention to suggest that the heroes in our movies are somehow "better" than action heroes in other mainstream movies. We would hope that the reader at this point might conclude that we are suggesting that our heroes are to some degree more realistic and more three-dimensional than many of the other examples that could have been discussed in the book. It

is perhaps an argument for another time to point to characters from other movies who have to negotiate the tenuous balance between "soul healing" and "world saving." At this point, it might be enough to suggest that the stories that these movies tell—whether the hero saves the world or not, whether the heroine gets the boy or not, whether any character achieves a clearer vision of their place in their world—are stories that tap into myth, legend, and human behavior both good and bad to entertain, and perhaps to enlighten and inspire. The movie theaters and online streaming in our homes pull us out of our world into the story of another world, where we can feel the struggles of our own.

Romance

We have been using the term *romance* as a shorthand term to refer to this sort of plot device in any character's journey. Indeed, it would be almost impossible to catalog the stories, plays, and movies in which heroes and heroines, whether or not world saving is a part of the plot, eventually get the boy or girl. A film that we have been discussing between ourselves as an example of this type of romance is Garry Marshall's *Pretty Woman* (1990), in which Richard Gere's Edward saves Julia Roberts's Vivian from a life of prostitution, while she delivers him from a cold, utilitarian life of banks, boardrooms, and boredom. Placed into a context of a contemporary fairy tale, Edward and Vivian drive off together at the end of the movie, after confirming all of our romantic expectations:

> Edward: So what happens after he climbs up and rescues her?

> Vivian: She rescues him right back.[4]

Or, consider a film that is framed as an actual fairytale, like *The Princess Bride* (1987). At the conclusion of the movie, in voice-over, the grandfather, who has been reading this story to his sick grandson, says the following, while Westley (the hero) and Buttercup (his lady love) gaze longingly at each other (and eventually kiss): "Since the invention of the kiss, there have been five kisses that were rated the most passionate, the most pure . . . this one left them all behind."[5]

4. *Pretty Woman*, DVD.
5. *The Princess Bride*, DVD.

An action movie series that follows very much the same pattern of "the hero saving the damsel" is the *Mission Impossible* series, starring Tom Cruise. In *Mission: Impossible III* (2006) for example, Ethan Hunt's (Tom Cruise's character name) fiancée (and later wife) functions as a damsel in distress who is used to trap and manipulate the hero, and who he eventually saves by the end of the movie. Here, the hero's romantic desire provides a personal level of motivation for battling the villain. In *Mission: Impossible: Ghost Protocol* (2011), the apparent death of Hunt's wife becomes a secondary plot thread, serving to allow the audience some sympathy for both Hunt and Brandt (the IMF agent who was supposed to be her protector). Thus, she becomes the object of hero's romantic longings, and remains outside the primary plot of the movie until the very end. The knowledge that we get at the end of the movie, however—that she is still alive—clearly adds a noble dignity of courtly love to Hunt's character, as we see that he still loves her and protects her from afar.[6] By the time of *Mission Impossible: Rogue Nation* (2015), Hunt's wife has disappeared from the plot line. The audience could assume that Hunt is still watching over her; an expectant audience might actually want to see her.

These narrative devices (that the hero serves as a protector/savior/ eventual mate for a lady love), seen in both *MI: III* and *Ghost Protocol*) are utilized in *The Bourne Supremacy* and *The Bourne Ultimatum*. *The Bourne Identity*, however, represents a deeper interweaving of romance and action. Indeed, in nearly all of the movies we are examining, that interweaving of romance and action is necessary for the hero to find both the healed soul and the saved world. For our purposes at this point, we would like to suggest that a "healed soul" connects to the romantic tropes that we have been developing, while the "saved world" connects to the actions of the hero while on their quest. If the heroes can find romance at the same time they battle their particular enemies, then souls and world can potentially be knit back together. This is, however, a very delicate balance to try to achieve.

Is "healing the soul" an inevitable conclusion to the romances that we see in these movies? When these heroes and heroines "fall in love," are they succumbing to the inevitable, or rather, are they consciously participating in a necessary part of their larger quest? Conversely, is "saving the world" necessary for a hero to feel that his or her mission has been fulfilled? Does every crisis need to be averted? Does every villain need to be vanquished?

6. Hunt's serving as Julia's protector is almost classically chivalric—despite the fact that she's actually married to her protector knight.

And, even if these characters fall under the broad umbrella of "action hero," must we consider the larger moral issues that are at play with some of their actions? For example, do they have a "license to kill," killing indiscriminately on the way to the climactic confrontation with the major villain? Can we expect that the hero's moral framework will be able to be replicated in the larger world? Can we even compare their moral framework to that of a dystopian future, or a corrupt espionage community, or a Gotham in which rich and poor seem always divided?

It is fair to suggest that, in films like *Pretty Woman*, where "they all lived happily ever after" could flash on the movie screen right before the credits roll, that romance, fantasy, and fairytale win out over realism. Conversely, in three of the four movie series we are examining, whether the framework is vampires or superheroes or science-fiction dystopias, a more realistically satisfying, if less fantastical, combination of self-discovery and world saving happens. Only in the *Bourne* series, which in many ways presents to the audience a more "realistic" picture of the world than do the other three "sagas," does the character lose love and not regain it. And, only in the *Bourne* series does it seem that all of the hero's actions, in the end, wind up not counting for all that much against the leviathan that he battles, in this case the espionage community. A simple answer could be that the *Bourne* movies were not conceived as a continuous narrative, whereas the stories of Bella and Katniss come from their novels, while the "*Dark Knight* arc" was conceived by Christopher Nolan as a single story told as a trilogy.

Examining all four series only as romance, the romantic does carry the tone of "other-worldly" liberation. In *Twilight* and in *The Hunger Games*, we see a very traditional romantic triangle, with the heroines in both eventually having to choose between two very different male suitors. One could also suggest that once Bruce Wayne/Batman loses Rachel Dawes, he too is in the position of choosing between two different women. To be fair, one of those women, Miranda Tate, turns out to be Talia al Ghul, the daughter of his greatest enemy and the driving force behind Bane's takeover of Gotham—not a particularly good choice for Batman. But this is the point: Miranda represents destruction of Bruce's world, while Selina Kyle/Catwoman is his companion as he achieves personal liberation. In the *Twilight* series, the audience really does know from the beginning that Bella will end up with Edward. For all of the support that "Team Jacob" has, Edward and Bella are fated to be together—as Edward represents her liberation from the bonds of the human world and her eternal possession of love. In *The*

Hunger Games, Katniss's choice is much more fraught with potential problems. In the films, Gale is initially depicted as the "proper match;" with the same background as Katniss, and sharing many of the same concerns. Only through the course of the movies do we see the development of the relationship between Katniss and Peeta, with various scenes through the four movies depicting the growing connection and eventual intimacy between them. Peeta will be the one who trusts Katniss's path beyond the political and social "games" of the corrupt world.

How do any of these four series show how romance helps to heal the hero's soul; to put it another way, do any of the eventual couples "rescue each other right back"? Again, in the case of *Twilight*, it is easy to see how Bella and Edward rescue each other. Edward literally saves her from any number of attacks through the first four movies, and, by eventually transforming her into the vampire that she has wanted to be, "saves" her from her mortal life, and makes her immortal. By the end of the entire saga, Bella saves not just Edward, but the entire Cullen vampire culture, and, through giving birth to Renesmee, secures Jacob's fate and unites the vampires and the werewolves.

In the *Batman* saga, as we have suggested, it is easy to see how Bruce Wayne's ultimately misguided love of Rachel drives him to difficult and unfortunate decisions by the end of *The Dark Knight*. His hope for a "normal" life with her cannot be fulfilled, and her death can be seen as one of the factors in his eight-year hiatus from being the Batman. In *The Dark Knight Rises*, the Bruce-Miranda-Selina triangle is not really a triangle in a traditional romantic sense. Nevertheless, the fact that Batman eventually persuades Catwoman to give up her life of crime, and apparently join him in some sort of "normal" romantic relationship in Europe, would seem to indicate the "healed souls," or at least the new and uncorrupted beginnings that both of the characters are searching for.

As mentioned above, in *The Hunger Games* film series, the audience is witness to the growing relationship between Katniss and Peeta. Given the film evidence, it is possible that the screenwriter wanted to show the development of that relationship in contrast to the already existing relationship between Katniss and Gale. Since the movies do not have Katniss's first-person narration from the novels, we don't hear her trying to negotiate the two relationships, as she does for nearly all three of the books. Thus, what the audience sees in many ways is the growth of a "cinematically traditional" romance between Katniss and Peeta, with both of them filling the gaps in

the other. At any number of points in the first two movies, both characters literally save each other from death. Then, through both *Mockingjay* films, Katniss is Peeta's lifeline back to sanity, and, by the end of *Mockingjay, Part 2*, Peeta has taken some measure of responsibility to help Katniss back into some semblance of a normal life.

In the *Bourne* saga, Jason's love for Marie clearly sets him on a path toward healing, and at the end of *The Bourne Identity*, we see the two of them attempt to begin the idyllic existence of a traditional romance. Unfortunately, that romance is destroyed by the leviathan, and through the next two movies, Bourne is not driven by a goal of romance; rather, he is driven by his desire for revenge. Not surprisingly, after Marie's death, neither of the next women in Bourne's life (Nicky Parsons or Pam Landy) fills the space in Bourne's soul that Marie's death has left).

So, in a comparison of the four sagas, who is healed by love? Jason Bourne seemed on the path to healing, and Marie's death seems to create a hole in him that cannot be filled. Bruce Wayne/Batman does not seem to be healed by romantic love, but rather by his understanding of a more universal and human interrelationship; by an understanding of his place in the larger human community. Bella Swan is not "healed" by love; she's healed by Edward's vampire venom. It's more to the point to suggest that Edward's fractured vampire soul is made whole by Bella, and that one part of the entire saga can be seen as Edward coming to understand the power of Bella's soul. It is perhaps Katniss Everdeen, by the end of her cinematic saga, who can most be seen as healed by love. In her case, it is not just Peeta's romantic love that saves her, but also her love for the family that she and Peeta are creating, as well as her continuing maturation. She begins the series as a sixteen-year-old girl, whose love for her sister causes her to "volunteer as tribute" and replace her in the Games. It is the death of Prim, that selfsame sister, that finally fractures Katniss's naïveté, and eventually allows her to see how she has been manipulated by the Capitol and the rebellion. And it is both the mourning for that sister and the eventual connection with Peeta that give the audience a sense, although a fairytale romance might not be possible, that a realistic and mature love might be enough to heal Katniss's soul.

Endings

How does it all end? Jason Bourne escapes the bonds of the espionage machine in three consecutive movies, finally plunging into the river and swimming away. The fact that he returns in a fourth installment (*Jason Bourne*) would seem that, like Michael Corleone, he's being pulled back into the things he once escaped from: there is no way out. Bruce Wayne does finally seem to have found peace, but among the "fanboys," there is a shadow of a doubt: does the final scene represent his real escape and freedom to love, or is it Alfred's dream vision that puts him at that café with Selina Kyle? Bella Swan Cullen has been released from her troubled humanity, and has found love and immortality with her "vampire husband with a soul," her nearly immortal child, and her "best friend," Jacob the werewolf. Katniss Everdeen has triumphed in three consecutive *Hunger Games* films (with, eventually, a great deal of help from the rest of the oppressed population of Panem), and has found what seems to be a sort of peace with husband Peeta and children (although the "movie Katniss" admits to still having nightmares). Are their souls saved? Well, in any traditional nineteenth-century romantic way, the answer might be "no." Bourne remains troubled; Batman might actually be dead; Bella is a vampire, and Katniss still has nightmares. There is no classical *anagnorisis* or awakening that affords the hero the insight needed to change or transform; there are merely "endings." Unless . . .

We will not be satisfied, unless we accept the rules of Stephenie Meyer's universe and believe that Bella has achieved everything that she wanted, and even won things that she didn't recognize that she needed (e.g., the protective "aura" that she can extend away from herself, a clear emblem of her new power and place in the vampire universe); unless we see the expression on Batman's face as he flies the neutron bomb out over the bay as one of a kind of "grace," with him understanding that, finally, he has "done enough" to save Gotham, and he can be released from his self-imposed bonds of obligation; unless we allow that *The Bourne Ultimatum* was the end of that story, with Bourne's leap into the river being a self-actualized "baptism" that brings his saga full circle for the audience (and in this regard, it is clear that *Jason Bourne* keeps Jason on the run and homeless far too long); unless we agree that Katniss and Peeta have found some measure of peace in their love for each other and for their children.

Is the key to personal salvation an admission of love for another? Seeing that statement in print seems naïve, as if our postmodern world cannot

admit the possibility of human love as a motivating factor for any sort of purification.

Take my hand,

I'll lead you to salvation;

Take my love,

For love is everlasting;

And remember

The truth that once was spoken,

To love another person

Is to see the face of God.[7]

What does this mean? Does human love heal souls? Do our heroes need an army behind them to save their world? If, as "Les Miz" suggests, "to love another person is to see the face of God," then, human desire for another and a giving of life for the beloved can be seen as reflective of some kind of divinity. In film, when romance and action come together, our personal battles can be transformed into community action; our own breaking down of social and cosmic bonds and barricades can be converted into a public movement, and we can go a long way to saving our world.

7. *Les Misérables,* "Finale."

Film Bibliography

Bourne Series

The Bourne Identity. Dir. Doug Liman. Perf. Matt Damon, Franka Potente, Chris Cooper, Clive Owen. Universal, 2004. DVD.

The Bourne Supremacy. Dir. Paul Greengrass. Perf. Matt Damon, Brian Cox, Julia Styles, Joan Allen. Universal, 2004. DVD.

The Bourne Ultimatum. Dir. Paul Greengrass. Perf. Matt Damon, Julia Stiles, David Strathairn, Joan Allen. Universal, 2007. DVD.

The Bourne Legacy. Dir. Tony Gilroy. Perf. Jeremy Renner, Rachel Weisz, Edward Norton, Stacy Keach. Universal, 2012. DVD.

The *Batman* Trilogy

Batman Begins. Dir. Christopher Nolan. Perf. Christian Bale, Michael Caine, Liam Neeson, Katie Holmes. Warner Brothers, 2005. DVD.

The Dark Knight. Dir. Christopher Nolan. Perf. Christian Bale, Heath Ledger, Gary Oldman, Maggie Gyllenhaal. Warner Brothers, 2008. DVD.

The Dark Knight Rises. Dir. Christopher Nolan. Perf. Christian Bale, Gary Oldman, Anne Hathaway, Tom Hardy. Warner Brothers, 2012. DVD.

The *Twilight* Saga

Twilight. Dir. Catherine Hardwicke. Perf. Kristin Stewart, Robert Pattinson, Billy Burke, Peter Facinelli. Summit Entertainment, 2009. DVD.

The Twilight Saga: Eclipse. Dir. David Slade. Perf. Kristin Stewart, Robert Pattinson, Taylor Lautner, Bryce Dallas Howard. Summit Entertainment, 2010. DVD.

The Twilight Saga: New Moon. Dir. Chris Weitz. Perf. Kristen Stewart, Robert Pattinson, Taylor Lautner, Ashley Greene. Summit Entertainment, 2009. DVD.

The Twilight Saga: Breaking Dawn, Part 1. Dir. Bill Condon. Perf. Kristen Stewart, Robert Pattinson, Taylor Lautner, Billy Burke. Summit Entertainment, 2011. DVD.

The Twilight Saga: Breaking Dawn, Part 2. Dir. Bill Condon. Perf. Kristin Stewart, Robert Pattinson, Taylor Lautner, Billy Burke. Summit Entertainment, 2012. DVD.

The Hunger Games Series

The Hunger Games. Dir. Gary Ross. Perf. Jennifer Lawrence, Josh Hutcherson, Liam Hemsworth, Woody Harrelson, Donald Sutherland. Lionsgate, 2012. DVD.

The Hunger Games: Catching Fire. Dir. Francis Lawrence. Perf. Jennifer Lawrence, Josh Hutcherson, Liam Hemsworth, Woody Harrelson, Donald Sutherland. Lionsgate, 2013. DVD.

The Hunger Games: Mockingjay, Part 1. Dir. Francis Lawrence. Perf. Jennifer Lawrence, Josh Hutcherson, Liam Hemsworth, Woody Harrelson, Donald Sutherland, Philip Seymour Hoffman, Julianne Moore. Lionsgate, 2015. DVD.

The Hunger Games: Mockingjay, Part 2. Dir. Francis Lawrence. Perf. Jennifer Lawrence, Josh Hutcherson, Liam Hemsworth, Woody Harrelson, Donald Sutherland, Philip Seymour Hoffman, Julianne Moore. Lionsgate, 2015. DVD.

Secondary Sources

"Action Film." *Wikipedia*, July 21, 2016. https://en.wikipedia.org/wiki/Action_film.

"Box Office History for *Twilight*." *The Numbers*. www.the-numbers.com/movies/franchise/Twilight#tab=summary.

Dexter. Directed by Michael Cuesta, written by James Manos Jr. Showtime.

"Film-makers, what has London ever done to you?" *The Guardian,* April 25, 2013. https://www.theguardian.com/film/filmblog/2013/apr/25/film-makers-what-london-done.

"Jason Bourne Hits $110 Million Globally, Bad Moms Opens Strong." *Comingsoon.net*, last modified July 31, 2016. http:// http://www.comingsoon.net/movies/news/751569-jason-bourne-hits-110-million-globally#/slide/1

"Twilight." *Box Office Mojo.* www.boxofficemojo.com/franchises/chart/?id=twilight.htm.

Barth, Karl. *Epistle to the Romans.* Translated by Edwyn C. Hoskyns. Oxford: Oxford University Press, 1968.

Batman: A Celebration of 75 Years. New York: DC Comics, 2014.

Batman: The Movie. Directed by Leslie H. Martison. Twentieth Century Fox, 1966.

Brook, Peter. *Between Two Silences: Talking with Peter Brook.* Edited by Dale Moffitt. Dallas: Southern Methodist University, 1999.

Campbell, Joseph. *The Hero with a Thousand Faces,* 2nd ed. Princeton, NJ: Princeton University Press, 1972.

———. *The Power of Myth.* New York: Anchor, 1991.

Collin, Robbie. "Batman V Superman: Dawn of Justice is the most incoherent blockbuster in years." *The Telegraph,* March 26, 2016. www.telegraph.co.uk/films/2016/04/14/batman-v-superman-dawn-of-justice-is-the-most-incoherent-blockbu/.

Dargis, Manohla. "'The Bourne Ultimatum': Still Searching, but With Darker Eyes." *The New York Times,* August 3, 2007. www.nytimes.com/2007/08/03/movies/03bour.html.

————. "'Twilight Saga: Breaking Dawn, Part 1': Edward, You May Now Bite the Bride." *The New York Times.* November 17, 2011. http://www.nytimes.com/2011/11/18/movies/the-twilight-saga-breaking-dawn-part-i-review.html.

————. "'Twilight Saga: New Moon': Abstinence Makes the Heart Grow … Oh, You Know." *The New York Times,* November 19, 2009. http://www.nytimes.com/2009/11/20/movies/20twilightnewmoon.html?_r=0.

————. "'Twilight': The Love That Dare Not Bare Its Fangs." *The New York Times,* November 20, 2008. http://www.nytimes.com/2008/11/21/movies/21twil.html?_r=0.

————. "A Rejected Superhero Ends Up at Ground Zero, Review: 'The Dark Knight Rises,' With Christian Bale." *The New York Times,* July 18, 2012. http://www.nytimes.com/2012/07/20/movies/the-dark-knight-rises-with-christian-bale.html?_r=0.

————. "Dark Was the Young Knight Battling His Inner Demons." *The New York Times,* June 15, 2005. http://www.nytimes.com/2005/06/15/movies/dark-was-the-young-knight-battling-his-inner-demons.html.

————. "Infusing the Bloodline With a Problem Child, 'The Twilight Saga: Breaking Dawn—Part 2' Ends the Series." *The New York Times,* November 15, 2012. http://www.nytimes.com/2012/11/16/movies/the-twilight-saga-breaking-dawn-part-2-ends-the-series.html.

————. "Showdown in Gotham." *The New York Times,* July 18, 2008. www.nytimes.com/2008/07/18/arts/18iht-18knig.14598651.html.

————. "Striking Where Myth Meets Moment: 'The Hunger Games: Catching Fire,' With Jennifer Lawrence." *The New York Times,* November 21, 2013. http://www.nytimes.com/2013/11/22/movies/the-hunger-games-catching-fire-with-jennifer-lawrence.html.

————. "Tested by a Picturesque Dystopia: 'The Hunger Games,' Based on the Suzanne Collins Novel." *The New York Times,* March 22, 2012. http://www.nytimes.com/2012/03/23/movies/the-hunger-games-movie-adapts-the-suzanne-collins-novel.html.

————. "Tested by a Picturesque Dystopia: 'The Hunger Games,' Based on the Suzanne Collins Novel." *The New York Times,* March 22, 2012. http://www.nytimes.com/2012/03/23/movies/the-hunger-Games-movie-adapts-the-suzanne-collins-novel.html.

————. "Under New Management, Movie Review: 'The Bourne Legacy.'" *The New York Times,* August 3, 2007. www.nytimes.com/2012/08/10/movies/movie-review-the-bourne-legacy.html?_r=0.

————. "Up From Rubble to Lead a Revolution: 'The Hunger Games: Mockingjay Part 1' Opens." *The New York Times,* November 20, 2104. http://www.nytimes.com/2014/11/21/movies/the-hunger-games-mockingjay-part-1.html.

Ebert, Roger. "The Bourne Identity." *RogerEbert.com,* June 17, 2002. www.rogerebert.com/reviews/the-bourne identity-2002.

————. "The Bourne Legacy." *RogerEbert.com,* August 8, 2012. www.rogerebert.com/reviews/the-bourne-legacy-2012.

————. "The Bourne Ultimatum." *RogerEbert.com,* August 7, 2007. www.rogerebert.com/reviews/the-bourne-ultimatum-2007.

————. "The Dark Knight Rises." *RogerEbert.com,* July 17, 2012. http://www.rogerebert.com/reviews/the-dark-knight-rises-2012.

———. "Twilight." *RogerEbert.com,* November 19, 2008. www.rogerebert.com/reviews/twilight-2008.

Ehrlich, David. "From Swashbucklers to Supermen: A Brief History of Action-Movie Heroes." *Rolling Stone,* September 1, 2015. http://www.rollingstone.com/movies/news/from-swashbucklers-to-supermen-a-brief-history-of-action-movie-heroes-20150901?page=10.

Fforde, Jasper. *Thursday Next: First Among Sequels.* New York: Penguin, 2007.

Fleisher, Michael L. *The Encyclopedia of Comic Book Heroes Volume 1 Batman.* New York: Collier, 1976.

Greeley, Andrew. *The Catholic Imagination.* Berkeley, CA: University of California Press, 2000.

Klimek, Chris. "This Time Out, Matt Damon's Not Feeling The 'Bourne.'" *NPR.org,* July 28, 2016. http://www.npr.org/2016/07/28/486936145/this-time-out-matt-damons-not-feeling-the-bourne.

Les Misérables. "Finale." Original Broadway Cast Recording, The David Geffen Company, 1987.

Lohfink, Gerhard. *Does God Need the Church?* Translated by Linda M. Maroney. Collegeville, MN: Michael Glazier, 1999.

Miller, Frank. *The Dark Knight Returns.* New York: DC Comics, 1986.

Pretty Woman, 10th Anniversary Edition. DVD. Directed by Garry Marshall. Dimension Films, 2000.

Priester, B. J. "The Heroine's Journey: How Campbell's Model Doesn't Fit." *Fangirl.com,* April 30, 2012. http://fangirlblog.com/2012/04/the-heroines-journey-how-campbells-model-doesnt-fit/.

The Princess Bride. DVD. Directed by Rob Reiner. MGM Home Entertainment, 2001.

Scott, A. O. "In 'Jason Bourne', a Midlife Crisis for a Harried Former Assassin." *The New York Times,* July 27, 2016. http://www.nytimes.com/2016/07/29/movies/jason-bourne-matt-damon-review.html?_r=0.

———. "'Bourne Identity': He Knows a Lot, Just Not His Name." *The New York Times,* June 14, 2002. www.nytimes.com/2002/06/14/movies/14BOUR.html.

———. "'The Twilight Saga: Eclipse': Global Warming Among the Undead, Kristen Stewart and Robert Pattinson, Smoldering." *The New York Times,* June 29, 2010. http://mobile.nytimes.com/2010/06/30/movies/30twilight.html?referer=.

Seitz, Matt Zoller. "Batman V Superman: Dawn of Justice." *RogerEbert.com,* March 22, 2016. http://www.rogerebert.com/reviews/batman-v-superman-dawn-of-justice-2016.

Sims, Chris. "Comics Alliance Reviews 'Batman'. 1966, Part 1." *Comics Alliance,* October 10, 2011. http://comicsalliance.com/batman-1966-review-2/?trackback=tsmclip.

Sleepless in Seattle. DVD. Directed by Nora Ephron. Sony Pictures, 2003.

Taylor, Charles. *A Secular Age.* Cambridge, MA: Belknap, 2007.

Travers, Peter. "'Jason Bourne' Review: Matt Damon Is Back and Badass." *Rolling Stone,* July 27, 2016. http://www.rollingstone.com/movies/reviews/jason-bourne-movie-review-w430923.

Weintraub, Steve. "Matt Damon Interview—*The Bourne Ultimatum.*" *Collider.com,* July 25, 2007. http://collider.com/matt-damon-interview-the-bounre-ultimatum/.

Weintraub, Steve. "Paul Greengrass Interview—*The Bourne Ultimatum.*" *Collider.com,* July 25, 2007. http://collider.com/paul-greengrass-interview-the-bourne-ultimatum/.

Wertham, Frederick. *Seduction of the Innocent.* New York: Rinehart, 1954.

Index

Film Index

Batman Trilogy, Character Index

Bourne Series, Character Index

The Hunger Games Series, Character Index

Twilight Saga, Character Index